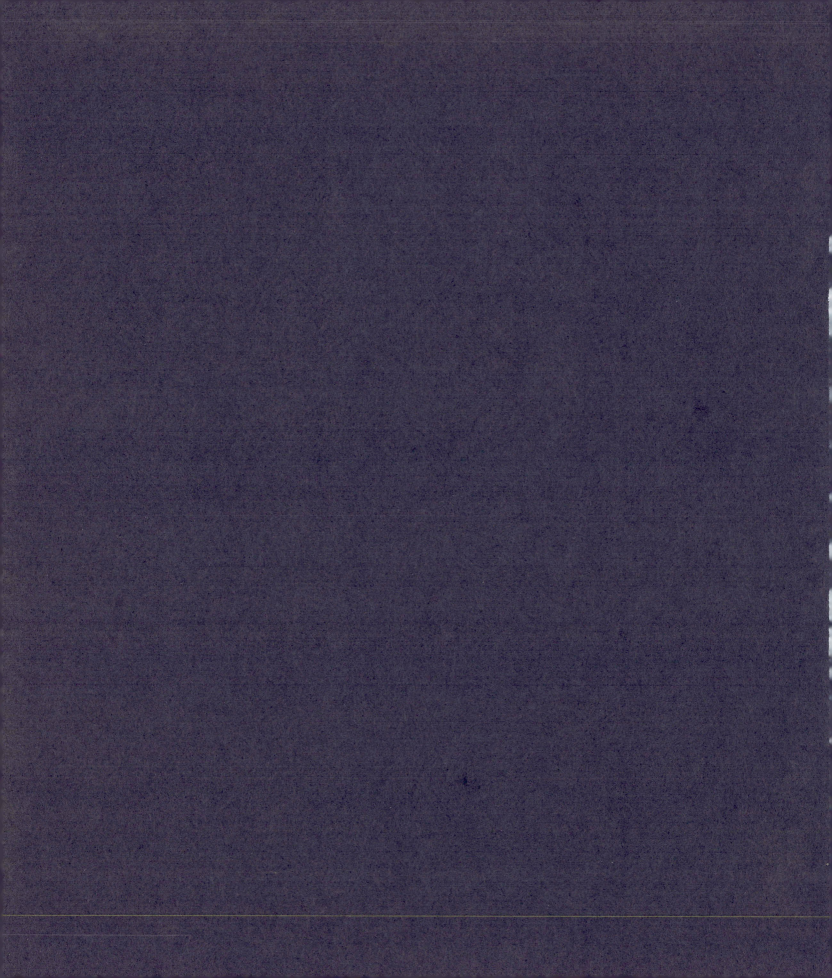

American Civilization: a series edited by Allen F. Davis

Mind's Eye, Mind's Truth: FSA Photography Reconsidered

Mind's Eye,

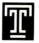

Temple University Press
Philadelphia

James Curtis

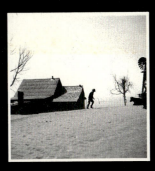

Mind's Truth

FSA Photography
Reconsidered

Temple University Press, Philadelphia 19122 Copyright

© 1989 by Temple University.

All rights reserved Published 1989 Printed in the United

States of America

The paper used in this publication meets the minimum

requirements of

American National Standard for Information Sciences –

Permanence of

Paper for Printed Library Materials, ANSI Z39.48-1984

Library of Congress Cataloging in Publication Data

Curtis, James, 1938–

Mind's eye, mind's truth: FSA photography reconsidered /

James Curtis.

p. cm. — (American civilization) Bibliography: p.

Includes index.

ISBN 0-87722-627-X (alkaline paper) 1. Photography,

Documentary — United States.

2. United States. Farm Security Administration. I. Title.

II. Series.

TR820.5.C87 1989 770′.973 — dc19 89-4375 CIP

Contents

Preface

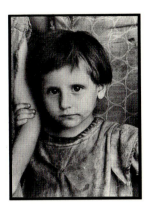

Now we see as through a glass darkly,
but then, face to face.
—Corinthians 1:13

For more than half a century, the photographs of the Farm Security Administration (FSA) have been regarded as the ultimate expression and achievement of the documentary movement in still photography.[1] In 1939, noted photographer Edward Steichen chose more than forty FSA photographs for a special edition of *U.S. Camera Annual*. In his introduction he wrote that these government images were "the most remarkable human documents ever rendered in pictures"—high praise indeed from the man who would go on to create in 1955 the twentieth century's most celebrated photographic exhibition, "The Family of Man." Steichen continued to be fascinated with the FSA collection and in 1962 selected nearly two hundred file photographs for exhibit at the Museum of Modern Art.[2]

Steichen was not the first artist to praise the photographic project and incorporate its images in his own work. In 1938, America's prize-winning poet Archibald MacLeish used these government pictures as part of his impassioned critique of American society, a book entitled *Land of the Free*. So strong was MacLeish's belief in the inherent realism of these documents that he was moved to write that his work was "not a book of poems illustrated by photographs" but "a book of photographs illustrated by a poem." Modern scholars have enhanced the FSA's realistic reputation by presenting the photographic project as a painstaking, objective inquiry that disclosed the actuality of rural suffering during the Great Depression.[3]

Academic praise for the FSA collection as a repository of revealed truth partakes of the widespread public belief in the inherent honesty and authenticity of all documentary photographs. Photographers themselves have helped to nurture this public trust. "There is a branch of photography concerned with justifying the medium's credibility," writes critic A. D. Coleman in a perceptive contribution to the century-old debate on photographic realism. He defines this justification as "a religious discourse between image-maker and viewer," involving "an act of faith on both parts." The photographer pledges not to manipulate the image by resorting to what Walker Evans once called "a bag of mysterious tricks."[4] The viewer in turn promises not to examine the photographer's motives or to investigate the genesis of the final print. This compact protects the image-maker from untoward inquisition and the viewer from unnecessary doubt. The chapters that follow question this belief system but are not iconoclastic by design. Rather they assert the primacy of photographs as historical evidence and present a new methodology for visual analysis.

Literary predispositions have posed formidable obstacles to such a path of inquiry. Previous histories of the FSA project have been based on manuscripts and recorded recollections. Although

contemporaneous with the photographs, FSA correspondence rarely provides specific information on field assignments or individual images. Nor are oral histories a sure guide; most of the FSA photographers were interviewed nearly three decades after submitting their photographs to the file.

This dependence on traditional sources has obscured the most obvious visual evidence. The FSA file, now housed at the Library of Congress, provides scholars with a rare opportunity to examine thousands of images by noted artists who were prevented by government regulations from editing their work. As salaried civil servants, the FSA photographers were required to submit *all* their pictures to Washington. Walker Evans and Dorothea Lange occasionally withheld negatives, but most of their photographs became part of the burgeoning file, as did the pictures produced by the eleven other members of the photographic team.

Examination of the file as originally arranged makes it clear that FSA photographers took series of pictures as a matter of course.[5] Even Walker Evans, advocate of the single transcendent image, experimented with different arrangements of the same scene, as evidenced in his file photographs of southern sharecroppers. *Migrant Mother*, easily the FSA's most celebrated image, was the sixth and final photograph in a series. In the first five, Dorothea Lange placed her subjects in various poses, both to elicit their cooperation and to set the stage for her final composition. Arthur Rothstein employed a similar strategy in creating *Fleeing a Dust Storm*, his famous photograph of a farmer and his two young sons.

While all the FSA photographers took sequential photographs, Russell Lee was the first staff member to embrace the pictorial essay, a new form derived from photojournalism, mural art, and motion pictures. Working from "shooting scripts" developed by project head Roy Stryker, Lee produced extended series on American village life, most notably portraits of San Augustine, Texas, and Pie Town, New Mexico. On these two assignments alone, Lee took more than six hundred photo-graphs. Even today, the Library of Congress houses more pictures of Pie Town than this tiny community has residents.

Given the richness of the FSA file, it would be tempting to feature lesser-known photographers and photographic series. I have limited my analysis to the work of these four photographers—Evans, Lange, Rothstein, and Lee—precisely because they have gained such widespread recognition. Indeed, it is the fame of Lange's *Migrant Mother* that has made her masterpiece almost impenetrable. Similar acclaim occludes Walker Evans's photographs for *Let Us Now Praise Famous Men* (1941). Conversely (or perhaps perversely) scholars have used the infamous steer skull series to brand Arthur Rothstein an unaccomplished artist and to present his photographs as examples of documentary malpractice. I seek neither to rescue Rothstein's reputation nor to diminish the accomplishments of his more illustrious colleagues, but rather to reconsider FSA photographs as historical documents that reveal the richness and complexity of American culture during the Depression decade.

My reconsideration of the FSA project necessarily begins with an assessment of its director, Roy Emerson Stryker, whose approach to photography was an outgrowth of his urban experience. Although he was born in the countryside, Stryker, like the photographers he would employ, came of age in the city. First as teacher, then picture editor, and finally as Washington bureaucrat, he grew to appreciate the power photographs exerted in urban culture.[6] Stryker often said that his greatest accomplishment was to head a project that introduced "Americans to America."[7] But his intended audience was far less egalitarian than this recollection suggests. As both promoter of documentary field work and purveyor of photographic prints, Stryker communicated with an urban, middle-class clientele, the same consuming public to which his photographers looked for approval.

That Stryker and his staff made calculated appeals to this audience should come as no surprise. What is surprising is the degree to which they ma-

nipulated individual images and entire photographic series to conform to the dominant cultural values of the urban middle class. FSA field work often involved conscious arrangement of subject matter, posing of people, and construction of assignments to follow predetermined points of view. Thus Walker Evans went to great lengths to superimpose his own love of neatness and symmetry on the lives of Alabama sharecroppers. Dorothea Lange reduced the size of Migrant Mother's family to suit prevailing norms. Arthur Rothstein borrowed heavily from the powerful and popular medium of motion pictures to dramatize the plight of Dust Bowl farmers. In response to America's search for a usable past, Russell Lee recreated the nineteenth-century small-town ideal to allay public anxiety about the growth of a mass, impersonal society at home and abroad.

In my analysis of these and other key FSA assignments, I have come to appreciate the wisdom of noted critic and photographer Allan Sekula, who contends that "any meaningful encounter with a photograph must necessarily occur at the level of connotation."[8] Stated otherwise: a photograph has no inherent or intrinsic message—only an assigned meaning. In our rush to place trust in the objectivity and realism of documentary photographs, we have lost sight of their historical value and, as a consequence, of their primary meaning. It has long been fashionable to hold FSA photographs so that they mirror present circumstances. But this is to indulge narcissism in the name of nostalgia. *Mind's Eye, Mind's Truth* searches for the meanings that Depression-era Americans assigned to these images. When examined in the light of history—when held so that they reflect the lives and beliefs of image-makers, subjects, and audience alike—the full power and potential of these photographs comes into view.

This project began more than a decade ago, during which time I received generous support from a number of individuals and institutions. To Ian Quimby, director of publications at the Henry Francis du Pont Winterthur Museum, I want to give especial thanks for publishing earlier versions of Chapters Two and Three in the *Winterthur Portfolio*. With the able assistance of Kate Hutchins and Patti Lisk, Ian has established *WP* as one of the nation's most influential journals on American material culture. I am equally grateful to Allen Davis, who encouraged me to submit the complete manuscript to Temple University Press, where Director David Bartlett and Janet Francendese have been enthusiastic supporters of this project since its inception. I would like to thank Jennifer French for her thoughtfulness and patience during the various stages of the editorial process, and Richard Eckersley for the book's superb design.

My colleagues at the University of Delaware have given unsparingly of their time and advice. George Basalla and Thomas Pauly provided innumerable suggestions that improved the essays on Walker Evans and Dorothea Lange. I also received excellent commentaries from Richard Bushman, Bernard Herman, David Hounshell, and Patricia Leighten. Grants from the University of Delaware allowed me to finish my research and to purchase the photographs for this book.

The chapters that follow began as lectures in my American history survey course. I would like to express my gratitude to current and former teaching assistants for their keen interest in the study of documentary photography: Sheila Grannen (co-author of the article on Walker Evans), John Rohrbach, Steven Schoenherr, and Charles Watkins. My work on documentary photography would not have been possible without the support of the staff at the University's History Media Center, a unique facility that has attracted two major grants from the National Endowment for the Humanities for the development of courses in the field of visual history. The Media Center's purchase of the FSA microfilm has greatly facilitated my research.

I am particularly grateful to David Culbert for his constant encouragement and expert reading of my work. Thanks also to Leroi Bellamy of the Prints and Photographs Division of the Library of Con-

gress for helping me locate several images buried in the FSA negative file; and thanks to Theresa Hayman of the Oakland Museum for permission to reproduce three Dorothea Lange photographs (Courtesy of the Dorothea Lange Collection. ©The City of Oakland, The Oakland Museum).

Would that I could find the right words to express my admiration for my wife Susan, whose love of humanity and dedication to her students have been constant sources of inspiration.

JAMES CURTIS, *New Castle, Delaware*

Mind's Eye, Mind's Truth: FSA Photography Reconsidered

Chapter One

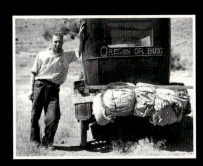

"Introducing Americans to America"

Roy Stryker and the
Creation of the FSA
Photographic Project

Early on the afternoon of April 18, 1938, an eager crowd jammed the sidewalks outside the Grand Central Palace in New York City, awaiting the official opening of the First International Exposition of Photography. Police convinced the exposition managers to open the doors early to relieve the congestion. By evening, more than seven thousand visitors had paid the forty-cent admission to what promoters advertised as a "Mecca" of photographs. Three thousand images were on display in the main exhibit hall. Several hundred companies set up booths to show the latest photographic technology. Nightly vaudeville shows promised amateurs a chance to "snap America's most photographed girls." A special photo mural, created by advanced "aerial camera equipment," offered a spectacular bird's-eye view of the city. Throughout the eleven-day fair, special trains brought more than five thousand visitors to the Palace.[1]

Amidst the cavalcade of modernism at the Grand Central Palace was a small exhibit simply titled "How American People Live." This collection of photographs from the Farm Security Administration emphasized not technological innovation but the consequences of an agricultural depression that for more than a decade had ravaged the country. Spare captions underscored the magnitude and extent of the suffering: "Sharecropper's Family—Alabama," "Oklahoma Drought Refugee—California," "Tubercular Mother and Child—New York," "Children in Farm Shack—Iowa."[2]

Public response to the FSA exhibit was immediate and visceral. "Wake up smug America," wrote one of the more than five hundred tourists who filled out response cards. "A hell of a subject for a salon," scribbled another shocked viewer. While a few of these respondents saw these photographs as contrived instruments of propaganda, most shared the sentiments of a viewer who commented, "These pictures impress one as real life of a vast section of the American people." The pictures aroused more than concerned curiosity; they prompted many in the audience to reflect on their own lives. "It makes you think of tomorrow and what it will bring," wrote one anxious tourist. Realism and self-reference were the keynotes in art critic Elizabeth McCausland's review praising the FSA show. "The hard, bitter reality of these photographs is the tonic the soul needs. . . . In them we see the faces of the American people [and] (if we are completely honest and fearless intellectually) the faces of ourselves."[3]

The bitter reality of which McCausland wrote was not the result of clinical, photographic field work, as many admirers of the FSA project would later maintain.[4] The realism was deliberate, calculated, and highly stylized. Borrowing heavily from current fashions in both documentary photography and film making, project director Roy Stryker

and his staff created a powerful portrait that communicated rural suffering in terms that an urban middle class would readily understand. The Grand Central exhibit purported to show New Yorkers how rural folk lived. Yet neither Roy Stryker nor his photographers had firsthand knowledge of agrarian America. In background, education, and experience they were urbanites; as the city spurred their ambitions and structured their professional lives, so it shaped their vision.

As presented in this exhibit, agrarian America was on the move, its traditions uprooted by economic chaos, its people driven to the highways in search of food, shelter, and employment. Dorothea Lange's photograph of a Texas family on the road between Austin and Dallas provided one of the most compelling statements of this concern (see figure 1). Here Lange invested a traditional American theme with new and urgent meaning. The open road had long been the setting for real and allegorical journeys in search of wealth, property, redemption, and renewal. Indeed, restlessness and mobility had become synonymous with the American spirit of individualism. No journey had a more profound impact than the country-to-city migration that by the 1930s left the rural population in a distinct minority. Although they had followed the path of progress, newcomers to urban America remained ambivalent about their own relocation. They continued to romanticize the open road and the "central importance of moving" but at the same time they reasserted "a basic allegiance to home, stability and family continuity."[5]

Visitors to the international exposition identified with the lonely figures in Dorothea Lange's photograph, not as free-spirited on-the-roaders but as victims of a harsh environment. The FSA exhibit concentrated on the migrant condition. Whether hitchhiking on a Texas road, living in a Florida fruit pickers' camp, finding temporary shelter in a roadside tent in California, or occupying a company house in Arkansas, migrants were deprived of the traditional protections of family and home. Urbanites already anxious about the uprooting in their own lives responded strongly to this pictorial presentation of the homeless, migrant condition. The word "home" itself appeared frequently on the response cards: "The truth is strikingly and forcibly brought home." "It brings home to me some of the things in our own country that we need to do something about." "Brings home to me how sordid life can be."[6]

The Washington bureaucrat who directed the FSA photographic project had called the city his home for nearly two decades. Born in Kansas in 1893, Roy Stryker was raised in Colorado. After a brief stint of military service during World War I, he began an extended educational migration that ended at Columbia University, where he completed his undergraduate degree in economics in 1924. Upon graduation, Stryker became an assistant to Rexford Tugwell, a Columbia economist who was then in the process of writing (with coauthor Thomas Munro) a comprehensive and theoretical textbook, *American Economic Life and the Means of Its Improvement* (1925).[7]

Rexford Tugwell, too, had been drawn away from his rural home by the prospects of an urban education. Much as he valued his agrarian upbringing, Tugwell saw little to glorify in traditions that stressed self-sufficiency and resisted technological change. In his new textbook, the young Columbia professor advocated a progressive agricultural policy, adoption of labor-saving machines, and an active interchange with the city. Such a policy would "lessen the cultural differences between country and city" and create a more uniform "American thought." As the progressive farmer relied on the latest technology, so the modern educator used the most up-to-date means of communication. Tugwell worried that "newspapers, pictures, phonographs and radios" might become "tools of dishonest propaganda," but properly employed, the new media could promote "public education, democratic exchange of opinions, and the discriminating enjoyment of life."[8]

Tugwell wanted to enhance the appeal of his textbook with illustrations. Pictorial materials were deemed so central to *American Economic Life* that when Roy Stryker agreed to design, select, and cap-

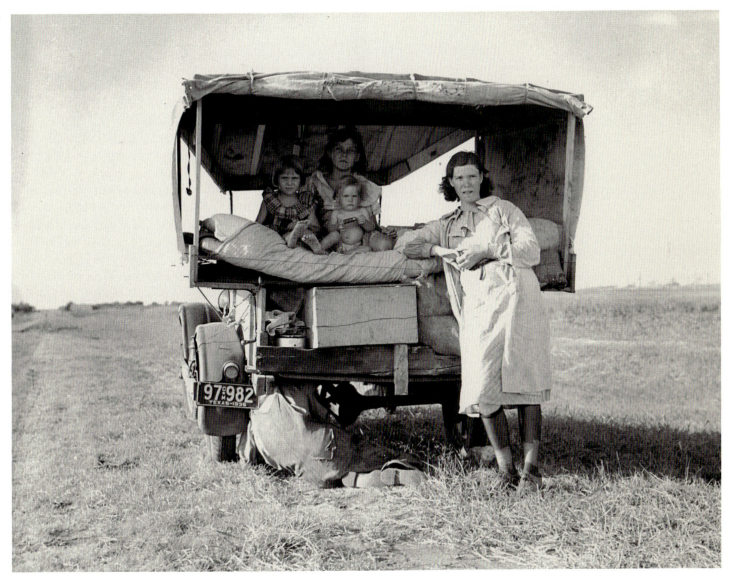

1. Dorothea Lange, migrant family, Fort Worth vicinity, Texas, 1936 (FSA-LC).

tion all the illustrations, Tugwell listed his young assistant as a coauthor. This editorial apprenticeship introduced Stryker to the visual materials from which he would fashion his life's work.

When he went to work on *American Economic Life*, Roy Stryker knew little about textbook design and even less about photography. As an undergraduate he had financed part of his education by making graphs and charts for his professors, in the process demonstrating a strong ability to translate statistics and economic data into clear, concise, and compelling illustrations. But this was hardly sufficient experience for the new project. Tugwell

suggested that Stryker consult J. Russell Smith, a Columbia geographer whose *North America* used hundreds of illustrations, including charts, maps, lithographs, cartoons, and photographs.[9] Embedded in text and accompanied by detailed captions, photographs took on the appearance of objective data. Smith's layout greatly impressed Stryker, as did the geographer's analysis of America's landscape and culture.

Billed as a pioneering work in the new field of human geography, *North America* still bore the heavy imprint of nineteenth-century environmental determinism. Smith claimed to be on a "scientific

search" to determine why "North America is fit to be the home of a great and powerful people." Such chauvinism made a mockery of science and produced a host of cultural stereotypes: hardy yankees, slothful southerners, independent yeomen, and dim-witted immigrants. This bias was especially evident in Smith's treatment of California's migrant labor, a problem that Stryker's government photographers would later cover in great detail. One passage in *North America* told of the "Indian, the Mexican and the bum who beats his way on the freight train" to work in the fields, followed by Smith's assertion that such transients were "not particularly good for the social life of the rural community." Smith paid much more attention to central California's large-scale agricultural interests, in return for which he received photographs for use in his text. Apparently, Stryker overlooked Smith's prejudice. For the next two decades he praised *North America* as a work of great insight and required his photographers to read it before going on assignment.[10]

Following Smith's example, Stryker filled *American Economic Life* with images that reinforced the didactic and technocratic style of Tugwell's text. Stryker refused to let illustrations stand alone. He wrote detailed captions for even the most elementary charts and for all the photographs in the book. Like Smith, Stryker obtained many of his images from corporate and government sources such as the Ford Motor Company and the Department of Agriculture.

Stryker also drew heavily from the photographic file of Lewis Hine, America's pioneer documentarian. By the time he met Stryker in 1924, Hine had been a professional photographer for nearly two decades. He was best known for his pictorial investigations of working conditions and for his commitment to the reform of the abusive child labor system.[11] Having contributed photographs to more than two hundred articles in *The Survey* and *Survey Graphic*, Hine was accustomed to having his pictures surrounded by dramatic captions and explanatory text. Indeed, he was an early advocate of the creative combination of the printed word and the photographic image. Speaking to a group of social workers in 1909, Hine argued that when a photograph was "sympathetically interpreted" by what he called "social pen-pictures," the result was a powerful lever "for social uplift."[12]

Wielding his own pen, Roy Stryker wrote captions that often changed Hine's original intent. This alteration is particularly evident in Stryker's handling of Hine's work portraits of the early 1920s. In these images, later collected and published in *Men at Work* (1932), Hine celebrated the "courage, skill, daring and imagination" of America's laborers with compositions that likened the modern factory worker to the skilled craftsmen of the preindustrial era. Hine believed that "the more machines we use the more do we need real men to make and direct them."[13] Stryker stripped away the skills of Hine's "real men." Under a photograph designed to highlight the experience of a punch press operator, Stryker wrote, "Almost any worker can be trained to do [the job] in a relatively short time." Where Hine took great care to compose his portrait of a silversmith as the last of a dying breed of craftsmen, Stryker inserted the image in the middle of Tugwell's critique of luxury goods. Hine's famous image of an electrician "feeling the pulse" of a large turbine is a classic portrait of man's interaction with machine, but Stryker used the picture to illustrate the confrontation between management and unions.[14]

By appropriating the image, Stryker asserted a measure of control over the photographer himself. He did not become Hine's confidant as had Paul Kellog, the editor of *The Survey* and *Survey Graphic*. The relationship between Stryker and Hine was purely contractual. Tugwell's young assistant wanted proven pictorial material; the aging photographer needed money.

A decade later, Stryker, now a Washington bureaucrat, was again searching for images to inform the public about a new Tugwell enterprise: the Resettlement Administration (RA). Ironically, Lewis Hine applied for a job on Stryker's staff but was rebuffed.[15] Stryker's rejection of Hine was not an act

of vengeance but the result of a bewildered bureaucrat's struggle to gain some control over his new assignment.

The Resettlement Administration was created in the spring of 1935, and Tugwell became its first administrator. Stryker signed on with his former mentor in the summer of that year, to compile visual evidence for a massive educational campaign. Tugwell believed that worn-out soil was a major source of agrarian poverty; he hoped to identify submarginal land and then resettle its inhabitants on more productive soil and in progressive agricultural units. These goals met with stiff resistance from Republican critics who charged the former Columbia economist with importing leftist, academic theories into the Department of Agriculture and the President's inner circle, thereby contaminating America's traditional agricultural policies.[16]

Stryker's early efforts as a New Deal publicist were hardly innovative. He began by collecting existing images from various government archives to illustrate RA's publicity releases. Stryker was slow to grasp the concept of photographic inquiry. Although he has long been credited with creating a team of traveling photographers, the inspiration for field work may well have originated outside Stryker's domain. Tugwell was greatly enamored of the new medium of documentary film and, in the summer of 1935, had given a substantial budget to Pare Lorentz for a motion picture on the Dust Bowl, despite the fact that the young director had no previous film-making experience. For his location shooting, Lorentz hired two cameramen with outstanding reputations as still photographers, Paul Strand and Ralph Steiner.[17] Lorentz's ability to mobilize resources and direct the work of experienced artists no doubt spurred Stryker to seek greater authority for his own photographic project.

In the fall of 1935, Tugwell gave Stryker permission to take centralized control over all photographic activities associated with the Resettlement Administration.[18] This was no minor responsibility since the RA was the repository of a multitude of New Deal relief efforts, including the recently approved Greenbelt Towns program, agricultural camps for migrant workers, more than a hundred experimental communities, and the various plans to retire worn-out farmland. Underfunded from its very inception, the Resettlement Administration nevertheless reflected Tugwell's optimistic belief that planned government intervention could provide cures to the nation's many agricultural ills. Stryker was expected to supply Congress and the nation's news media with pictorial information on the work of this burgeoning bureaucracy.

Empowered by Tugwell and inspired by Lorentz, Stryker envisioned a task force of thirty or forty photographers, fanning across the country to compile information on the American landscape and on RA's relief efforts. These investigators would report directly to his office, which would have a central darkroom to develop negatives and make prints. Publicists working for the RA would then draw freely on this central file to supply pictures to congressional committees, investigative agencies, newspapers, magazines, and commercial publishing houses.

Budgetary constraints handicapped Stryker from the very beginning. He could barely equip three photographers, let alone thirty. Unsympathetic government accountants questioned the cost of film and camera equipment, per diem expenses, and the subsidy of automobile travel. Hostile congressional critics resisted photographic forays into their districts and demanded explanation of the entire concept of visual information.

Stryker countered these criticisms by adopting the bureaucratic precept of cost effectiveness, not by appealing to the principles of artistic integrity or freedom of inquiry. "Let me again warn you that you must push as hard as possible and get your pictures done," he wrote to one of his photographers late in 1935, adding later, "Your monthly expenditures look pretty large and unless I can lay down lots of pictures with your name on them each month, I am afraid I am going to be in for some difficulty." Even when budgetary pressures eased late in 1936, Stryker demanded more and more images. The

sheer bulk of the picture file became his first line of defense. "I am really quite disturbed over the inability to convince our superiors of the necessity of keeping up a definite momentum in this photographic work," he wrote to another photographer in 1938 at the time of the Grand Central exhibit. "They seem to think that because there are over 20,000 negatives in the file that our job may be pretty well done."[19] By 1942, the file had quadrupled and still Stryker was not satisfied; he continued to maintain pressure for large-scale output from his staff.

As the file took on a mass, it acquired a philosophy. Stryker began to think of himself as a national historian accumulating images for future generations. In part, this outlook was the result of his academic background; Stryker believed that he had a responsibility to educate his public. Once fortified with philosophical and historical zeal, he was ready to counter charges that the file was a collection of propaganda pictures. By defining FSA photographs as objective documents, taken solely "for the record," Stryker and his associates believed that they were serving the cause of historic preservation.

To protect the file and its rationale, Stryker insisted on total control of photographs and accountability from his photographers. He refused to allow them to retain their own negatives, reasoning that staff members were government employees, traveling on government per diem and recording pictures on government film. Inevitably, Stryker's bureaucratic preoccupations shaded into proprietary control. Stryker himself took not a single image in the more than eighty thousand prints that would eventually constitute the FSA collection, yet he came to regard the file as his own. He took possession of the work of his photographers just as he had previously appropriated the pictures of Lewis Hine: by process of selection and by insistence on detailed explanatory captions.

Although he later claimed that he never rejected negatives without the photographer's consent, there is ample evidence that Stryker reserved the right to edit the file. Even his most loyal staff photographer, Arthur Rothstein, later admitted that "there were lots of pictures that he [Stryker] went through

and didn't put in the files," adding that Stryker was not opposed to "killing" bad negatives with a hole punch.[20]

What has struck some later critics as artistic mutilation, Stryker regarded as basic editing. In his estimation, the negative was simply a first draft, the finished print merely one part of a collective pictorial presentation. Stryker insisted that before a print could be placed in the file, it had to bear a detailed caption. Images could not stand alone. "The photograph is only the subsidiary, the little brother, of the word," he wrote late in life, concluding: "In truth there's only one picture in a hundred thousand that can stand alone as a piece of communication."[21] Stryker was speaking as editor, historian, and bureaucrat, not as patron of photography as fine art. Ironically, the fame of the file would be built upon the work of two photographers who were deeply committed to the single artistic image, temperamentally opposed to bureaucratic regulations, and resentful of Stryker's managerial style.

Four years before his death in 1975, Walker Evans spoke to a group of students about his work for Stryker and the FSA project. "I felt this great opportunity to go around quite freely—at the expense of the federal government . . . and photograph what I saw in this country." Evans remembered his early thirties as a time of rebellion, when he cheated on his government employers by photographing "like mad whatever I wanted to. I paid no attention to Washington bureaucracy. I'm sorry to say that Mr. Stryker was representing the government of bureaucracy. Naturally I antagonized him, poor fellow. I gave him a hard time, and he was very nice about it."[22]

The conflict between Roy Stryker and Walker Evans was grounded in their diametrically opposed views on the nature of documentary photography. "What, in a word, was our contribution?" Stryker asked rhetorically in defining the FSA project two years before his own death in 1975. There was no doubt in Stryker's mind that his photographers had "produced some great pictures, pictures that will live the way great paintings live. But is it art? Is any photography art? I've always avoided this particular

controversy," Stryker contended. "Nothing strikes me as more futile, and most of us in the unit felt the same way." Uncomfortable with art, Stryker did not hesitate to summon other words to define his life's work: sociology, journalism, history, and above all education. "I'm sure it's made a contribution to public education," Stryker said of the FSA project, concluding that the "full effect of this team's work was that it helped connect one generation's image of itself with the reality of its own time in history."[23]

Contrary to the aging Stryker's recollections, the FSA staff was never a cohesive unit devoted to taking pictures solely for the historical record. All of the dozen or more photographers employed by the project had well-developed artistic inclinations and most of them tried to model their work after that of Walker Evans. John Vachon, who started out as a staff messenger, even returned to some of Evans's most cherished locations to take pictures in imitation of his idol.[24] A novice like Arthur Rothstein might accept Stryker's tutelage and later recall the project as "more like a seminar in an educational institution than a government agency." Yet in the next breath, he paid lavish tribute to Walker Evans and Ben Shahn. "They made me very much aware of the elements that go into photography—that go beyond just the content of the picture," Rothstein told an interviewer in 1964, going on to define these artistic ingredients as style, "individual approach, of being able to see clearly, being able to visualize ideas. They were not concerned at all with photojournalism. They were interested in photography as fine art."[25]

Much to Stryker's chagrin and Rothstein's dismay, Walker Evans refused to be a team player, either in the field or in postproject interviews. Evans was passionately committed to photographic artistry. On assignment, he often refused "to do some bureaucratic, stupid thing," so that he could indulge his penchant for painterly composition.[26] Moreover, he believed that he alone, among his FSA colleagues, had the true artistic vision, and he was often outspoken in his criticism of staff photographers like Rothstein, whom he considered a man of little talent.

What galled Stryker was not Evans's self-indulgent style or his arrogance so much as his erratic behavior and failure to respond to repeated calls for increased production. Evans refused to keep Stryker informed of his whereabouts, made only minimal efforts to maintain an accurate accounting of his expenses, and regarded required government paperwork as a nuisance. As a consequence, Stryker had to write numerous interoffice memos to justify Evans's reimbursements and to keep his photographer in good standing. Contrary to Evans's later claim that on assignment he took pictures "like mad," his output was the lowest of any staff member. Evans also exhibited a strong aversion to Stryker's insistence on detailed captions. His file prints bear little more than a location and a date. He never included the type of social-scientific data that Stryker and his staff appended to other project pictures.

This conflict over the process of photography and the meaning of the individual image helps explain why Stryker released Evans in the summer of 1936 to work with writer James Agee on an article on southern tenantry for *Fortune* magazine. With the file beginning to fill up with pictures from Dorothea Lange in California, Ben Shahn in the Midwest, Carl Mydans in the South, and Arthur Rothstein in the Dust Bowl, Evans was expendable. In allowing Evans to go on assignment for *Fortune*, Stryker nevertheless insisted that all resulting images were government property and must be returned to the file. Clearly he was hoping that when *Fortune* published Evans's pictures they would bear the RA imprint and thus call attention to the work of Stryker's "team." Stryker could not have anticipated the delays that Evans encountered with his co-worker James Agee, delays that led to the demise of the *Fortune* article; nor could he foresee that Evans's images would be resurrected to accompany a much larger Agee text in the twentieth century's most distinguished documentary book.[27]

Like most of his contemporaries, Roy Stryker paid little attention to *Let Us Now Praise Famous Men* when it appeared in 1941. Evans had left the project nearly five years earlier. There had been

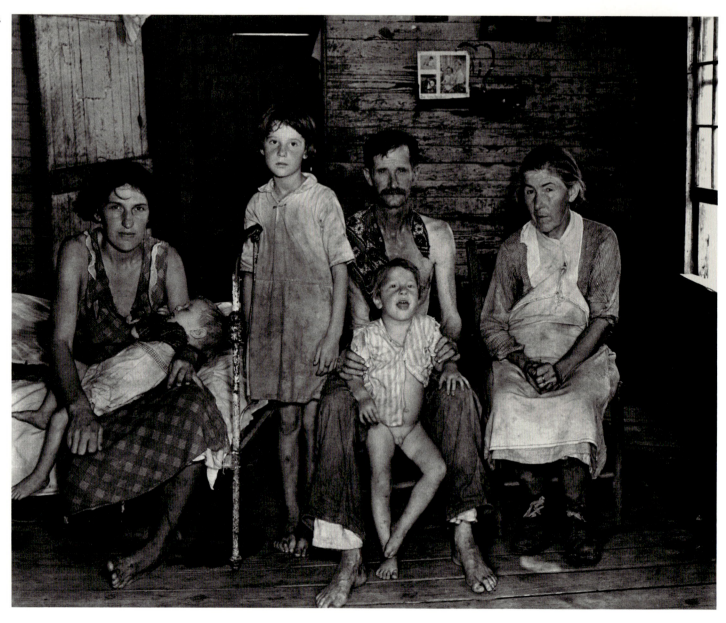

2. Walker Evans, the Fields family, Hale County, Alabama, Summer 1936 (FSA-LC).

no public quarrel but staff members were aware of Stryker's mounting frustration with Evans. Stryker's annoyance had increased in 1938 when the Museum of Modern Art (MOMA) selected Evans for the first one-man show by an American photographer, especially since more than half the pictures in *American Photographs* came from the FSA file. More aggravating still was critic Lincoln Kirstein's accompanying essay, which made no reference to the government's sponsorship for Evans's most distinguished work. Stryker may have taken some per-

verse pleasure, however, from the public response to the only Evans photograph included in the 1938 Grand Central exhibit (see figure 2). "Object very much to picture of boy without pants," scribbled one outraged viewer. "Shameful to hang it." With more than a thousand photographs from which to choose, Stryker selected the sole Evans print that exhibited frontal nudity.[28]

Even the artist was slow to display a picture now regarded as one of his masterpieces. He did not choose this portrait of the Fields family for his 1938

MOMA show. This image does appear in the first edition of *Let Us Now Praise Famous Men*, but opposite another photograph of the same interior showing only three figures: father, mother, and sleeping infant. This placement makes it clear that the Fields family posed for Evans and arranged themselves in response to his direction. Evans usually went to great lengths to disguise such arrangement, fearful that it might be perceived as a violation of the canons of documentary photography. But here, for unknown reasons, he abandoned his normal caution. By producing a second, less sensational view, Evans may have been offering a visual defense against charges that his photography violated standards of decency and subjected these Alabama sharecroppers to public ridicule. One thing is clear. Stryker, without any apparent consultation with Evans, first brought this image to the public's attention at a time when the relationship between the two men was far from friendly.[29]

Roy Stryker had an equally tempestuous relationship with Dorothea Lange, who provided many of the file's most renowned images. Like Evans, Lange came to the project with established artistic credentials and influential connections that did not fit easily into Stryker's bureaucratic structure. An experienced studio photographer, Lange had enlisted in the fledgling documentary movement nearly two years before Stryker founded the file. Her pictures of urban poverty and the misery of California's agricultural workers had received considerable attention on the West Coast and had been published in influential national periodicals, including *Survey Graphic*. Prominent photographers such as Willard Van Dyke promoted Lange's work and brought her pictures to the attention of Rexford Tugwell, who saw them as ready-made illustrations for Resettlement publications. In a sense, then, Stryker had little choice but to place Lange on the payroll in the fall of 1935, even though she intended to work out of her California studio. Desperately short of quality photographs, Stryker could draw on Lange's archive much as he had used Lewis Hine's work a decade earlier.

More congenial and less eccentric than Evans,

Lange nevertheless presented serious challenges to Stryker's authority. She insisted on developing and printing her own film, eventually convincing Stryker to underwrite part of her darkroom costs in Berkeley. Stryker reluctantly agreed but made Lange promise to furnish Washington with the original negative and a file print for each of her pictures. Contrary to his rules for other staff photographers, Stryker allowed Lange to retain copy prints for her own use.[30]

This battle over negatives was part of a much larger struggle between a photographer's demand for autonomy and a bureaucrat's insistence on accountability. Stryker waged war with Lange on much different terms than with Evans, but the outcome was the same. Where Evans refused to reply to Stryker's numerous letters, Lange responded dutifully, often appearing to beg for critical evaluation. But this was more the result of Lange's perpetual anxiety than any regard for Stryker's esthetic judgment. In postproject interviews, she portrayed Stryker as a bureaucrat who jealously guarded the file, not as a patron whose opinion she respected.[31]

Stryker's attempts at mentoring were wasted on Lange, who looked to her husband, Paul Taylor, for background information on the plight of the agricultural poor. A noted University of California economist, Taylor had years of field-work experience among migrant workers. When Stryker was struggling to give definition to the photographic project, Taylor was a field director for California's emergency relief administration. In this capacity, he conducted in-depth investigations of conditions among the refugees who flocked to California following the disastrous dust storms of 1934–35. Taylor regularly employed a team of researchers to record work conditions and to conduct interviews. Dorothea Lange joined this unit as a photographer in the spring of 1935; she and Taylor were married later that year.

Always guarded in his public statements about Stryker, Taylor must have resented the bureaucrat's presumed sociological expertise, based as it was on his reading of academicians such as J. Russell Smith, and not on experience in the field. Taylor, not

3. Dorothea Lange,
plantation owner
and field hands,
Clarksburg vicinity,
Mississippi, 1936
(FSA-LC).

Stryker, helped Lange develop the photographic caption that would be her trademark: an extended commentary that incorporated economic data from field notes and quotations from the migrants themselves. Lange's respect for her husband's prowess as an interviewer bordered on adulation. Indeed, some of Lange's most memorable images resulted from sessions in which Taylor engaged an individual or a group in conversation, leaving Lange free to compose her portraits. Such is the case in Lange's 1936 photograph of a Mississippi plantation owner and his black field hands (see figure 3). This photograph has often been cropped so that the owner's corpulent frame dominates the foreground of the photograph, as he no doubt dominated the lives of his workers. Lange may have intended this cropping to heighten the racial implications of the image, but there was a pragmatic reason as well. Lange later discovered that in composing the picture she had inadvertently included Taylor in the far left of the frame. By printing the negative so that the owner occupied the center of the stage, she neatly moved her husband into the wings and thereby disguised one of her favorite photographic strategies.[32]

Ironically, Taylor was not present for Lange's most famous photograph—*Migrant Mother*—although he had introduced her to the exact locale the previous year.[33] Taylor's absence may help explain why Lange worked so hurriedly in making the six exposures as well as the photographer's failure to record her subject's name. Once he saw the *Migrant Mother* series, Taylor may well have encouraged Lange to rush her pictures to the San Francisco *News*, where they were published before she submitted them to the file. Such independent action did not sit well with Stryker and may help explain why he took Lange off the payroll little more than six months after she took these momentous photographs.

Glossed over by previous historians, this rift between Lange and Stryker in the fall of 1936 was more the result of a personality clash than of economic stringency. Despite her willingness to make several tours through the South (and even to return to the payroll for short periods), Lange remained firmly rooted in California, frustrating Stryker's efforts to centralize administrative control of the project. She did not believe in the detailed preparation and in-depth research that Stryker required of his staff. "The reading that was most fruitful and the best was the reading that I did after I had been [in the field]," Lange maintained in an interview shortly before her death in 1965; "it is often very interesting to find out later how right your instincts were."[34]

Lange's relationship with Taylor may well have posed the greatest threat to Stryker. The California economist was in great demand as a specialist on rural poverty and could therefore easily promote Lange's pictures. The two collaborated on several articles for *Survey Graphic* and in 1939 on a stunning picture book entitled *American Exodus*. This powerful and moving portrait of the Dust Bowl and its refugees drew heavily on Lange's file photographs, stripping off their official captions and substituting material that Lange and Taylor gleaned from field interviews. Stryker cooperated in this venture, much as he had supported Evans's *American Photographs*, because he hoped that the publication would call attention to the work of his project. Privately, he must have been jealous of yet another staff enterprise over which he had no control.[35]

The frustration and bitterness that accompanied Lange's several departures from the project eased over time but never disappeared entirely. While recognizing Stryker's ability to fend off some hostile government critics, Lange was unwilling to join in the 1960s campaign to enshrine her former employer as the guiding genius of the file and as one of the founders of documentary photography. Quite the contrary, Lange believed that her early photographs, not Stryker's vision, had provided the primary impetus for creation of the FSA project.[36]

If unsuccessful in managing Evans and Lange, Stryker did find several loyalists whose artistic ambitions were not yet fully developed and who regarded the project as an ideal training ground. Chief among these was Stryker's former student, Arthur Rothstein, who was hired after his graduation from Columbia in the summer of 1935. At the tender age of twenty-one, Rothstein had almost no profes-

sional experience and was as eager to learn from Stryker as he was awed by the reputations of his more experienced colleagues. No assignment was too mundane, no task too onerous for the enthusiastic young easterner. Stryker repaid this devotion by featuring his former student's work in Resettlement publications and in the Grand Central exhibit. Rothstein's portrait of Vernon Evans, one of the most popular prints in the 1938 show, demonstrated the young photographer's enterprise (see figure 4).

As with many of Rothstein's most famous photographs, there is more to this image than meets the eye. Having dutifully read *North America* and other texts recommended by Stryker, the young photographer was well versed in the western mythology acted out by the jaunty subject who vowed to reach Oregon or bust. By posing young Evans next to his trusty Ford, Rothstein suggested the optimism, individualism, and enterprise that were well-established hallmarks of the pioneer spirit. Although Rothstein had come to the West fully awakened to the persistence of frontier traditions, he almost slept through his golden opportunity.

Rothstein was parked on the side of the road on the outskirts of Missoula, Montana, trying to catch a few hours of sleep. Vernon Evans and three young companions were driving past when they saw Rothstein's government car. The young travelers from North Dakota honked and shouted as they drove past, waking Rothstein, who spotted "Oregon or Bust" and decided to give chase. Vernon Evans later recalled his enormous relief when he discovered that Rothstein was only a government photographer in search of pictures and not a federal official turning back undesirable migrants. Stripped of its comic elements, this encounter reveals the energy and boyish enthusiasm that Rothstein brought to the project and maintained in interviews thereafter. "Well, it was a great educational experience," he recalled in 1964. "Coming from this . . . very provincial New York background, it was a wonderful opportunity to travel around the country and see what the rest of the United States was like."[37]

Rothstein's hurried travels in 1936 left him little time for sightseeing. President Roosevelt's reelec-

tion campaign and the appointment of an investigatory commission on the drought created a dramatic increase in requests for file photographs. Working at a frenzied pace, Rothstein responded to these demands as best he could and still managed to meet with local RA officials and satisfy their pleas for publicity stills. By the time he reached Missoula in mid-July, he had been on the road for nearly five months and had traveled through a dozen states. After leaving Montana, he would retrace his route through the Dust Bowl to his starting point in the Texas Panhandle. Unlike Evans and Lange, Rothstein was a dutiful civil servant who rarely questioned official directives and shared Stryker's belief in the necessity of accumulating images for the historical record.[38]

Rothstein also helped compensate for Stryker's technical inexperience. "Perhaps my greatest asset was my lack of photographic knowledge," Stryker boasted in a postwar interview.[39] Knowing little about how pictures were taken, Stryker knew even less about how negatives were developed and printed. He was therefore enormously grateful to Rothstein for creating the central darkroom in Washington. Without such a facility Stryker never could have won the battle for control of the file and possession of his photographers' negatives.

Official gratitude did not shield Rothstein from censorship or criticism. Stryker monitored the work of his inexperienced staff photographers and attacked those who would not accept his advice. "I never took a picture, and yet I felt a part of every picture taken. . . . I sat in my office in Washington and yet went into every home in America. I was both the Stabilizer and the Exciter." Stryker's method of exciting new photographers like Rothstein was to provide copious criticism of their prints. This vicarious participation in field work was no doubt a reaction to the alienation Stryker felt from the art world of Evans and Lange. "I was never a photographer. I was a teacher and gadgeteer. I always had a camera but I had no more business with a Leica than with a B-29," Stryker later admitted, adding, "I got a hell of an inferiority complex because of it." Stryker's feelings of inferi-

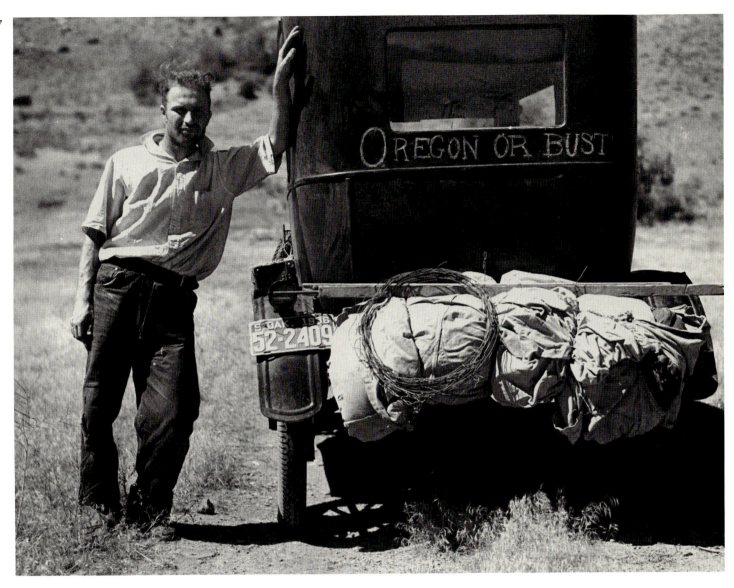

4. Arthur Rothstein,
Vernon Evans,
Missoula vicinity,
Montana, July
1936 (FSA-LC).

ority alternated with his educational zeal to make life miserable for two original staff photographers, who resigned after receiving intemperate critiques of their field work.[40]

Rothstein stayed on, despite being made a political scapegoat in the summer of 1936 during the Republican tirade against his steer skull photographs. During this famous controversy Stryker defended Rothstein, for a number of reasons. Had he fired his loyal lieutenant he would certainly have lent credence to the charges that the RA practiced photographic fakery. Stryker saw nothing wrong with moving an object or posing a subject to create

a photograph that called attention to a known social or economic problem.[41] Indeed, he insisted that his photographers be so schooled that they would not overlook such obvious symbols as the bleached skull that Rothstein unearthed in Pennington County, South Dakota. Practical considerations played an equally important part in Stryker's defense of Rothstein. Notorious though his young staffer had become, Stryker could not afford to lose the services of yet another photographer. Rothstein alone had the technical skills to create the new darkroom and was thoroughly familiar with the emerging organization of the file.

Yet in retaining Rothstein, Stryker appears to have subtly altered his lieutenant's role within the project. Rothstein would continue to make field trips but never again on the scale of his marathon travels through the West in 1936. And while he would produce a number of powerful pictures thereafter, none would bring him the acclaim of his Dust Bowl photographs. Rothstein participated in the expansion of the file following Roosevelt's reelection but lost his position as the most favored and productive field photographer. That mantle passed to another photographer, older than Rothstein but still a professional novice: Russell Lee. Stryker found more than a diligent student in Lee; he discovered a soulmate as well. "One photographer stood out from all the others and that was Russell," Stryker would recall later. "Not because he was better than the others, but because there was some quality in Russell that helped me through my problems."[42]

In the fall of 1936, Stryker's problems went far beyond the steer skull controversy. Rexford Tugwell resigned shortly after Roosevelt's reelection, throwing the entire Resettlement Administration into confusion. The budgetary constraints that had plagued the project throughout the summer appeared to be getting worse. In despair, Stryker thought about returning to Columbia. He may have been contemplating such a move when he met in New York with Robert Lynd, professor of sociology and author of the influential *Middletown*. Lynd took an immediate interest in the file's photographs and encouraged Stryker to embark on a thorough investigation of rural America to determine whether small towns retained traditional values or had been subject to the same forces of decay that altered cities such as Middletown.[43]

Lynd's encouragement could not have come at a more opportune time. For years, Stryker had clung to the hope that he could produce a visual record of American agriculture. The small-town project would be a part of that larger enterprise and would allow the file to accumulate positive images of rural life that would balance the necessary but controversial portraits of agrarian distress. Russell Lee was

ideally suited to the study that Stryker had in mind.

Born in Illinois, trained as an engineer, passionate about his new calling as a photographer, Lee was a man of independent means who had already traveled throughout the country and welcomed the opportunity to make an extended investigation of his native Midwest. Where other staff photographers had been as eager to learn from Evans as from Stryker, Lee spent very little time examining the file and showed no inclination to model his work after that of his well-known colleague. Lee read such required works as *North America*, not out of a sense of obligation but with a genuine curiosity. Stryker was delighted to find a staff member who shared his enthusiasm for scholarly inquiry, and the two began an active correspondence in which they regularly traded reading lists. Despite the growing sense of intellectual companionship, Lee habitually deferred to Stryker's experience as a teacher and considered himself the debtor in the relationship. "We were always at least five books behind," recalled Lee's wife in a postwar interview.[44]

Lee soon proved himself to be the ideal field photographer. He dutifully submitted all required paperwork and kept Stryker fully informed of his whereabouts. New to the profession and naturally concerned about the quality of his photographs, Lee nevertheless relinquished his negatives without question. He began his first extended field trip in December 1936 and did not return to Washington until the following June. During all that time he saw only a few of his finished prints. Loyal, collegial, and cooperative almost to a fault, Lee was also more productive than any other staff photographer. He would work for more than six years, from 1936 to 1942. He later estimated that he spent an average of eleven months a year on the road.[45] His travels took him throughout the country, from New York City to the Pacific coast and from south Texas to the Canadian border. Although Arthur Rothstein's name is always associated with file photographs of the Dust Bowl, Lee spent far more time in Oklahoma and Texas than his young colleague. Dorothea Lange's reputation would eventually rest on her extensive documentation of California's migrant

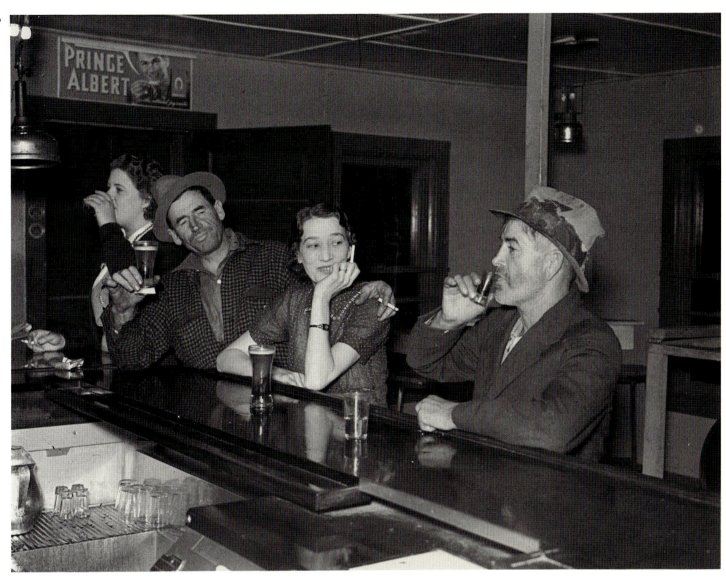

5. Russell Lee, lumberjacks, Craigsville, Minnesota, September 1937 (FSA-LC).

labor, yet Lee produced almost as many prints of this pressing social problem.

Stryker was quick to reward Lee's loyalty and diligent effort. Less than eighteen months after joining the project, Lee learned that his photographs were to be featured at the Grand Central exhibit. Stryker was intent on using this show to introduce New Yorkers to the file and the work of his two most loyal photographers. Together, Lee and Rothstein accounted for more than half of the seventy-six prints in the display, with Lee leading all staff members with twenty-four photographs.[46]

The majority of Lee's Grand Central prints

dealt with the distress of the rural population, but one photograph signaled a direction that he and Stryker would energetically pursue over the next two years. Like Arthur Rothstein's picture of a new frontiersman bound to reach Oregon or bust, Lee's photograph of a rural Minnesota saloon on a Saturday night brought into sharp focus a cherished mythology and established a note of optimism in the midst of an otherwise disturbing exhibit (see figure 5). At first glance, this photograph appears to criticize, not celebrate, small-town life. But Stryker's terse caption "Lumberjacks—Saturday Night—Minnesota" reduced the likelihood

that viewers would look with disapproval on these drinking companions. Recalling the folk legends of Paul Bunyan, the word "lumberjack" was as steeped in tradition as the pioneer slogan Vernon Evans had scrawled across his car.

But where Rothstein had met his subject in a chance encounter that yielded only a few photographs, Lee's portrait was part of an extended pictorial essay that gave Stryker more than a hundred photographs from which to choose. Had he been intent solely on introducing New Yorkers to lumbering in the North Woods, Stryker could have selected one of the eighty-seven pictures of the lumberjacks in their camp near Effie, Minnesota. Here Lee had covered all aspects of logging, focusing on the use of such traditional hand tools as the broadaxe and the peavey. His interior shots of the mess hall and the bunkhouse emphasized abundance, camaraderie, and cleanliness. Lee studiously avoided compositions that might convey worker dissatisfaction, loneliness, or despair.[47]

Stryker passed over these camp pictures in favor of Lee's portrait of a tiny saloon in Craigsville, Minnesota, where the Saturday-night celebrations of visiting lumberjacks suggested a convivial and harmonious community spirit. But Lee's other photographs from this tiny North Woods village show a meaner side of community life. Later the same evening he took pictures of a young logger passed out under the bar and another wandering aimlessly outside the saloon. The following day, Lee took three pictures of a young logger, his face half covered with gauze. The caption reads like a parody of the community ideal Stryker conveyed to his New York viewers: "A lumberjack with a bandaged head after being beaten up and 'rolled' in a saloon in Craigsville, Minn. on Saturday nite."[48]

The FSA show at New York's Grand Central Palace marked more than the successful debut of Russell Lee. Roy Stryker's administrative triumphs and educational mission were on display as well.

Confused and uncertain during his first year in office, Stryker gradually took control of the photographic project. Budgetary headaches would recur from time to time, but he would never again fear for the safety of the enterprise as he had at the time of Tugwell's resignation. The departures of Evans and Lange eased Stryker's inferiority feelings, and his leadership strengthened as Rothstein and Lee proved to be able and willing workers. They were eager to follow Stryker's intellectual lead and remained firmly committed to the emerging concept of the file as a repository of historical evidence, not a showcase of individual artistry.

In the years following the Grand Central exhibit, Roy Stryker would vigorously pursue the small-town project and search for new ways to promote the FSA file. He embarked on this educational crusade in the belief that, by creating finely wrought pictorial essays that called attention to America's agrarian heritage, he was helping to erect a bulwark against the chaos that engulfed Europe in the late 1930s. "If Democracy is going to mean anything to us and if we are going to hold it against the terrific odds which seem to face us, we must do our utmost to help the younger generation of America tie themselves to something pretty solid," he wrote to Rothstein in 1940. That "something" was a disciplined commitment to what Stryker called "craftsmanship." And who were the skilled craftsmen that Stryker proposed as role models to America's youth? Certainly not the entertainers who dominated "the radio and the movies." These media had, in Stryker's estimation, helped create "a whole generation of confused young men and women." No, the nation needed the traditional skills "of the tool maker, the expert farmer, the fine teacher, even the good politician. . . . We all need discipline," Stryker concluded. "I am convinced that with the right leadership this country can evolve a total defense and at the same time demonstrate our democratic integrity."[49]

Chapter Two

"An Art for All That"

Walker Evans
and Documentary
Photography

James Agee, in the introduction to *Let Us Now Praise Famous Men*, pleaded with his readers not to misinterpret his prose. "In God's name don't think of it as Art."[1] Despite the author's emotional appeal, the book has become an artistic success and is recognized as a moving documentary of rural poverty and a stunning literary masterpiece. All but ignored after publication in 1941, the book gained recognition in the early 1960s, nearly a decade after Agee's death. With John F. Kennedy calling attention to suffering in Appalachia and Michael Harrington exposing poverty in *The Other America*, the time had come to "rediscover" Agee's neglected work.

But what of Agee's colleague, Walker Evans, the man who accompanied him to Alabama during that warm summer of 1936 and created the magnificent photographs that precede the text of *Let Us Now Praise Famous Men*? Evans, too, achieved fame, but for different reasons. Even the most admiring critics feel compelled to contrast the obsessive soul searching of Agee's prose with the sobering clarity and understated simplicity of Evans's photographs. What makes this such a powerful work, most people feel, is the unique blend of Agee's empathy and Evans's realism.

Walker Evans won recognition as a photographic realist before publication of *Let Us Now Praise Famous Men*. In 1938 he had a one-man show at the Museum of Modern Art, the first American photographer so honored by the prestigious new museum. In his review of *American Photographs*, the published collection of that exhibit, noted critic William Carlos Williams spoke of Evans's "straight puritanical stare" and claimed that there were no "trick shots" among his pictures. "He has spurned artifice," commented *Art News*. "In his photographs the curious anomalies of contemporary life in America are exposed relentlessly, free from falsification, exaggeration or distortion." "If the word 'documentary' is saved from fashionable vulgarization," the *Magazine of Art* maintained, "Walker Evans should be given much of the credit." Subsequent reviews of *Let Us Now Praise Famous Men* picked up the same themes, referring to the "naked realism which is the truth as Walker Evans's camera eye sees it."[2]

On close examination, what strikes the viewer as "naked realism" is instead the artistry of Walker Evans. He produced precisely the effects he intended. In so doing, he helped perpetuate popular misconceptions that cameras do not lie and that photographs are true because they are mechanical reproductions of reality. Documentary photography derived its power and authority from artful manipulations of these fictions. But credibility came at a price. Since the photographic image was chemical-mechanical and not handcrafted, it did not fit into prevailing standards of fine art. What then was to

distinguish the professional from the rank amateur, the photographic artist from the photographic technician? The answer was artistic vision.

Photography was a way of seeing and involved the ability to capture what photographer Henri Cartier-Bresson has called the "decisive moment" —the ability to envision the completed picture before the actual tripping of the shutter. Yet there was a built-in dilemma here for the documentary photographer. Too much emphasis on artistic creativity or individual vision implied subjectivity and would undermine the veracity of the finished product. No wonder documentarians so often dodged the issue of art versus reality! When cornered, they often spoke in riddles aimed at dissolving this uncomfortable dichotomy. "Photography," Evans maintained in a 1947 interview, "has nothing whatsoever to do with art. But," he added, "it is an art for all that."[3]

Despite a diminution in both the quantity and quality of his post-Depression–era work, Evans retained his reputation as exemplar of photography's documentary tradition. At times he served as the conscience of the movement as well. Where other proponents of "straight" photography admitted to some necessary technical manipulations or to the need for posing subjects, Evans argued for purity, preferring to work with the most basic equipment, avoiding darkroom manipulations, and insisting on the utmost integrity in composition. "That's where the word 'documentary' holds," he said three years before his death in 1975. "You don't touch a thing. You manipulate if you like when you frame a picture, one foot one way or one foot another. But you are not sticking anything in."[4]

Evans's definition of documentary method is misleading and ultimately self-defeating. It perpetuates the notion that photographs are inherently objective artifacts rather than subjective, artistic creations. But in pursuit of an artful composition, Evans often arranged subject matter in ways that directly contradicted his self-proclaimed documentary creed. To achieve a desired effect, he frequently posed his subjects. During his photographic sessions in the sharecroppers' homes in Alabama, he occasionally moved their belongings or arranged to have them moved. When a scene was too cluttered to suit his intent, he removed objects; when necessary he added others to achieve a certain balance. He made these alterations not to mislead the public and certainly not to betray the tenants but rather to show the order and beauty that he believed lay beneath the surface of their poverty. Like Agee, Evans sought to ennoble the sharecroppers and to express his own concern at the condition of their lives. He was not a passive recorder but was drawn, however reluctantly, by the subject matter he arranged before his camera. In this sense his motives resembled those of Agee. But their methodologies differed greatly.

Evans once commented that Agee wanted to "shock and scare people. He wanted to make people who were not poor . . . really feel what it was like to be up against it."[5] To succeed in this, Agee had to convince his readers that the sharecroppers were real people, not the creations of his literary imagination. He changed their names, but let his readers know that he was doing this to protect the tenants from public scrutiny. He catalogued the work habits of the sharecroppers, drew detailed word pictures of their homes, and listed the contents of their households—all to establish an aura of reality and to demonstrate his skill as artist turned objective reporter. He wanted to overcome public disbelief in the accuracy of literary reportage. He knew that total objectivity was impossible, but he sought to record the tenant existence "for its own sake, not for art's sake." Consciously he tried to turn art into life. Yet despite his faithful, detailed note taking, he feared that both his motives and methodology would remain suspect. "If I could do it, I'd do no writing at all here," Agee said in the introduction to *Let Us Now Praise Famous Men*; "it would be photographs."[6]

Evans faced different problems in expressing his social concern. He did not need to create an atmosphere of realism; public perception of photography did that already. Instead he had to communicate the meaning of that reality, and this demanded that he become the creative artist who saw a larger significance in the particular details of poverty. He had to

discover the universal symbols beneath the welter of their everyday existence. Unconsciously, he made life into art.

The photographs in *Let Us Now Praise Famous Men* are not diversionary illustrations; they fully collaborate the text, as Agee maintains. Appearing at the beginning of the book, they are designed to establish confidence in the reportage that follows. They do so with remarkable effectiveness. Yet the words comment on the photographs as well. They describe scenes that Evans never photographed, intimacies and events that he could not or would not capture on film. When the two men did record the same scene, they often saw things differently. Ironically, it is often Agee's self-conscious literary prose that provides the more detailed and objective description of tenant life and exposes not the realism of Evans's pictures but their studied artistry and painterly perspective.

Whatever they may say about the lives of America's rural poor, Walker Evans's photographs are emphatically a product of his own artistic experience. Born in St. Louis, reared in a wealthy suburb of Chicago, educated in affluent eastern schools, he found himself in the late 1920s out of college and out of work. A two-year residence in Paris heightened his interest in photography, and, when he returned to New York in 1928, he decided to make his way in the uncertain world of professional cameramen.[7] Evans sought artistic identity by rebelling against the leading photographers of his day, Alfred Stieglitz and Edward Steichen.

Long considered the great patron of American photography and the champion of its acceptance as a fine art, Stieglitz turned in the 1920s from promotional efforts to his own camera work. In soft-focus, abstract imagery, he tried to express his innermost emotions. Stieglitz believed that the "goal of art was the vital expression of self." Evans would later label such expression "screaming aestheticism" and claim that Stieglitz's "personal artiness veered many younger camera artists to the straight documentary style."[8] For Evans, this meant sharp, hard-focus pictures, not photographic abstractions or impressions.

In his choice of subject matter, Evans further

sought to distinguish himself from photographers like Steichen, who by 1930 had become famous for his portraits of the elite in *Vanity Fair*. Evans spurned studio work, preferring to take pictures outdoors in natural light. Here he could pursue his primary love of architecture and architectural detail. His photographs from the early 1930s of Victorian houses in Massachusetts and summer homes in New York state reveal his fascination with geometry and with the play of light and shadow. So, too, they indicate his preference for the decaying and sometimes decadent remnants of the past. His inspiration often came from commonplace objects, not acknowledged works of art. "The picture postcard is a folk document," he maintained affectionately. Such "honest and direct little pictures" represented both inspiration and challenge.[9] Evans believed that, while technical competence might produce such images, artistic insight alone could give them meaning and impact.

Despite his criticisms of Stieglitz and Steichen, Evans never renounced artistic methodology or the concern for careful composition that was the trademark of all artists, whether they worked with camera or brush. Although drawn to the concrete and commonplace, Evans resisted the craze for candid photography that swept the country in the 1930s with the introduction of the small-format, 35mm. camera. Evans chose to work with the large-format 8 x 10 view camera, which allowed him to compose his pictures with care and precision. He often drove friends to distraction with his deliberate, methodical approach. His meticulous care in composition may help to explain Evans's preference for the inanimate world of architecture and cityscape. In the 1971 Museum of Modern Art retrospective of Evans's photography, people appear in only one-fourth of the more than one hundred images and then often in the background.

Evans's straight style and choice of commonplace subject matter also reflect powerful currents in American art of the Great Depression. Like Evans, American artists of the era were struggling to establish their own identities and to shake free from the abstract European-inspired art that had swept the

country in the wake of the famous 1913 Armory exhibit. At first this revolt was only partially successful, producing a precisionist style that retained the love of geometric design inherent in cubism while rejecting the abstraction of the European avant-garde. Precisionist painters like Charles Sheeler searched for typically American thematic material. In factual, clean-edged paintings of barns, factories, and machines, they sought to promote an art that acknowledged America's stunning economic and technological achievements and saw them rooted in native traditions. By the late 1920s this concern for geometric precision gave way to a more sweeping and unabashed nativistic impulse known as the American Scene movement. Grounded on a fundamental belief in the uniqueness of the American environment, the American Scene considered native art superior to European imports. By the mid-1930s the movement had split into regionalism and social realism.[10]

As he struggled to develop his own style during the 1930s, Walker Evans could not help but be influenced by these artistic currents. Early in the decade he undertook some photographic work for the Museum of Modern Art, thus beginning a lifelong association with a museum that would promote his work while introducing him to the latest trends in art and design. Evans's photographs from the 1930s, especially those of rural poverty, reflect a variety of artistic and cultural impulses.

Evans shared with the precisionists an appreciation for the camera's ability to produce clean, hard lines. Painters like Charles Sheeler often used the camera to record factual detail that would later lend authenticity and realism to their canvases. Evans, who once admitted to being a frustrated painter, emulated this concern for sharp detail and the look of reality.[11] Many of his photographs have the static quality of precisionist art, yet they lack the anonymity and coldness that made precisionism such a short-lived movement.

Although committed to portraying the American scene, Evans did not identify completely with either social realism or regionalism but drew inspiration from both movements. From his friends James Agee and Ben Shahn, he gained a heightened social consciousness, yet he never embraced their radicalism. Nor did Evans seek the significance of poverty in a detailed, candid exposure of individual suffering. His photographs were more positive in appearance, more universal in choice of symbols than much social realist art. Evans regarded American society with a critical but accepting eye, much as did his contemporary Edward Hopper, whose paintings of empty city streets suggest the loneliness of urban life but not a decay of moral fiber or municipal institutions. In 1930 Evans exhibited some of his first photographs at Truro on Cape Cod, where Hopper was in residence. While several later Evans photographs resemble Hopper paintings, the similarity between their work is more in outlook than in specific style. Like Hopper, Evans was keenly "aware of the ugliness of certain aspects of our country. But it was his world, to which he was bound by strong ties. He accepted it completely and in a deeply affirmative spirit, built his art out of it."[12]

Evans's affirmation of the American scene was always restrained, never exuberant. Where regionalist painters like Thomas Hart Benton and John Steuart Curry extolled agrarian institutions such as family, farm, home, and small town, Evans maintained a critical distance. He admired such traditional rural virtues as simplicity, order, and functionalism. Indeed they are key elements in his esthetic; they give his photographs visual crispness and intellectual clarity. Yet Evans did not locate these virtues in any specific regional locale or geographic setting. He was just as apt to admire the spartan interior of an urban apartment as the plain exterior of a rural church.

In his belief that even the most commonplace dwelling or ordinary object could stand for utility, economy, and simplicity, Evans struck a responsive chord with his contemporaries who had embraced a new style of design: the streamlined look of Depression Modern. Consumers could easily rationalize the purchase of furniture, appliances, automobiles, even homes that abandoned the luxurious look of the 1920s for a sheer economy of line more suitable to an era of hard times.[13] In Evans's photographs,

and in displays at the Museum of Modern Art, which exhibited these photographs along with the latest modern design, Americans could see the concern for functionalism elevated to the status of fine art.

If Walker Evans's esthetic was a product of art and popular culture it was also directly linked to the technology of large-format photography. As an artist interested in careful composition, precise rendering of detail, and absolute clarity, Evans found the 8 x 10 view camera exactly to his liking. Although he never extolled its virtues in print, he undoubtedly agreed with photographer Berenice Abbott's claim that "the great virtue of the view camera . . . is that you *see* the picture on the ground glass; you are not shooting in the dark. You are composing, creating your picture as you take it." Furthermore, the special features of the view camera—the swings, the rising and falling back and front—allowed for corrections and "subtle reconciliations of elements in nature." The camera seemed designed for the creative artist. "You can manipulate the picture in a thousand ways," Abbott continued, "so that the image expresses your sense of reality."[14]

Creativity thus occurred in the act of composing and taking a picture, not in the developing or printing process. Most 8 x 10 negatives were not enlarged but were contact printed, ensuring maximum clarity, minimum grain, and absolute fidelity to the scene that originally appeared before the camera. Such a simple, direct, and faithful relationship between visualized picture and final product pleased Evans greatly, for he never considered himself a darkroom technician. "Developing chemicals smell bad and the darkroom is torture," he once confessed to a surprised admirer.[15]

Although outstanding for architectural detail, landscapes, interiors, and still life, the 8 x 10 tripod-mounted view camera was considered too cumbersome for documentary field work, and many of Evans's professional colleagues switched to the hand-held cameras, 4 x 5 or smaller. They willingly sacrificed some clarity for an appreciable gain in versatility. Evans saw little to gain in such sacrifice. Although he used smaller-format cameras, he was not happy with the results and rarely selected prints from small-format negatives for exhibition or publication. Most of his famous government photographs, especially those in *Let Us Now Praise Famous Men*, are products of the bulky 8 x 10 view camera that fascinated Agee: "Walker setting up the terrible structure of the tripod crested by the black square heavy head, dangerous as that of a hunchback, of the camera; stooping beneath cloak and cloud of wicked cloth, and twisting buttons; a witchcraft preparing, colder than keenest ice and incalculably cruel."[16]

Agee's remarks constitute a useful commentary on the photographic process in general and on Evans's work in particular. A photographer working with a view camera mounted on a tripod had to make numerous preparations before actually exposing the film. Composition and focusing required use of the "cloak and cloud of wicked cloth" drawn over the photographer's head to cut out light and allow him to see the scene before him on the viewing screen. The photographer also had to judge available light and then, if necessary, ask his subjects to be still for the period of the exposure. In Evans's case, this final step was often essential, as he tended to work with relatively long exposure times to achieve maximum depth of field and sharp focus at all points in the photographic frame.

While the photographer prepared for his subjects, so they prepared for him. The view camera and the tripod were too large to disguise or conceal. Subjects knew they were about to have their pictures taken. The very bulk of the equipment and complexity of preparation thus formalized the picture-taking event. During these mutual preparations a bargain was struck. Subjects agreed to be still for the period of exposure; in return the photographer promised not to catch them off guard. By their compliance, the subjects became part of the creative process. They might arrange their clothes or their facial expressions, even strike some significant pose that became their personal statement. The photographer had to allow them this much.

Such posing created problems for a purist like Evans. If the documentary photographer was to

6. Walker Evans, main street architecture, Selma Alabama, December 1935 (FSA-LC).

7. Walker Evans, battlefield monument, Vicksburg, Mississippi, March 1936 (FSA-LC).

8. Walker Evans, tin building, Moundsville vicinity, Alabama, Summer 1936 (FSA-LC).

record things exactly as they were, subjects should be involved in everyday activities, not frozen in stiff, unnatural poses. Yet the "terrible structure of the tripod crested by the black square heavy head . . . of the camera" was not designed to record the candid or the commonplace.[17] The 8 x 10 view camera was a portrait camera. When it was set up, people gathered before it to have their pictures "taken." This process, so ideally suited to rendering sharp, clear, static images, actually endangered the natural setting and threatened to turn people into actors or, worse yet, into props.

The control Evans surrendered in taking pictures he regained in exhibiting his finished photographs. He presented his work free of any technical information on camera size, lenses used, or times of exposure, making it extremely difficult to determine whether some scenes were in fact posed. He wanted his public to react to the final image, not to speculate how it was produced. Nor did Evans believe in detailed captions; in *Let Us Now Praise Famous Men* there are no captions whatsoever. The presence of words implied that the image was somehow deficient; Evans believed his photographs were self-explanatory.

In selecting pictures for publication, Evans rarely placed them in the sequence in which they were originally shot. Such arrangement might encourage the viewer to treat the images as part of a photo essay of the type popularized by *Life* and other picture magazines of the 1930s. For Evans, photojournalism was not art; the single image, like the individual painting, carried the message. Yet from 1935 to 1937, the most productive years of his career, Evans did not have total artistic control; he was working for Roy Stryker. When he traveled to Alabama in 1936 with James Agee, Evans was still a government employee. As a consequence, many of his most famous photographs, including most of those that eventually appeared in *Let Us Now Praise Famous Men*, became part of Stryker's file. In 1975 the Library of Congress helped issue a catalogue, containing miniature prints of all extant Evans negatives in its possession, arranged by original government assignment and in the order the negatives were received from the field. The catalogue also includes a key to the negative numbering system, indicating the type of camera used to take each picture. Issued as a convenient guide for purchasing prints, the catalogue is an invaluable research tool.[18] Comparison of the catalogue images with Evans's published photographs shows which pictures he considered suitable for publication and which he chose to suppress. More important, it enables us to examine Evans's most famous photographs in the context of other unpublished images he created at the time. Such examination indicates the controlling influence of Evans's artistic vision and the special demands of the equipment he used. Together, personal esthetic and technical constraints shaped his portraits of rural poverty and, through them, our understanding of tenant life.

When he met James Agee in Alabama in August 1936, Walker Evans was not a total stranger to rural life. Since joining the Resettlement Administration the previous year, he had made several trips through West Virginia, Mississippi, and Alabama to document the problems of worn-out soil and eroded hopes. Like other project photographers, Evans was instructed to portray the plight of the small farmer

and sharecropper, who were attempting to eke out existence on submarginal land. Colleagues like Ben Shahn sought the meaning of the Depression in individual countenance, taking candid pictures of faces twisted by anger and despair. In one of his first government assignments in West Virginia, Evans used the 35mm. camera in a similar fashion and captured some interesting and evocative countenances.[19] But the informality and roughness of these snapshots displeased him. Thereafter he relied more heavily on the large 8 x 10 view camera, portraying hard times through static symbols, not fleeting glances or casual stares.

In Selma, Alabama, in December 1935, Evans suggested the quality of small-town life in photographs of empty commercial establishments in early-morning light (see figure 6). These pictures work in much the same way as Hopper's paintings of lifeless rowhouses or deserted storefronts. A small parking sign and the announcement of a football game directly reflect the concerns of the unseen inhabitants.[20] Similarly, when Evans wanted to explain the impact of economic dislocation on southern tradition in Vicksburg, Mississippi, he did not record the looks of an anxious citizenry but rather the heroic, anachronistic poses of Civil War statues (see figure 7).

Throughout his travels in the South, Evans searched for symbolism in such commonplace surroundings. Discovering a rude, metal building on a dirt street in Moundville, Alabama, he was "taken in by the cross light on silvery, corrugated tin. This was just in itself so beautiful, I set my camera up, knocked over by the barren look of the false front, and how the pile of dirt added to it" (see figure 8).[21] For Evans, as for many artists, this visceral response was the wellspring of creativity.

But buildings were not always unoccupied, and it was often impossible or inconvenient to photograph them during the still hours of the day. During his stay in Selma, Evans tried to use his view camera to photograph a storefront in the midst of daytime activity. He did not seek cooperation from the store owner or the patrons; their actions appear as blurred images in the final picture (see figure 9).[22]

9. Walker Evans,
sidewalk scene,
Selma, Alabama,
December 1935
(FSA-LC).

Although such motion may be suggestive, it distracts from the static elements of storefront design or advertising lettering that Evans depended on to give his street scenes a clean, precise, realistic look. The alternative, of course, was to ask the public to halt its normal activity for a few moments to pose for the camera. A number of Evans's street scenes are so arranged.[23]

Occasionally the potential was so great and the creative urge so strong that Evans went beyond asking his subjects to be still and suggested where and how they might arrange themselves. In the spring of 1936 in Vicksburg, Evans happened upon a row of storefronts in the black section of town. He was drawn to the play of light on the wooden frame structures and by the juxtaposition of handlettered signs for Barber Shop and Shoe Shine with printed posters for Camel cigarettes and Stud tobacco. Evans approached the black citizens outside the barbershop and they agreed to pose, even to exchange places, while he took pictures and searched for the best way to compose architectural line, plane of light, lettering, and human form. He wanted his subjects to be motionless and so arranged that they

would be flanked by, but would not obscure, the advertising lettering. He had them sit on a small wooden bench situated to one side of the barbershop window. (Conceivably Evans asked that the bench be moved to that location, for it blocked two doorways.)

After he arranged his subjects, Evans neatly avoided a posed look by turning one figure at right angles to the camera. He then took at least five photographs of this scene; the first, a long shot taken from across the street, shows three black males sitting on the bench (see figure 10); the grillwork of a car is just visible in the right-hand portion of the picture. In a medium shot of the same scene (see figure 11), the men on the left and in the center of the bench have surrendered their places to two new individuals. Two additional black males have entered the scene and stand to the right of the bench against a storefront. A different automobile now occupies the right foreground, its passenger in the shadows.[24] Evans also took a vertical closeup of this scene; here the two black males on the left have shifted pose slightly. In a fourth version, published in *American Photographs* in 1938, the bench has only two occupants. The passenger of the car, a scowling white man, is now clearly visible; the black males standing at the storefront have assumed different poses. In yet a fifth version, a white man has joined the three black males on the bench.[25] In all five pictures, Evans deliberately maintained one constant; he persuaded a black male to sit on the right of the bench and to remain in the same pose, at right angles to the camera, his arms folded, his legs crossed. Only when joined by the white man does he break out of that pose, and then he faces the camera, a somewhat startled expression on his face.

When viewed individually, as Evans intended, these pictures suggest a variety of things about southern lifestyle, especially the role of the barbershop as a social institution, the significance of sidewalk gathering, even the relationship between blacks and whites. Yet can we draw such inferences when we lack assurances that these were normal or even natural poses? Close study reveals that the subjects have allied with the photographer to help

10. Walker Evans, street scene, Vicksburg, Mississippi, March 1936 (FSA-LC).

11. Walker Evans, street scene, Vicksburg, Mississippi, March 1936 (FSA-LC).

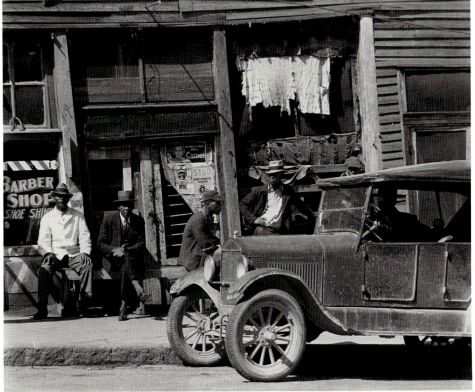

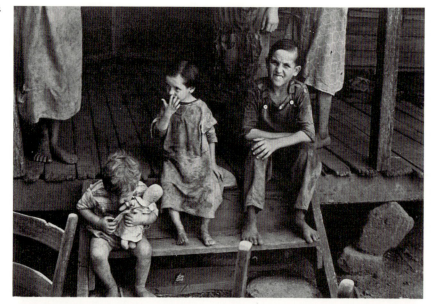

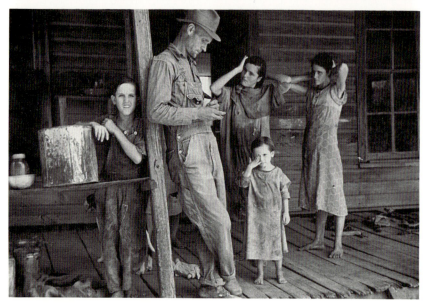

12. Walker Evans, Floyd Burroughs and the Tengle children, Hale County, Alabama, Summer 1936 (FSA-LC).

13. Walker Evans, Floyd Burroughs and the Tengle children, Hale County, Alabama, Summer 1936 (FSA-LC).

him achieve artistic effect. Although these arrangements allowed Evans to capture a clean, crisp series of images and to bring the entire sidewalk scene into sharp focus, they intrude a question: at what point does fiction begin to masquerade as truth?

Evans encountered similar problems during his work with Agee. The two men spent the first few weeks of their stay in Alabama looking for the best way to document farm tenantry. After deciding to adopt a personal approach, they sought permission to live with a tenant family for three weeks. Thanks to the cooperation of William Edward (Bud) Fields, a tenant farmer they met standing in a relief line, they found lodging with his son-in-law, Floyd Burroughs. They lived with Burroughs and visited Fields and another neighbor, Frank Tengle. *Let Us Now Praise Famous Men* encompasses the lives of these three tenant families.

Where Agee's ingrained courtesy and respect for the tenants' individuality gained him access to their lives, Evans's reticence kept him an outsider. Perhaps the camera was also at fault, for picture taking became an event in the lives of these sharecroppers. Agee and Evans first met the entire group at Frank Tengle's house, where all three families eagerly gathered to have their pictures taken. To put them at ease, Evans began taking pictures with his 35mm. camera. In the process, he recorded a remarkable sequence of the tenants preparing to have their pictures taken. Frank Tengle's daughters are fixing their hair, while the younger Tengle children are gradually seating themselves on the wooden porch steps, occasionally responding to remarks from the onlookers (see figures 12 and 13).[26]

Although they are of great interest, Evans never published these eight preliminary "snapshots," probably because they were a product of the small-format camera and lacked the artistic merit he sought. They also clearly show the kind of arrangement necessitated by a formal portrait, but that Evans would not admit because of his documentary scruples. The formal picture Evans wanted was an 8 x 10 photograph of one of the Tengle children, who minutes before had been preparing for the camera (see figure 14).[27] This beautiful

14. Walker Evans,
Laura Minnie Lee
Tengle, Hale
County, Alabama,
Summer 1936
(FSA-LC).

portrait, one of his most famous photographs, is an outstanding example of both documentary art and Evans's romantic approach to tenant life. Beautifully composed, carefully framed, the picture captures the haunting expression of this young child, her dark eyes and smooth skin set off against the rough texture of cotton sack clothing. It symbolizes the suffering and endurance that Agee and Evans honored and sought to record. Yet a comparison of this picture with the informal photographs of Laura Tengle makes one wonder how much of the effect of the formal portrait was the result of superb photographic craftsmanship.

A significant percentage of Evans's Hale County tenant photographs appear formal and posed. Many of them seem to have been taken in blocks on the same day, suggesting that after the initial session on the Tengle porch each family consented to a visit from Evans and then prepared to have its picture taken. Considering the difficulty of bringing all family members together during a busy part of the agricultural season, such an arrangement made good sense. With the exception of the remarkable series of pictures in Bud Fields's bedroom, Evans took these family pictures outdoors, usually on the porch of the house. While the porch appears a natural setting, it was also the usual place to receive visitors. The formal tone of Evans's photographs suggests that he was rarely more than a visitor himself.[28]

The lack of volume and variety in Evans's photographs is also surprising. Although he stayed with the tenants for three weeks, Evans took fewer than one hundred pictures and ignored many aspects of the sharecroppers' lives. He took only one series of pictures of work in the cotton fields, and none of them documents the painful process of picking cotton that Agee describes at length. Perhaps Evans felt that such work portraits had been overdone. Instead, he preferred to suggest hard labor with a picture of a worker's shoes; yet the striking similarity of this picture to Vincent Van Gogh's famous *Les Souliers* robs the photograph of originality and suggests an affectation of artistry that Evans usually sought to avoid.[29] Evans did not take a single pic-

ture of the families at mealtime, probably because indoor photography with a view camera required either a very long exposure time or the use of a flash. It would also have been difficult to compose a picture of a large family seated around a table in a small room.

Evans tried very hard to achieve a sense of intimacy, but his artistic scruples seemed to stand in the way. He took a much higher percentage of 35mm. pictures in Hale County than on other assignments in the South. Yet he chose very few of these small-format pictures for inclusion in the various editions of *Let Us Now Praise Famous Men*. Perhaps he sensed that his strengths were artistic, not journalistic. When asked later to compare his views of rural poverty with those recorded by other, more prolific FSA photographers, Evans claimed, "I knew at that time who I was, in terms of a real eye, and other people were phony about it."[30] As an artist committed to deliberate, careful composition, he considered it far more rewarding and ultimately less phony to photograph the tenants as he thought they wanted to be portrayed. It was also much less an invasion of their privacy to have them pose on the porch for a few carefully prepared pictures than to pursue them into the fields or into their cabins.

Walker Evans felt much more comfortable taking pictures of the tenants' homes than of the tenants themselves. He dutifully recorded the exteriors of the plain wooden structures, but the bleak, rural settings and uncomplicated design sparked little interest in a man accustomed to the richness and variety of urban architecture and the wealth of detail in small-town settings. He took no pictures of the Tengle house, perhaps fearing that his viewers would not understand why a poor sharecropper occupied a large house formerly owned by a well-to-do farmer.

Inside the tenant homes there was sufficient detail to stimulate Evans's interest and creativity. Like Agee, he was fascinated by the arrangement of rooms and their contents. Here he was in total control, with no worry about sudden movement, suspicious subjects, unruly children, or invasions of privacy. These still-life compositions unleashed

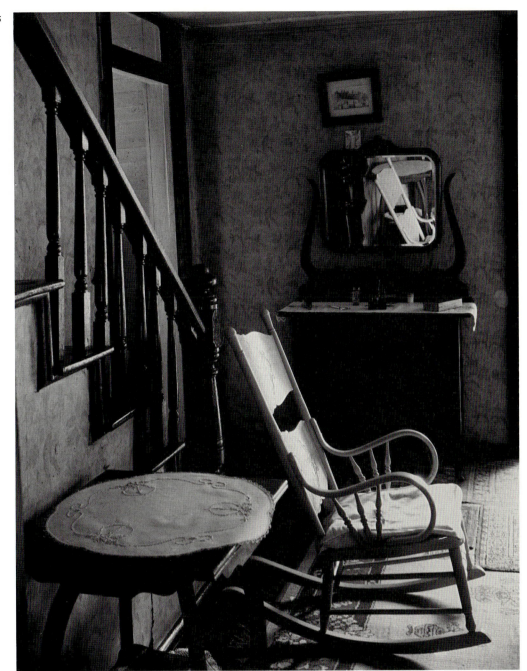

15. Walker Evans, unemployed worker's home, Morgantown, West Virginia, July 1935 (FSA-LC).

the creativity so characteristic of Evans's best work. Here in the interior world of poverty, his search for order and beauty reached its height, as did his departure from his documentary credo. For, as he once admitted to an interviewer, "I can't stand a bad design or a bad object in a room."[31]

It was not the first time Evans sought sym-bolic significance in the order and arrangement of common household possessions. In 1935, in an un-employed worker's home in Morgantown, West Virginia, he produced one of his most memorable interiors, a rocking chair next to a stairway (see figure 15). Working with natural light, Evans com-posed the photograph to show the smooth curves

of the rocker reflected by the sunlight in a nearby mirror and set off against the sharp angle of the banister and the stairs. It is a magnificent composition, a flowing portrait of geometric and curvilinear shapes. In its praise of the functional object, it is also reminiscent of much of the regionalist art and popular design of the 1930s. The photograph also reflects Evans's social concerns. He suggests that even in the midst of poverty and unemployment, a family can still create a world of order and beauty.[32]

But whose world is this? Does it belong to an unemployed worker or to Walker Evans? The rocking chair is certainly graceful, and its placement allows a marvelous composition. The reflection in the mirror is an added touch of genius. Yet this beautiful, functional object occupies a nonfunctional location. There is no room for it to rock backward without hitting the stairway. Anyone sitting in the chair would interfere with traffic up or down the stairs. Evans probably moved the chair, or arranged to have it moved, to a position where he would have adequate lighting from the open doorway.

The implications of staging in this photograph are surprisingly confirmed by the text of *Let Us Now Praise Famous Men*. Agee's extremely detailed descriptions provide both the floor plans of the tenant homes and inventories of furniture and personal belongings. A close comparison reveals serious discrepancies between Agee's word pictures and Evans's photographs.

It is possible, of course, that lapses in Agee's memory account for these differences. He wrote the text for *Let Us Now Praise Famous Men* several years after his stay in Alabama. Yet he worked from exhaustive notes taken at the same time Evans took his pictures. In fact, Evans's photographs confirm the accuracy of Agee's inventories. An Evans picture and an Agee word portrait of a room interior will agree on most specifics. Where discrepancies occur, they are almost always modifications that improve the artistic composition of the scene and suggest that Evans rearranged objects for the sake of photographic appearance.

Such is the case of the bedroom in Floyd Burroughs's house. Agee wrote, "There are two beds

here, both three-quarter size, set parallel, their heads near the rear wall, their sides near the two side walls." Agee maintained that such exact symmetry was typical of "all really simple and naive people" who had an "instinctive dislike" for geometric complication. Therefore beds and other furniture were "set very plainly and squarely discrete from one another and from walls, at exact centers or as near them as possible."[33]

Yet in the Evans photograph of this scene (see figure 16), one of the two beds sits at an angle away from the wall and extends into the center of the room. It had been moved to that position out of necessity and for the sake of composition. The room was small and Evans had very little space for his tripod and camera. Locating them near the foot of the bed, he set about composing the picture. Here he faced a problem. To shoot the bed as it stood parallel to the wall would confuse the picture, as the bedstead at the foot of the bed would appear to blend into that at the head. Evans wanted to separate this wrought iron and to have it stand out against the grain of the wooden walls, and so the bed was moved. It is possible that he made this move with the knowledge and cooperation of the Burroughs family, but more likely that he took this and other pictures of their home on the same day that Agee compiled his detailed inventory. The entire family was away, and the two reporters could lend each other assistance.

There are other discrepancies between Agee's verbal description and Evans's pictures of the Burroughs's bedroom. According to Agee: "Above the head of this nearer bed, suspended on two forked sticks nailed to the wall, is a light-gauged shotgun. On a nail just beside the window hangs the white summer union suit George sleeps in." The photograph clearly shows the shotgun, but the white summer union suit is nowhere in evidence.[34] The smooth, lustrous stock of the shotgun added warmth to this orderly scene without in any way breaking up the architectural line or distracting from the desired textural comparison. But the union suit would have occupied the center of the frame and would have conflicted with the bed linen,

16. Walker Evans, bedroom in Floyd Burroughs's home, Hale County, Alabama, Summer 1936 (FSA-LC).

thereby destroying the meeting of horizontal and vertical planes in the wood. The white summer union suit was clearly a distraction.

By creating the contrast of dark wood and white linen, Evans further altered the scene that Agee recorded. The author had firsthand knowledge of the Burroughs's bed linen, having spent a sleepless night in combat with various forms of crawling insects. He wrote about the sheets with some feeling. "They smell old, stale, and moist, and are morbid with bed bugs, with fleas and, I believe, with lice."[35]

While Evans's picture shows flies on the bed and floor, the bedspread appears relatively clean. Evans achieved this effect in the darkroom, where he chose to accentuate the contrast between light and dark when he printed this particular negative.

Evans rarely made such manipulations in printing his negatives. By so doing on this one, he eliminated much of the dirt that was so evident to Agee. Evans found dirt both a distraction and an esthetic liability. He wanted to show that despite grinding poverty, these heroic sharecroppers were not suc-

17. Walker Evans, fireplace and objects in bedroom of Floyd Burroughs's home, Hale County, Alabama, Summer 1936 (FSA-LC).

cumbing to their environment. Rather than dwell on dirt, as so many documentarians did, Evans chose to concentrate on the potential for order and beauty in the tenants' lives. But the dirt remained in his original negative. In 1971 he made another print from that negative for inclusion in the Museum of Modern Art retrospective of his photography. This time he lowered the contrast, and the resulting photograph clearly shows the dirty linen. By 1971

Walker Evans was apparently more willing and able to deal with ambiguity, even that in his own work.[36]

Discrepancies of a different sort exist between Agee's description of a fireplace in the Burroughs's bedroom and Evans's photograph of the same scene. Both agreed on the contents of the mantelpiece, including "a small bright mirror in a wire stand." The mirror is not immediately recognizable in Evans's picture, for he was forced to face it away from the

18. Walker Evans, fireplace and objects in bedroom of Floyd Burroughs's home, Hale County, Alabama, Summer 1936 (FSA-LC).

camera so that it would not reflect his flash (see figure 17). In addition, Evans removed two small containers from the mantel, a bar of soap from the shaving mug, wadded paper from the fireplace, and a pair of shoes from the hearth.[37] All these alterations contributed to the orderly appearance Evans sought. So did a small clock in the center of the mantel. Agee makes no mention of this object. Perhaps he overlooked it, although the exhaustive

and exact nature of his inventory suggests otherwise. More likely, Evans added the clock, perhaps to establish a sense of the specific, the concrete, in an otherwise timeless scene.[38]

A calendar performs a similar function in Evans's photograph of another bedroom fireplace in the Burroughs's house (see figure 18). Evans did not add the calendar, but he apparently placed two items on the table in front of the fireplace. Agee recorded

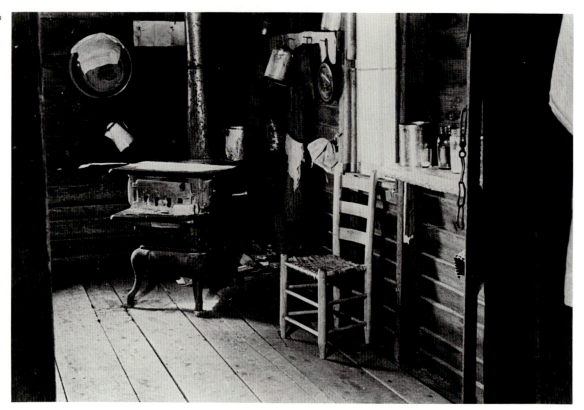

19. Walker Evans, kitchen in Floyd Burroughs's home, Hale County, Alabama, Summer 1936 (FSA-LC).

20. Walker Evans, washstand and kitchen of Floyd Burroughs's home, Hale County, Alabama, Summer 1936 (FSA-LC).

the scene: "On the table: it is blue auto paint: a white cloth, hanging a little over the edges. On the cloth, at center, a small fluted green glass bowl in which sits a white china swan, profiled upon the north." In the Evans photograph, the swan is off center and to the right of a piece of cloth and a vase.[39] From the standpoint of composition, such additions make good sense, for the swan by itself was too small and would have been lost in the whitewashed background of the fireplace. The two new items draw attention to the lower third of the photograph, especially to the shoes on the bottom shelf of the table. Both Agee and Evans were struck by the incongruity of these mud-caked shoes so neatly arranged and so carefully placed beneath the table.

Much more extensive alterations occurred in the Burroughs's kitchen. Evans found the room enormously intriguing. Although it was small—only ten by twelve feet—there was adequate lighting from two windows, one directly opposite the kitchen door, the other on an adjacent wall at right angles

to the door. With a good source of light, Evans would not need his flash. He began by taking some 35mm. shots from the kitchen doorway, looking into the room, but soon discovered that from this point of view he would have a difficult time controlling the light with his view camera (see figure 19). He solved the problem by using the special technical features of his equipment. He set up his tripod in a doorway directly opposite the kitchen door. From that vantage point, he could record the washstand on the outside kitchen wall and the interior of the kitchen itself. By sliding the front of his camera sideways, he could look directly into the kitchen without having the kitchen window in his picture. In short, he moved the entire scene in front of him off center to avoid inclusion of an unwanted light source in his photograph.[40]

The resulting picture is one of Evans's most brilliant compositions, but as a document on the quality of tenant life it is very misleading (see figure 20). However necessary for esthetic and technical reasons, Evans's manipulations distort the

architectural design of the Burroughs's house. On several occasions, Agee commented on the placement of doorways, noting that those opening onto the breezeway were located directly opposite one another. This was a standard design in rural housing to provide maximum ventilation in the heat of summer.[41]

Evans's photograph of the doorway and kitchen creates the impression of a cool, spacious room, an impression that directly contradicts Agee's verbal picture of the same scene: "The difficulty is more with heat. The room is small: very little more than big enough to crowd in the stove and table and chairs. . . . The outdoor sunlight alone is in the high nineties during many hours of one day after another for weeks on end; the thin metal roof collects and sends on this heat almost as powerfully as a burning-glass; wood fires are particularly hot and violent and there is scarcely a yard between the stove and one end of the table." Nor was the room as clean or uncluttered as it appears in Evans's picture. The oilcloth on the table was "worn thin and through at the corners and along the edges of the table and along the ridged edges of boards in the table surface, and in one or two places, where elbows have rested a great deal, it is rubbed through in a wide hole. In its intact surfaces it shines prettily and bluntly reflects the window and parts of the objects that are on it. . . . Where it has rubbed through, the wood is sour and greasy, and there are bread crumbs in the seams and under the edges of the cloth, which smell of mold." Agee also noted that the table was set for dinner, a standard practice when the family planned to be gone during the day. After the previous meal, they washed the plates and utensils and put them back on the table along with a "jar of sorghum, a box of black pepper, and a tall shaker of salt whose top is green, all surrounding the unlighted lamp which stands in the bare daylight in the beauty of a young nude girl."[42]

It is easy to see why the oil lamp alone remains on the table in Evans's picture. The other objects would have created a look of disorder. In taking away these items, Evans seems to have added one element to the scene. On the cupboard, visible in the center background of the picture, stands a large crockery vessel, probably the butter churn. Agee never mentions this object in his precise description of the cupboard and its contents. An item so valuable would not normally have been located in such a precarious position. It was probably placed there to reflect light from the nearby window and later returned to its proper location on the floor.

Both Agee and Evans were fascinated by the arrangement of commonplace items in one corner of the kitchen: "The broom stands in the corner at the foot of the table and above, on nails, hang the round crockery head of the churn, and the dasher. It is pleasantly bright here, with no sunshine, but an almost cool-looking strong, calm light, of the sort that takes up residence in any piece of glass without glittering in it."[43]

Evans was so captivated by the potential in this corner that he brought his view camera into the kitchen (see figure 21). The problem was one of space. In a ten-by-twelve-foot room with "scarcely a yard between the stove and one end of the table," where could he locate his tripod and still take an unobstructed view of the kitchen corner at the foot of the table? Making the only choice possible under the circumstances, Evans moved the kitchen table out of the way and put his equipment in its stead. He also removed a "long and quite narrow bench" that was normally along the wall side of the kitchen table. (This bench is evident in Evans's picture of the kitchen doorway, figure 20.) Had the bench remained it would have extended into the kitchen corner and would have destroyed the symmetrical composition Evans sought, so he moved it. In its place he put a chair brought from its usual spot near the stove, on the other side of the room (compare the earlier 35mm. shot in figure 19). Since Agee makes no mention of the white towel strung across the corner, it is possible that Evans added this to the scene as well. He completed his composition by moving the broom from one corner to another.[44]

The rearrangement within the Burroughs's household was not manipulation for the purpose of deception but careful arrangement for the sake of beauty, art, and, hopefully, public enlighten-

ment. Had he been interested solely in historical authenticity, Evans would doubtless have proceeded differently, and his work would have suffered as a consequence. He was not a trained field researcher, and his photographs should not be regarded as literal documents of poverty. Evans, for one, found the term disturbing. "An example of a literal document would be a police photograph of a murder scene." He wanted no part of such criminal acts. He believed in style and education. "Fine photography is literate, and it should be. It does reflect cultivation if there *is* cultivation. . . . I always remember telling my classes that the students should seek a cultivated life and an education."[45]

Evans sought that cultivation in Hale County, Alabama, in the summer of 1936. Like so many well-intentioned government reformers of the 1930s, he wanted to show that, although the sharecroppers needed help, they were not helpless. He sensed that his fellow Americans would respond more sympa-

thetically to a positive portrayal of tenant life than to morbid curiosity with dirt, disease, or suffering. By ennobling the tenants, by focusing on their strengths and not their frailties, their dignity and not their defects, he tried to show how they created a world of order in the midst of poverty. Evans was not fabricating or lying, he was simply uncovering the potential he believed the sharecroppers possessed. The public could see that potential very clearly, for they, too, believed that a life of order and simplicity was necessary to endure in the face of hard times.

Sadly, the tenants may not have shared this vision or appreciated its intent. Where Walker Evans pictured hope, they knew despair. Where he saw beauty in the reflection of light on a faded oilcloth, they saw dirt and the ravages of time. As Mrs. Burroughs once said with tears in her eyes, "'Oh, I do *hate* this house *so bad!* Seems like they ain't nothing in the whole world I can do to make it pretty.'"[46]

"The Contemplation of Things As They Are"

Dorothea Lange
and
Migrant Mother

On a cold, rainy afternoon in March 1936, Dorothea Lange made a brief visit to a camp of migrant pea pickers near Nipomo, California. She took a series of pictures of a thirty-two-year-old woman seated under a makeshift tent with her children. One of these images soon became known as *Migrant Mother*; it has been called the most famous documentary photograph of the 1930s. "When Dorothea took that picture, that was the ultimate," recalled Roy Stryker. "To me, it was the picture of Farm Security. The others were marvelous but that was special."[1]

After its publication in 1936, *Migrant Mother* became a timeless and universal symbol of suffering in the face of adversity. The image was reproduced repeatedly, even retitled and refashioned to serve other causes in other cultures. In his introduction to the Museum of Modern Art's 1966 retrospective of Lange's work, critic George P. Elliott maintained that *Migrant Mother* had developed "a life of its own" with "its own message rather than its maker's. There is a sense," he continued, "in which a photographer's apotheosis is to become as anonymous as his camera. . . . For an artist like Dorothea Lange, the making of a great, perfect, anonymous image is a trick of grace, about which she can do little beyond making herself available for that gift of grace."[2]

Lost in the appreciation of *Migrant Mother* as a timeless work of art is its personal and cultural gene-sis. Like many documentary photographers, Lange thought of herself as a clinical observer committed to a direct, unmanipulated recording of contemporary events. On the door of her darkroom, she displayed the following quotation from Francis Bacon:

The contemplation of things as they are
Without substitution or imposture
Without error or confusion
Is in itself a nobler thing
Than a whole harvest of invention.[3]

Lange believed that to stray from this credo was to record only one's preconceptions; to her this was false and limiting. Yet the power of Lange's work came directly from her own personal values and from her own heartfelt need to communicate with her contemporaries in terms they would understand. While not inventions, the exposures Lange took on that chilly and damp March afternoon reveal more about the photographer and her audience than about the life of the migrant mother.

This is not to argue that Lange broke faith with the documentary tradition, but only that our understanding of that tradition is somewhat limited. Recent definitions of documentary photography have concentrated on the act of taking pictures and the bearing a photographer's motives had on that decisive moment: honesty, directness, a lack of manipulation—these qualities distinguish the work of

documentarians, often regarded as sociologists with cameras. However insightful and persuasive this line of argument is, it obscures the artistic ambitions of influential figures such as Lange and Walker Evans. They knew from experience that nobility of purpose and commitment to human betterment were not guarantees of success. They had to produce images of technical distinction and esthetic merit in order to communicate effectively with their audience.

As a professional artist who took pride in her work, Lange was constantly concerned with the critical second stage of the documentary process: public recognition and acceptance. So long as she remained inside her San Francisco portrait studio, Lange had only to satisfy the needs of her patrons. The onset of the Great Depression disrupted her commercial enterprise, not by depriving her of customers but by intruding a compelling question. How could she focus exclusively on well-to-do sitters when the unemployed gathered in relief lines near her studio? When she decided to take her camera into the streets, Lange assumed a new set of obligations. To succeed as an advocate of the downtrodden, she had to communicate with a jury of newspaper editors, book and magazine publishers, patrons of the arts, and government bureaucrats. By winning their support she might reach a larger audience, thereby gaining recognition for herself and for the cause of her subjects. Time and circumstance were in her favor.

Although experiencing the early stages of a communications revolution, Depression America was not yet saturated with images. Motion pictures exerted an enormous influence on popular culture, creating at once an interest in visual arts and an acceptance of contemporary events as appropriate subject matter for education and entertainment. Illustrated news magazines would build upon that appeal, but not until the late 1930s. At that time many of Lange's colleagues found work with publications such as *Life*, where new canons of photography emerged and sensationalism often outweighed esthetics. As a result, the photographic essay came to replace the single image as an accepted means of documentary reportage. Although three of the pic-

tures from the Migrant Mother series were first published in a San Francisco newspaper, the enterprise belongs in the realm of art rather than photojournalism. As the several exposures she took of the scene show, Lange sought to create a transcendent image that would communicate her sense of the migrants' condition. She created a portrait that incorporated elements she knew her contemporaries would understand and find worthy of support.

In addition to being a timeless work of art, *Migrant Mother* is a vital reflection of the times. Examined in its original context, the series reveals powerful cultural forces of the 1930s: the impact of the increasing centralization and bureaucratization of American life; the anxiety about the status and solidarity of the family in an era of urbanization and modernization; a need to atone for the guilt induced by the destruction of cherished ideals; and a craving for reassurance that democratic traditions would stand the test of modern times.

When Dorothea Lange went to work for the Resettlement Administration in the fall of 1935, she encountered a confusing bureaucracy more concerned about accountability than artistry. Struggling to defend his project from hostile critics, Roy Stryker applied constant pressure for more field photographs. Output was also important to Lange, but for different reasons. In the field, she often recoiled from the desperate poverty arrayed before her camera. How could she justify an art that literally fed on the starvation of the poor? Frenetic effort assuaged some of her guilt. "I worked at a pace and saw conditions over which I am still speechless," she wrote to Stryker after one grueling assignment. She "encountered dust, blowing sand, and misery to an extent that" her home seemed "like a heaven."[4] A quantity of exposed film was proof of a job thoroughly done, allowing Lange to leave the hellish environment of the migrant camps with good conscience. No matter that some of the images might be flawed; they would be useful in the file.

Lange's meeting with Migrant Mother came at the end of another long, arduous journey. The photographer was headed home when she passed the sign, Pea-Pickers Camp. "It was raining, the cam-

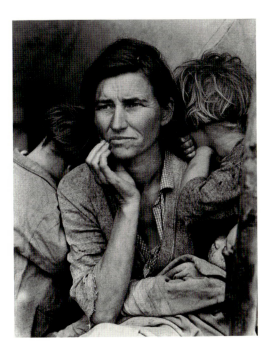

22. Dorothea Lange,
Migrant Mother,
Nipomo, California,
March 1936 (FSA-LC).

locations, and enduring the vicissitudes of weather. When Will Rogers quipped that the United States was "the only nation in the history of the world to go to the poorhouse in an automobile," he might have added, "and the only nation to hire a car and a photographer to document the exodus."[6]

Had Lange been at the beginning of an assignment instead of at the end that day in March, she might have stayed hours at the pea pickers' camp instead of minutes, but only to take more pictures, not to achieve greater intimacy. Migrant Mother remained nameless by design, not oversight. Stryker had his photographers follow contemporary social science techniques in captioning their images. Subjects photographed, like citizens interviewed, remained anonymous.[7] Stripped of their identities, they became the common men and women whose plight the Roosevelt administration was working to improve.

"I saw and approached the hungry and desperate mother, as if drawn by a magnet," the photographer would later say of her most famous assignment. "I do not remember how I explained my presence or my camera" but moved "closer and closer from the same direction." In her approach to the tent, Lange took a series of pictures, the last of which is a closeup of Migrant Mother and three of her children (see figure 22). Lange did not arrive at this final composition by accident, but by patient experimentation with various poses. The images in the series comment on one another and represent a logical progression and development of subject matter. Internal evidence in each provides important information on Lange's choice of symbolism and the values she sought to communicate.[8] As a group, the images provide a revealing commentary on middle-class attitudes toward the family.

Lange, her biographers, and scholars of documentary photography have described the Migrant Mother series as consisting of the five photographs that she submitted to Stryker and that are now located in the FSA collection in the Library of Congress.[9] But Lange took an additional picture that she withheld from the government, most probably for esthetic reasons. This long shot appears to

era bags were packed, and I had on the seat beside me in the car all those rolls and packs of exposed film ready to mail back to Washington." She recalled driving twenty miles toward home, trying to blot out that sign from her memory. "Haven't you plenty of negatives already on this subject," she asked herself. "Besides if you take your cameras out in the rain you are just asking for trouble." "Almost without realizing" what she was doing, Lange turned around and drove back to the camp, unloaded her camera, and took six pictures of the woman and her children. She remembered spending only ten minutes in front of the leanto shelter, working closer to her subjects with each shot. She did not ask the woman's "name or her history." Nor did she "approach the tents and shelters of other pea-pickers. It was not necessary." She knew that she "had recorded the essence of [her] assignment."[5]

This brief encounter was typical of Stryker's project; his photographers were constantly on the move. They were required to cover as much territory as possible and rarely remained in one location for more than a day at a time. Lange and her colleagues became transients themselves, working out of the backs of their vehicles, traveling to unfamiliar

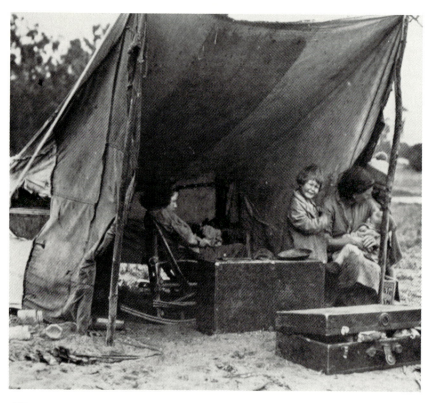

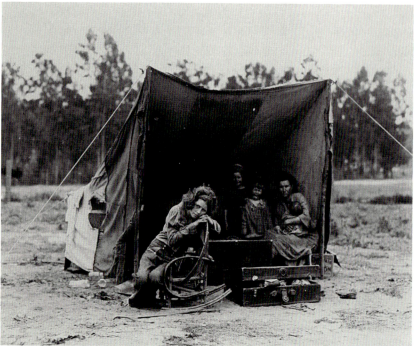

23. Dorothea Lange, Migrant Mother (no.1), Nipomo, California, March 1936. From Paul S. Taylor, "Migrant Mother: 1936," *American West* 7, no.3 (May 1970): 44.

24. Dorothea Lange, Migrant Mother (no.2), Nipomo, California, March 1936 (FSA-LC).

be the first in the series (see figure 23), probably taken as soon as Lange had unloaded her camera equipment. By comparison with the five known exposures, it is a rather chaotic image, lacking control and a central focus. The teenage girl, seated in a rocking chair inside the tent, is turned away from the camera. One of her younger siblings stands nearby, looking at Lange but crying and making a motion with her hand that blurs the image. Migrant Mother is close to being crowded out of the frame; she, too, is looking away from the camera, and her posture all but obscures the fourth child. It would appear that Lange took this as a trial picture, to introduce her subjects to the photographic process and to ease them into the posing and arrangement that a portrait session required.

The trial succeeded, for in the next image the family has rearranged itself and now fits more comfortably into Lange's viewfinder (see figure 24). Migrant Mother looks toward the camera, as do her younger daughters, who stand, somewhat stiffly, to her right. The teenage girl poses in a stylized fashion in the rocking chair, which has been moved from inside the tent and now occupies the foreground of the picture. While better composed and more neatly arranged than her first picture, this second photograph contains confusing elements. In her caption for this photograph, Lange says that

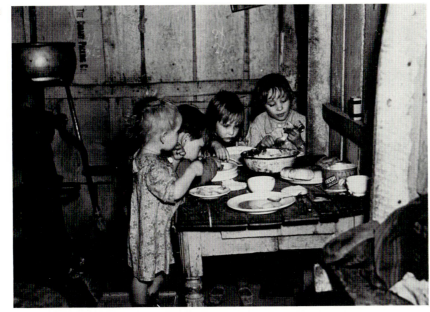

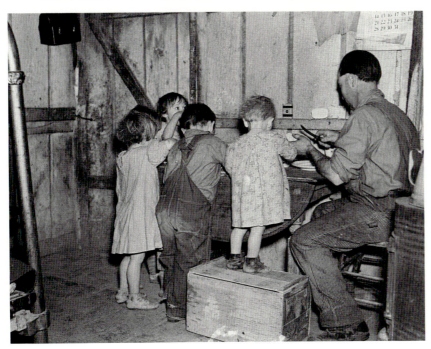

25. Russell Lee, *Christmas Dinner in Iowa*, Smithland vicinity, Iowa, December 1936 (FSA-LC).

26. Russell Lee, Christmas dinner, Smithland vicinity, Iowa, December 1936 (FSA-LC).

this was a "migrant agricultural worker's family. Seven hungry children and their mother aged 32. The father is a native Californian."[10] Although Lange conversed enough with her subject to learn that Migrant Mother's husband was a "native Californian" and thus even more deserving of relief funds than a newly arrived "Okie," she probed no further into the reasons for his absence or that of the other three children. Perhaps it was a press for time, perhaps a reluctance to learn more than she cared to know. What if the father had abandoned the family?

The father's conspicuous absence served several useful purposes. Viewers could easily presume that he was working or at least looking for work. Either interpretation highlighted the consequential cost to the remainder of the family unit. Lange's colleague Russell Lee had a similar idea in mind when he created *Christmas Dinner in Iowa* the following December (see figure 25). This photograph shows an empty place at the head of the table; the children are left to provide for themselves, their meagre repast a bleak commentary on the once-proud ideal of rural self-sufficiency. Lee took another picture inside that cabin, showing the father at his traditional place; significantly, that image has never before been published (see figure 26).[11] By way of extension, Lange's famous portrait of a drought refugee family

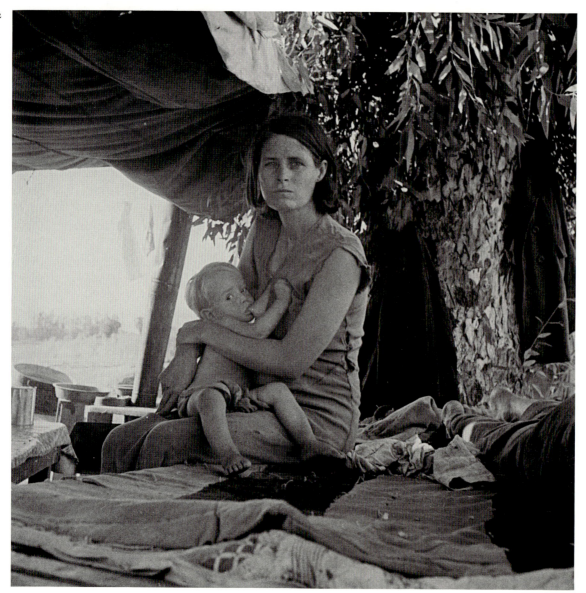

27. Dorothea Lange, Oklahoma drought refugees, Blythe, California, August 1936 (FSA-LC).

in which the focus is solely on the defiant wife nursing her child (see figure 27) is usually preferred to the variation in which the recumbent husband dominates the foreground.

In the Migrant Mother series, the father is absent from all the pictures; indeed, Lange's long shots do not even include all the children—three of the seven are missing. Where they were that cold March day is impossible to say. Even if they were nearby, it is quite possible that Lange chose not to include them in her photographs. Five figures posed enough of an obstacle to intimacy; one of the youngsters in

the tent was smiling, thereby negating the aura of desperation the family's plight evoked.

However much logistics may have governed her decisions, Lange was undoubtedly influenced by prevailing cultural biases. A family of seven children exceeded contemporary social norms. Family size had declined in twentieth-century America. In 1900, the average family had 4.7 children; by 1920 this figure had dropped to 4.3. Among business and professional elites, groups that exerted the strongest influence on public policy decisions, the ideal family contained no more than three children.

While there was a rise in the rate of early marriages in the 1920s (presumably the decade when Migrant Mother married), increased acceptance of family planning brought an offsetting delay in the arrival of the firstborn.[12]

Statistically, Lange's own family history conformed to these modern trends. Born Dorothea Margaretta Nutzhorn in Hoboken, New Jersey, in 1895, Lange adopted her mother's maiden name after her father abandoned the family in 1907. Lange's mother was one of six children from a German immigrant family of professional status. Married at age twenty-one, Joan Nutzhorn was twenty-two when she bore Dorothea and twenty-eight when her second, and last, child was born. After her husband left, she went to work at the New York Public Library and later became an investigator for the juvenile court system. This early form of social work served as an important role model for Dorothea's later career development.

As a teenager, Dorothea had scant respect for her mother's industry. A childhood bout with polio had left the young girl partially crippled in one leg; while never pronounced, her limp was a constant reminder that she was different. A sense of shame and humiliation fed her restlessness yet kept her from moving away from home. Against her mother's wishes, she set out to become a photographer and poured her youthful energies into a series of apprenticeships in commercial studios in New York City. For a time, she studied with Clarence White, a noted proponent of artistic photography, whose classes at Columbia represented one of the few academic programs in the field of photography. Lange never went to college and was twenty-three before she set out on her own, intending to travel around the world with a childhood friend. "Not that I was bitterly unhappy at home . . . it was really a matter of testing [my]self out."[13]

The test lasted less than six months and took Lange no farther than San Francisco. She went to work for a photograph supply house and then, at the suggestion of influential photographers in the Bay area, established her own studio. Friends soon introduced her to a prominent local artist, May-nard Dixon. In 1920 they were married. Dorothea was twenty-five; her husband was twenty years her senior, recently divorced, and father of a teenage girl. The couple waited nearly five years before having their first child. A second son was born in 1928 when Dorothea was thirty-three years old. Although Lange apparently tried to create the stable home life that she had lacked as a child, she was unsuccessful. Lange was never accepted by her stepdaughter, with whom she had several violent fights. She curtailed her studio work and arranged child care for her sons in order to accompany Maynard on his periodic artistic retreats to the desert Southwest. Despite such sacrifices, or perhaps because of them, the marriage fell on hard times. Both had affairs, and Dorothea had two abortions before she divorced Dixon in 1935.

Lange terminated her marriage not to escape from the bonds of a family but to wed Paul Taylor, a University of California economist whose research team she joined as a field photographer. They traveled together in the spring of 1935 and late that year obtained the divorces that left them free to marry. Taylor had temporary custody of his three children; Lange had permanent custody of her two sons. The couple's combined annual income of nearly $6,000 provided a financial base that Lange had sorely missed in the waning years of her first marriage, and enabled Lange and Taylor to pay for child care when their jobs took them on the road. Thus, for Dorothea Lange, the spring of 1936 was a season of new beginnings in both her personal and her professional lives. Believing that her new marriage would create family stability and nourish her own work, she embarked on her government assignments with renewed energy and optimism.

The Migrant Mother series reflects Lange's new mood. Despite her end-of-day fatigue, Lange moved confidently in arranging her compositions. She knew the image that she wanted, knew what to feature and what to leave out. Although focusing on the family and shaping it to manageable size, the two long shots contained unwanted elements. Technically the teenage daughter was almost old enough to be self-sufficient. Her presence in the

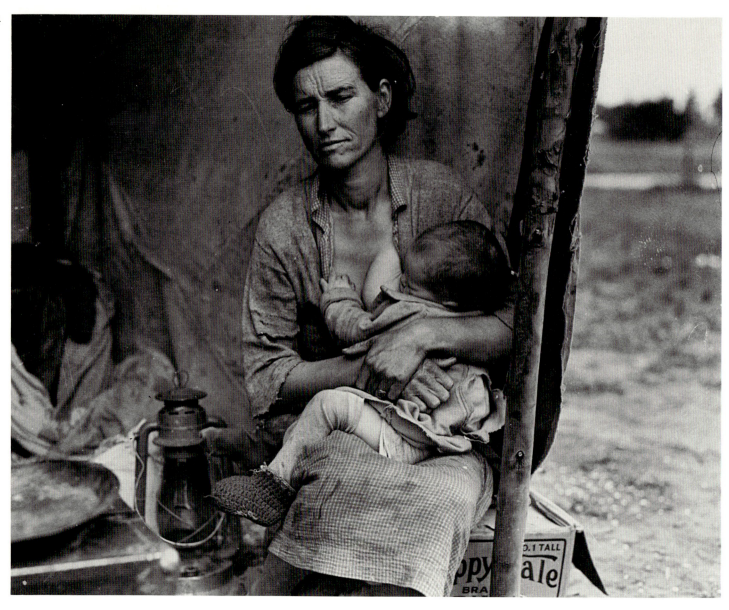

28. Dorothea Lange, Migrant mother (no.3), Nipomo, California, March 1936 (FSA-LC).

photographs presented awkward questions as to when Migrant Mother began bearing children. Was she a teenager herself when she gave birth to her first child? Having already produced more children than she and her husband could support, would she enlarge her family yet again? While middle-class viewers were sympathetically disposed to the needs of impoverished children, teenagers posed thorny questions of personal responsibility. Lange herself was fresh from several searing battles with her ex-husband's resentful daughter.

Lange's third photograph eliminated the teenager. For this, Lange moved closer to the tent, focusing on the powerful bond between the mother and her infant. Apparently she asked the two small children to step aside so that she could feature the act of breast feeding (see figure 28). Since neither of the first two photographs shows Migrant Mother nursing her child, it is possible that the photographer arranged this candid scene. With the decision to make an explicit record of this intimate nurturance, Lange related her composition to a cherished icon of Western art: the Virgin Mary in humble surroundings. Indeed, *Migrant Mother* is often called *Migrant Madonna*.

Despite their attraction to works grounded in contemporary events, presented in a style of social realism, Americans of the 1930s retained a reverence for tradition and religion. Throughout the decade, they found faith a powerful antidote to hard times. When the stock market crashed in 1929, Lloyd Douglas's *Magnificent Obsession* was atop the best-seller list. At the beginning of World War II, his powerful novel *The Robe* (1942) enjoyed even greater success. Both John Steinbeck in *The Grapes of Wrath* (1939) and James Agee in *Let Us Now Praise Famous Men* (1941) believed that they could best communicate the depths of rural deprivation by using overt religious symbolism. Significantly, each author began his research at the same time that Lange was exploring the sufferings of California's migrants. Many of Walker Evans's photographs for *Let Us Now Praise Famous Men* were styled to underscore Agee's religious allusions. Prominent painters of the era restated the nation's fundamental

religiosity. John Steuart Curry's *Baptism in Kansas* (1928), Thomas Hart Benton's *Susannah and the Elders* (1938), and John McCrady's *Swing Low Sweet Chariot* (1937) explicitly invoked biblical themes, while Doris Lee's *Thanksgiving Dinner* (1934) and Joe Corbino's *Flood Refugees* (1938) dealt indirectly with the primacy of faith in contemporary American culture. Exemplifying this reverential aspect of American art, Lange's composition employed fundamental and historic religious symbolism.[14]

Long a popular image in Western religious art, the nursing Madonna was often depicted as sorrowful; her tears, whether suggested or real, belonged to "a universal language of cleansing and rebirth." Regeneration and renewal were popular themes in American culture during the Great Depression, offering citizens convenient remedies for the sense of guilt and shame they felt as a result of the economic collapse. The Virgin's milk represented her "intercession on behalf of mankind" to promote "healing and mercy," again qualities that had special meaning during the 1930s. Steinbeck would end *The Grapes of Wrath* with Rosasharon nursing a starving old man, a scene derived from Charles Dickens and based on thirteenth-century religious lore. Like Lange, Steinbeck presented the Madonna in lower-class garb. Although such portrayal had been common during the Renaissance, by the sixteenth century society had considered it "indecorous for the Virgin to bare her breast."[15] Similarly, the 1930s had drawn the veil of propriety over the frank sexuality of the Roaring Twenties. Although grounded solidly in religious tradition, Steinbeck's closing allegory would strike hostile critics as one more example of licentiousness in a novel made notorious by its explicit language.

Experience, not modesty, pushed Lange to search for more subtle variations of the Madonna theme. Even as her shutter released, she sensed a flaw in her composition of the nursing mother. She had captured an intimate moment in her subject's life, one rich with symbolic potential, yet the woman's facial expression—the key ingredient in a revealing portrait—was all wrong. Migrant Mother looked downward, as if wishing to shield herself

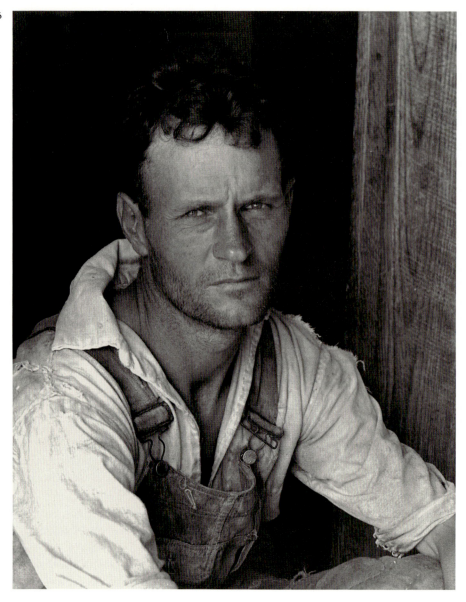

29. Walker Evans,
Floyd Burroughs,
Hale County,
Alabama, Summer
1936 (FSA-LC).

from the scrutiny of the camera. Lange knew this defense mechanism, having used it herself as a teenager in the streets of New York: "If I don't want anybody to see me," she later claimed, "I can make the kind of face so eyes go off me."[16]

That kind of face spoiled Lange's image. She and her documentary colleagues fought constantly to overcome the discomforts of their subjects, to present them as dignified human beings whose plight would elicit sympathy, not ridicule. To this end they tended to avoid recording certain commonplace emotions. Poverty was a distressing mat-

ter, they believed, not an embarrassing one. Such an outlook caused them to discourage the conventional smile as well. Evans's portrait of Floyd Burroughs compels attention because of the apparent anxiety of his tenant hero (see figure 29); Evans never published his alternate view of Burroughs (see figure 30). The hint of a smile or cynicism would have undercut the message Evans sought to convey. Anger was nearly as subversive as contentment. When Lange and Taylor published their story of the migrants, *American Exodus* (1939), they included only one photograph of an angry farmer;

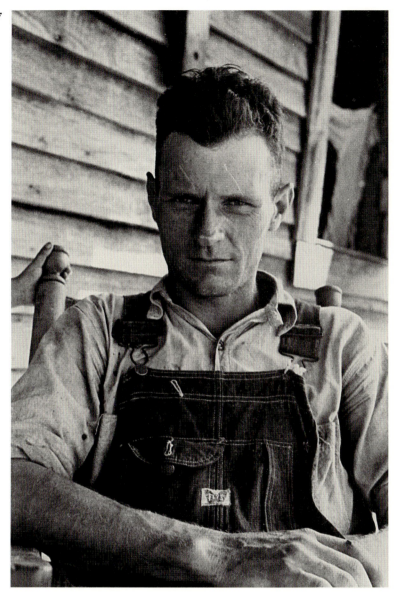

30. Walker Evans,
Floyd Burroughs,
Hale County,
Alabama, Summer
1936 (FSA-LC).

even then their caption explained that the man was not violent and certainly was no radical.[17]

Had Lange been able to elicit a more expressive facial gesture, one indicative of sorrow or anxiety, her portrait of the nursing mother would have succeeded. Instead, Lange had triggered what she would call "that self-protective thing." Because she sensed that she was invading her subject's privacy and was causing discomfort, Lange used her fourth shot to regain cooperation and recruited the children to help to overcome their mother's reserve.

She incorporated children into the closeup with some misgivings. Although preteenagers had long been used by documentarians to symbolize the sufferings of the dispossessed, Lange had limited experience making children's portraits. If she spent time taking pictures of her two sons, she chose not to exhibit these images in her own lifetime, and only a few have appeared in the several biographies published since her death. Her previous photographs of California's migrants concentrated exclusively on adults and their problems.

Despite her lack of experience with children as models, Lange managed in the next few minutes

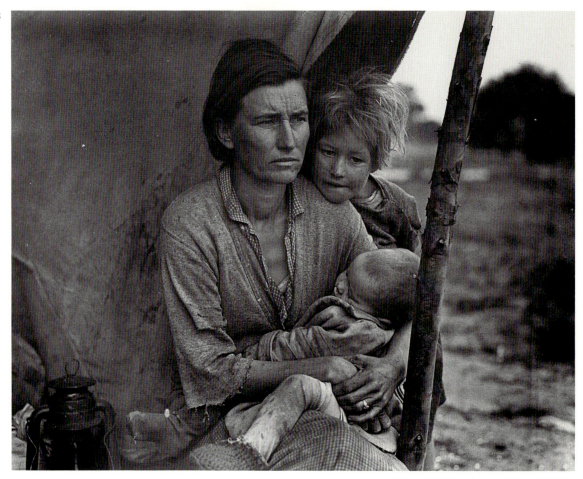

31. Dorothea Lange, Migrant mother (no.4), Nipomo, California, March 1936 (FSA-LC).

to elicit the complete cooperation of her young subjects. Moving slightly closer, she asked one of the young daughters to return to the tent and to stand resting her chin on her mother's shoulder (see figure 31). While awkward, this posture immobilized the girl's head, thereby reducing the chance that any sudden motion might spoil the picture. The young girl removed her hat so as not to obscure her facial features. The fading afternoon light fell on her tousled hair. Where she had been smiling at the photographer in the second picture, she now looked down and away from the camera.

The facial expressions of both mother and daughter were now acceptable, but Lange decided she could do better. She repeated the composition with critical modifications. Lange moved slightly to her left and switched from a horizontal to a vertical format. This allowed her to center her subjects in the frame, give them ample headroom, and present them against the backdrop of the tent canvas (see figure 32). The tent post no longer obscured part of the infant's head. This new perspective also enabled Lange to eliminate the piles of dirty clothes so visible in her third composition. Given the option, she preferred to excise such details and the suggestions they intruded. The public might be less sympathetic to migrants who could not even pick up their personal belongings. But if set against a spare backdrop, a migrant family could become a stirring symbol of deprivation and discipline and lay great claim to public support. Lange certainly did not go so far as her colleague Evans to avoid including dirt and disorder, yet she shared with him a determination to present her subjects as dignified human beings, struggling to surmount the consequences of society's neglect.

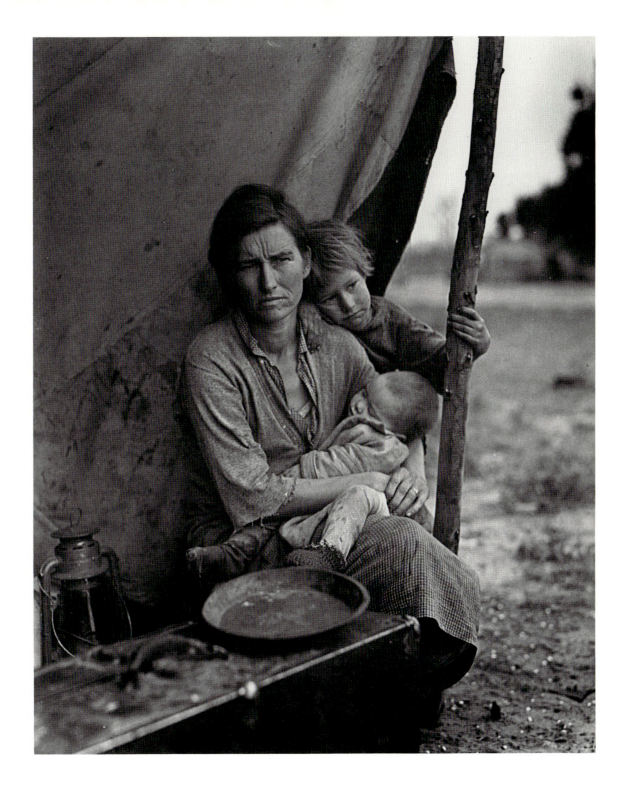

32. Dorothea Lange,
Migrant mother (no.5),
Nipomo, California,
March 1936 (FSA-LC).

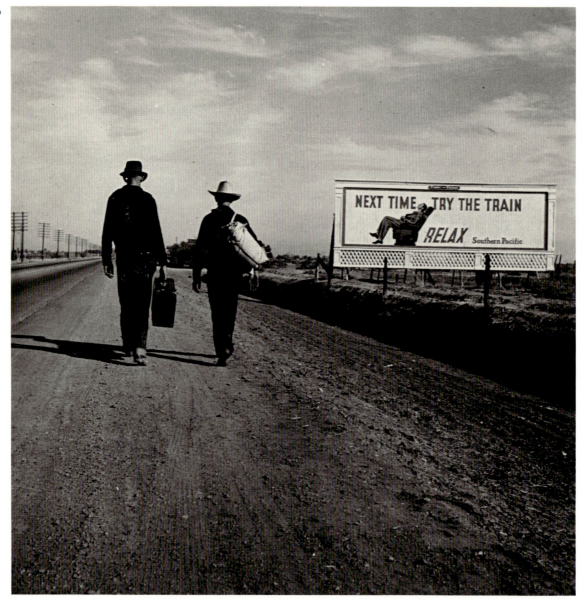

33. Dorothea Lange, *Toward Los Angeles*, California, March 1937 (FSA-LC).

34. Dorothea Lange, family bound for Krebs from Idabel, Oklahoma, 1939 (FSA-LC).

The vertical format also permitted Lange to feature the trunk and the empty pie tin, each a powerful symbol of the migrant condition. The well-worn trunk, which runs at an angle into the frame, provided clear evidence that this was a family on the move, forced by circumstances to leave home and to take to the road.

Having followed migrants for nearly a year, Lange had become increasingly more sensitive to the telltale signs of their tenuous existence. In her previous RA assignments, she had recorded itinerancy in rather obvious ways, focusing on hitch-hikers, makeshift shelters, stranded automobiles, and entire migrant camps. In the next few years, as she spent more time in the field, she developed new and more ingenious ways to dramatize the tragedy that she would later call an American exodus. In March 1937, she completed one of her most famous highway pictures, a photograph of two hitchhikers walking along the road toward a billboard that advised "next time try the train [and] relax" (see figure 33).

Less ironic but no less powerful is her 1938 photograph of a family moving from Idabel to

Krebs, Oklahoma. Like *Migrant Mother*, this picture distills the shock of displacement in a single expression: the anxiety of a young child whose prized possession has fallen off the wagon that serves as her family's means of transport. In that image, too, Lange used her wealth of portrait experience to create the mood. As with her first long shot in the Migrant Mother series, she took a trial photograph of the family walking away from the camera. Finding them cooperative and willing to rearrange themselves at her suggestion, she took the second picture from the front. The oldest son dropped back to the rear, leaving the father in the foreground pulling the wagon with its young passenger. Still the image would not work so long as the child turned away from the camera. Lange had to find a way to catch her attention without prompting a smile like the one worn by one of her siblings in the background. Close examination of the photograph suggests that Lange threw a small black object in front of the wagon, and as the girl turned to look at the object, Lange snapped the shutter (see figure 34). This strategic diversion worked to perfection, resulting in a classic portrait of America's proud rural folk,

humbled by economic hardship and forced to leave their homes and take to the road.[18]

More alarming than such signs of uprooting were those of starvation in a country renowned for the self-sufficiency of its agrarian populace and the plenty of its land. The bare pie tin on the corner of the trunk called attention to Migrant Mother's plight more forcefully than did the phrase "Seven hungry children without food" that Lange later used in the caption for the fifth image in the series (see figure 32). Lange's artistry made verbal descriptions superfluous. In this composition, she turned the portrait tradition on its head. Where affluent sitters posed amid artifacts attesting to their status and economic achievements, Migrant Mother was surrounded by objects mutely testifying to her poverty. The stained tent canvas, the kerosene lamp, the battered trunk, the empty plate—each suggested yet another dimension of poverty.

Lange's positioning of her subjects was no less accomplished than her focus on surrounding detail. She sensed the enormous power that lay in the contrast between the dignity of this family and the deprivation of its circumstances. To achieve this, she crafted a formal pose, a striking departure from the candid effect associated with most documentary photographs. She directed the daughter to shift position slightly; to rest her head on her mother's shoulder, not to peer awkwardly over it; to reach out and grasp the tent post so that her delicate hand came into full view of the camera; and then to look wistfully into the distance.

The arrangement succeeded brilliantly, combining and enriching the religious and familial themes that Lange had pursued from the outset of the series. Her composition could easily fit into a long-standing tradition in Western art: the Madonna and Christ child surrounded by young angelic figures whose innocence and devotion to Mary bespoke divine grace. Occasionally artists had even identified youthful attendants as Christ's siblings and showed them bound together by the purity and sacrifices of the holy family.[19]

Lange's photograph also reflected contemporary American attitudes on family bonding. During the early twentieth century, Americans had feared that the twin pressures of industrialization and urban growth had altered traditional family structure. They mourned the disappearance of the family farm, where home and work were one, where the father remained the head of the household and raised his children to respect parental authority. The financial and moral excesses of the 1920s prompted some critics to argue that the American family could not survive the rude transplantation from an agrarian to an urban setting.

If the city had its critics, it also had defenders. The field of sociology sprang primarily from urban universities like Columbia and Chicago. Sociologists regarded the city as a laboratory. Their research provided a bedrock for emerging social welfare agencies that tried to improve the quality of family life. Lange's mother had been involved in such work after World War I. Dorothea followed in her mother's footsteps, first by establishing herself as an urban professional, then by documenting San Francisco's problems, and finally by carrying her urban perspective into the California countryside.

The defense of the urban family reached full expression in a report by the White House Conference on Child Health and Protection. Published the same year that Lange's photograph of Migrant Mother first appeared, this document was the result of a series of annual meetings begun under presidential auspices earlier in the decade. The conference concluded that the urban middle-class family was far more open than its rural counterpart. Children raised in the city experienced more freedom, were more likely to confide in their parents, and were subjected to a less exhausting regimen of chores than rural youth. Granted greater independence, urban young people "were decidedly less hostile to parents." Affection rather than authoritarianism bound city families together; as a consequence, urban children were likely to give "open demonstrations" of their positive feelings for their parents. The conference viewed the rural family as overextended and rigid, operating "with harsh or stern methods of control." Rural youth enjoyed little independence and therefore developed resentments

35. Dorothea Lange, *Katten Portrait*, San Francisco, California, 1934. Courtesy of the Oakland Museum.

for which there were few acceptable outlets.[20]

In her fifth composition (see figure 32), Lange employs a pose that suggests the affectionate bonding that sociologists considered characteristic of the modern urban family. The daughter displays a familiarity and a fondness by resting both her head and her hand on her mother's shoulder. These loving gestures, at once dependent and supportive, contrast markedly with the presentation of the rural family in the literature and art of the Great Depression. Erskine Caldwell's *Tobacco Road* (1932) shocked readers with its lurid account of the Lesters, who were a family in name only. The oppressions of

southern tenantry had destroyed familial feeling as surely as they had ravaged the soil. While bound together by its determination to overcome adversities, the Joad family in *The Grapes of Wrath* is still reserved. In the film version of Steinbeck's masterpiece, Ma Joad bids farewell to her son Tom with the words, "You know we aren't the kissing kind," and then embraces him stiffly. Hollywood scriptwriters concocted this tender scene; in the novel, the parting is remarkable for its lack of affection.[21] Such stiff formality is also the hallmark of Grant Wood's *American Gothic* (1932), easily the most famous painting to emerge from the regionalist reaffirmation of rural traditions.

Whether affection or authoritarianism governed Lange's upbringing and early family relationships remains a mystery. She refused to discuss her father's departure and indicated some ambivalence toward her mother. Yet in her private and professional photography she was often drawn to an intimate style of family portraiture, where bonding is physically explicit. Her 1930 photograph of son Daniel and husband Maynard concentrates exclusively on their intertwined hands. One of the nine photographs Lange submitted for Edward Steichen's famous exhibit "The Family of Man" (1955) shows her newborn grandchild in the arms of her son John.

Lange repeated such expressive and affectionate gestures in her studio work as well. Her 1934 photograph of two members of the Katten family shows a grandfather and grandson seated in separate chairs, the youth's clasped hands resting on the patriarch's shoulder (see figure 35). The elder Katten is the epitome of strength and dignity, his head erect, his gaze fixed intently on some distant object. Without breaking this formal pose, he returns his grandson's affection by resting one hand on the boy's knee to pull him closer. The resulting image suggests a family in which intimacy and individualism coexist in natural and productive harmony.

Rich in symbolism and brilliantly composed, Lange's fifth Migrant Mother image (figure 32) did not quite measure up to her most expressive studio work. Migrant Mother's reserve continued

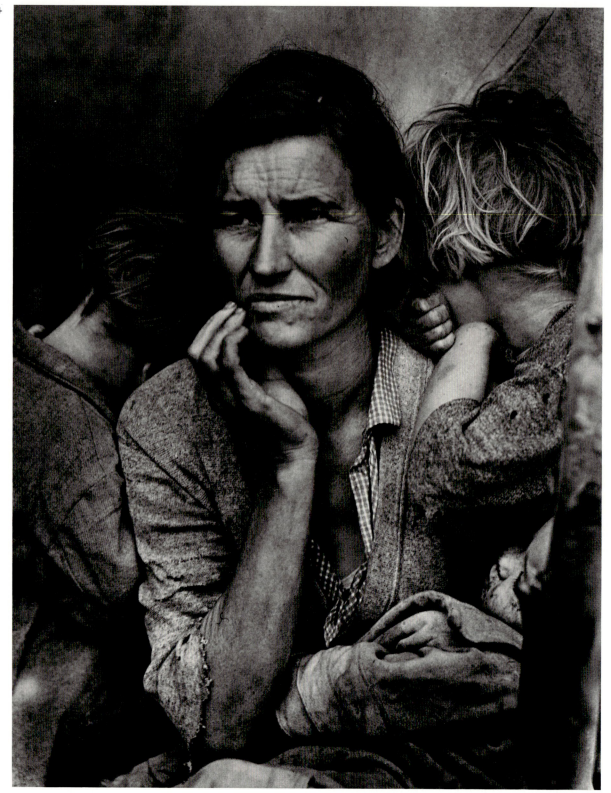

36. Dorothea Lange,
Migrant Mother (no.6),
Nipomo, California,
March 1936 (FSA-LC).

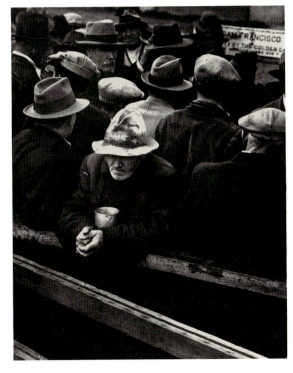

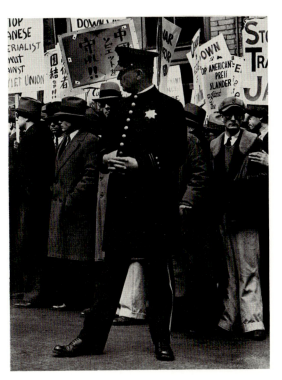

37. Dorothea Lange,
White Angel Breadline,
San Francisco, Califor-
nia, 1933. Courtesy of
the Oakland Museum.

38. Dorothea Lange,
the general strike,
San Francisco, Califor-
nia, 1934. Courtesy of
the Oakland Museum.

to be the main obstacle to intimacy. Throughout the brief photographic session, she had held the same posture, her body rigid, her face impassive, as if recoiling from the camera's lens. In all these pictures her hands are clasped to support and keep her infant near the soothing sounds of her heartbeat. Lange was reluctant to alter this arrangement for fear that the child might awaken and spoil her composition. Yet she knew that the mother's facial expression was the key to a powerful photograph. Lange moved closer, hoping that her subject would cooperate in one final picture. A beautiful metamorphosis occurred in the next few moments. Migrant Mother surrendered herself to Lange's expert direction, striking a pose that would burn itself into the memory of American culture (see figure 36).

Lange worked swiftly, with a confidence bolstered by her successful incorporation of the young child in the two previous frames. She balanced her composition by summoning the other small child to stand to Migrant Mother's right. Lange had the youngsters place their heads on their mother's shoulders but turn their backs to the camera. In this way Lange avoided any problem of competing countenances and any exchanged glances that

might produce unwanted effects. She was free to concentrate exclusively on her main subject. Again Migrant Mother looks away from the camera, but this time she is directed by Lange to bring her right hand to her face. This simple gesture unlocked all the potential that Lange had sensed when she first approached the tent.

In the studio and in the field, Lange had developed a keen sensitivity to the expressive potential of body language, especially the importance of hand placement. Two of her previous and highly acclaimed documentary images feature details similar to the gesture that Lange was incorporating in the final frame of the Migrant Mother series. *White Angel Breadline* (1933) shows an unemployed male, in the midst of a relief crowd, leaning on a wooden railing, his arms encircling an empty tin cup (see figure 37). The man's hands are clasped so that he resembles a communicant at the altar rail. Lange's message was obvious, as it was the following year in her portrait of a San Francisco policeman standing in front of a crowd of strikers (see figure 38). The power of the constabulary is evident from the repose of the folded hands against the man's uniform, with its gleaming buttons and badge. What makes

39. Rondal Partridge, Dorothea Lange, 1936. Courtesy of Rondal Partridge, Berkeley, California.

this presumption of authority so powerful is the position of the policeman: his back is turned to the protesters.

In both these pictures Lange had taken swift advantage of chance encounters with her subjects. "You know there are moments such as these when time stands still," she was moved to remark in looking back at *White Angel Breadline* thirty years later, "and all you do is hold your breath and hope it will wait for you."[22]

The exposure of the final frame in the Migrant Mother series (figure 36) was not such a moment. Instead Lange had seized control of the situation in an effort to create the type of portrait her sensibility perceived. The hand framing the face, calling attention to Migrant Mother's feelings, breaking down her reserve, was the critical element lacking in the previous exposures. Lange drew this gesture from her studio experience and employed it regularly in documentary fieldwork. When photographed by

friends, Lange often preferred such a pose herself, as in a picture by Rondal Partridge (see figure 39), taken the same year as *Migrant Mother*.

Lange may well have had personal reasons for presenting herself in this fashion to the camera. Even as an adult, she was still sensitive about the results of her childhood polio. "I've never gotten over it," she said shortly before she died, adding that she was constantly "aware of the force and power of" an injury that she felt had left her a "semi-cripple."[23] By wearing pants and by bringing her hand to her face, she could divert attention from her damaged leg. But Lange also believed that her handicap gave her a special sensitivity to the downtrodden and helped her to communicate their condition. She knew instinctively from her own fears of public scrutiny exactly the kind of gesture that might break down Migrant Mother's fearful reserve.

Ironically, Lange's control over her subject is confirmed by another gesture—an unwanted ele-

ment that escaped the photographer's attention in the field but that later in the darkroom would emerge as a "glaring defect." In bringing her right hand to her face, Migrant Mother apparently feared that she would lose support for her sleeping infant, and so she reached out with her left hand to grasp the tent post. Her thumb intruded into the foreground of the image.

Caught up in the excitement of what she knew was an extraordinary photographic session, Lange failed to notice this intrusion. Within days of her return to San Francisco, she rushed several prints from the series to the *News*, where they illustrated a wire service story of hunger in the frost-destroyed pea fields. An accompanying editorial claimed that only "the chance visit of a government photographer" had led to the immediate dispatch of relief rations to Nipomo. Although not mentioned by name, Lange was soon recognized as the artist who created *Migrant Mother*. In September 1936, *Survey Graphic* published the final picture in the series, prompting *U.S. Camera* to request that Lange submit the image for exhibit as one of the outstanding pictures of the year. By 1941 the picture had become a recognized documentary masterpiece and was enshrined in the Museum of Modern Art. While preparing her print for permanent exhibit, Lange was haunted by the disembodied thumb in the foreground of the negative. Over objections from Roy Stryker, Lange directed a darkroom assistant to retouch the negative and eliminate this esthetic flaw.[24] Having worked so hard to overcome her subject's defensiveness, having converted her to a willing and expressive model, Lange did not want a small detail to mar the accomplishment.

This alteration removed *Migrant Mother* further from the realm of reality toward that of universal symbolism. This transformation had begun with the required suppression of the subject's individuality so that she could become an archetypal representative of the values shared by Lange's middle-class audience. Lange never recorded Migrant Mother's name, eliminated her older daughter from all but the first posed photograph in the series, moved the young children in and out of the scene, and directed her subject's every gesture. Then in the darkroom she removed the last traces of the one instinctual motion that Migrant Mother made. Esthetic liability though it proved to be, this gesture gave clear evidence that Migrant Mother's highest priority remained the support of her family and that posing for a government photographer was a secondary concern.

For nearly a half a century *Migrant Mother* remained a powerful but anonymous symbol of the sufferings and fortitude engendered by the Great Depression. In the summer of 1983, the photograph appeared again in the national press, this time to benefit Migrant Mother herself, Florence Thompson, who lay gravely ill in California not more than fifty miles from the pea fields where she sat in front of a leanto and where chance had prompted Dorothea Lange to return for photographs. Like Lange, who died in 1965, Thompson had cancer; she had just been rendered speechless by a stroke. Thompson's children pleaded for funds to defray their mother's medical expenses, as she had no insurance. Within weeks contributions totaled nearly $30,000. In mid-September, Florence Thompson died.[25]

Chapter Four

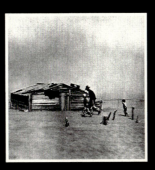

Flight from Reality

Arthur Rothstein
and
the Dust Bowl

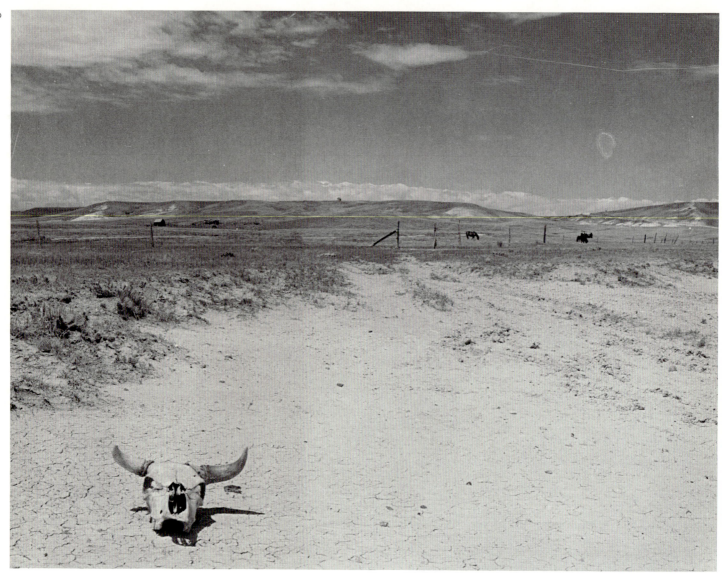

40. Arthur Rothstein,
steer skull,
Pennington County,
South Dakota,
May 1936 (FSA-LC).

Arthur Rothstein was by far the youngest member of Stryker's staff. Only twenty-one years old when he joined the unit in the summer of 1935, the Columbia graduate had no professional photographic experience and little sense of where he fit into Resettlement's historical section. He spent his first weeks on the job taking pictures of office space and official memoranda. But as Stryker developed a sense of purpose, so did his former student. Rothstein poured over the incoming pictures of Walker Evans and Dorothea Lange, taking note of their distinct styles and admiring their ability to communicate the many dimensions of rural poverty. In the late spring of 1936, barely two months after Lange created *Migrant Mother* and shortly before Evans journeyed south with James Agee, Rothstein took a series of photographs that suddenly made him the best-known member of the staff. "I became famous the first year," he said in a subsequent interview, "and could not resist the notoriety."[1] Despite receiving acclaim and recognition, Rothstein would spend the next fifty years trying to explain these notorious images.

The photographs in question came from one of the most remote and forbidding stretches of the American landscape: the Badlands of South Dakota. Rothstein went there in May 1936 to document the persistent drought that had ravaged vast sections of the Great Plains. In windswept Pennington County, in the southwest corner of the state, the young photographer came upon a scene too compelling to pass by.

Bleached white by the unforgiving sun, a steer's skull lay on a parched alkali flat. There was no shade in sight. Like a graveyard headstone, the skull was a memorial to the once-vital cattle industry that had originally brought fame to the Great Plains. Rothstein was so fascinated that he stopped to make multiple exposures of this desolate plateau. First he took a long shot with the skull in the foreground to establish scale and show the alkali flat in its entirety (see figure 40). In this arrangement, Rothstein may well have been responding to Stryker's earlier complaints about inadequate depth perspective and his suggestion of placing some object, such as a camera case, in the foreground of his photographs. The skull served Rothstein's technical and symbolic needs nicely.[2]

This composition also conformed to Resettlement Administration instructions that whenever possible, photographs should include evidence of land misuse and mismanagement. No matter how dramatic or artistic, a picture of abandoned land was not nearly so powerful as one that communicated how farmers or ranchers were continuing to eke out an existence on what the agency termed submarginal soil. Rothstein constructed his frame to include both the parched earth and the scrub growth that he claimed was the direct result of overgrazing. Ironically, Rothstein's other Pennington

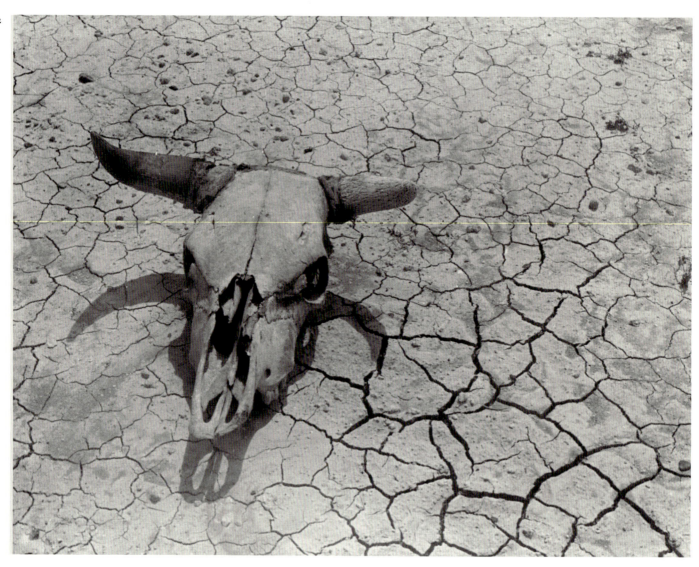

41. Arthur Rothstein,
steer skull,
Pennington County,
South Dakota,
May 1936 (FSA-LC).

42. Arthur Rothstein,
steer skull,
Pennington County,
South Dakota,
May 1936 (FSA-LC).

County pictures had shown well-fed sheep, not mal-nourished cattle, as the primary livestock in the area. Close examination of figure 40 reveals horses grazing in the background.[3]

Having concentrated on the sweep of barren land, Rothstein then proceeded to work with the skull itself (see figure 41). For some time before he happened upon this object, Rothstein had been on the lookout for cattle skeletons. He had been introduced to this potent symbol by an illustration in J. Russell Smith's *North America* (1925), the geographical primer that Stryker required his staff to read. Ironically, the cattle in Smith's photograph had perished not as a result of drought but of a "cold-soaking" in a late spring snowstorm. Smith did not label this event a calamity but rather chose to depict it as part of the process of natural selection by which animals as well as their masters adapted to the demands of the environment. Rothstein ignored Smith's Darwinian interpretation, instead arguing that ranchers had overgrazed the area.[4]

Intrigued by the closeup, Rothstein moved the skull a few feet to achieve more dramatic contrast and deeper shadow detail (see figure 42). This second closeup would become the best known of the steer skull pictures and would rank among Rothstein's most famous images, but it was not the last in this skull sequence. Having experimented with

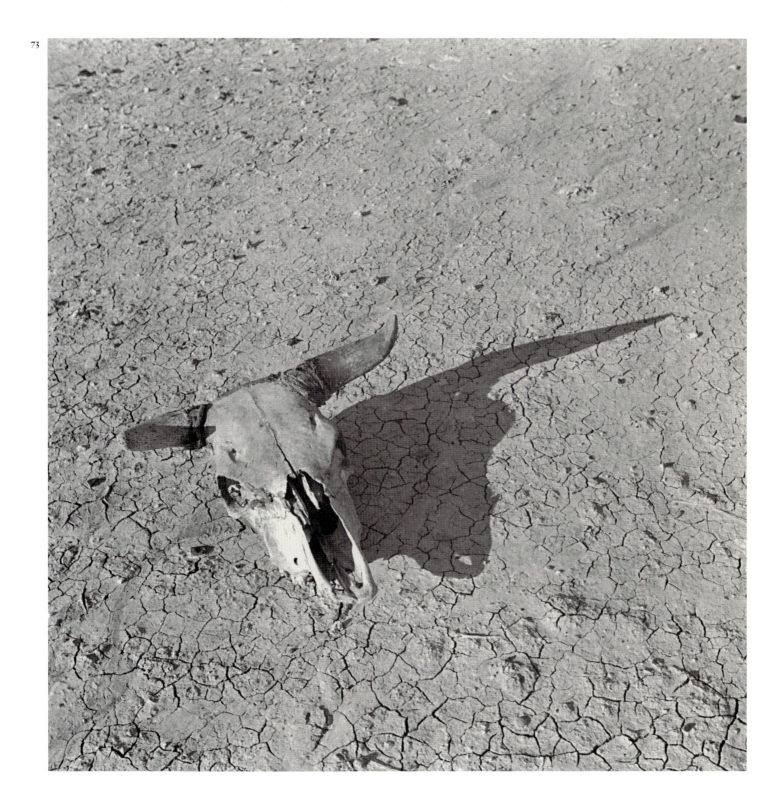

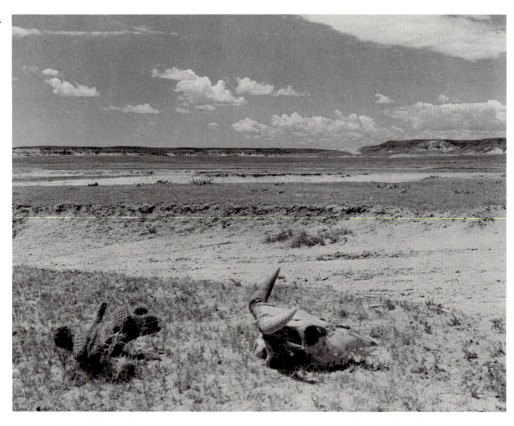

43. Arthur Rothstein,
steer skull,
Pennington County,
South Dakota,
May 1936 (FSA-LC).

44. Arthur Rothstein,
steer skull,
Pennington County,
South Dakota,
May 1936 (FSA-LC).

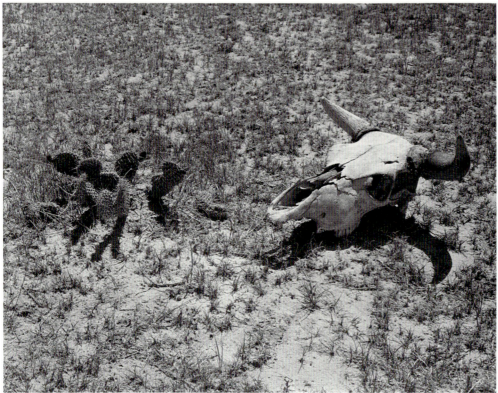

a background of parched earth, Rothstein transported the skull to a nearby knoll and placed it on the scrubgrass next to a cactus plant. Here he tried two arrangements that combined the sparse forage with the cactus, suggesting that overgrazing had created an environment that no amount of ingenuity could make productive (see figures 43 and 44). After completing these two closeups, Rothstein dispatched his film to Washington and awaited official reactions.

Stryker was delighted with the South Dakota images, especially the steer skull pictures. He urged Rothstein to continue "to pick up drought pictures wherever you see them. We will now probably have the finest collection of drought pictures in the United States when you finish this trip."[5] By the time Rothstein completed his tour of the drought-stricken West, his photographs had indeed attracted widespread national attention, though not the sort that he and Stryker anticipated.

The initial release of these drought pictures was an administrator's dream come true. The national press clamored for background photographs to accompany coverage of President Roosevelt's special trip to the Great Plains scheduled for late August, 1936. Ostensibly an investigative tour, this latest in FDR's "looksees" was a campaign stratagem designed to support his claim that in times of crisis he would always place the needs of the nation above his quest for reelection. Needless to say, the tour was organized to give FDR maximum exposure to the adoring crowds that would surround the presidential train at each stop. An advance party, headed by Rexford Tugwell, was to carry out the real investigation and to present its preliminary findings to the President when he reached Bismarck, North Dakota. While Tugwell and Roosevelt hoped that nature would favor their separate trips with occasional cloudbursts—which occurred with almost miraculous timing—neither was prepared for the thunderous controversy that greeted them in the Dakotas.

When copies of the Fargo *Evening Forum* suddenly appeared on the President's train as it neared Bismarck, there was little alarm. Like other regional papers, the *Forum* appeared to be making a routine report on the investigation and chose Rothstein's steer skull as an illustration. But this was no ordinary summary of Tugwell's activities. Angered that the Dakotas had been typed as the center of the drought, the *Forum* charged the Resettlement Administration with photographic fakery and fabricating drought conditions. "There never was a year that this scene couldn't be produced in North Dakota, even in years when rainfall levels were far above normal." Calling the photograph a "gem among phony pictures," the editor went on to claim that the same alkali flat could doubtless be found in "Maryland, Pennsylvania, Indiana. Wherever one chooses." As for the skull: "Oh that's a movable prop, which comes in handy for photographers who want to touch up their pictures with a bit of the grisly."[6]

The Republican press rushed to investigate the *Forum*'s charges. The Washington bureau of the archconservative New York *Herald Tribune* obtained three additional pictures of the steer skull from Stryker's file, pointing out that the object had indeed been moved and that the photographs were made in South not North Dakota. Stryker was on vacation in Vermont when the *Herald Tribune* story broke. His administrative assistant, Edwin Locke, made a feeble attempt to answer the barrage of journalistic charges. Locke admitted that the skull had been moved but denied that there had been any attempt to deceive the public. "I can't see how that can be called a fake," he said. Locke then told Rothstein to "stick close to my story," adding, "if you have that goddam skull, hide it for Christ's sake."[7]

Stryker also used humor to deflect criticism. He designed a papier-mâché skull for use as a paperweight and took orders from his superiors. Stryker's supervisor, C. B. Baldwin, added to the fun, requesting that his steer skull come with "the weathered surface so that no question of its authenticity could possibly arise. . . . It is not felt that the alkalai background is essential, since from all reports these backgrounds have been more plentiful this season." Stryker's staff also prepared a print of the skull picture to be used as a Christmas card.[8]

Like Rothstein's now-famous picture, this humor was not what it seemed. Behind the jocular memoranda lay anxiety that the entire photographic project might be killed by the weight of congressional criticism and cost consciousness. When Stryker wrote a mock requisition for teeth for the skull, he satirized an oppressive bureaucratic environment that had repeatedly driven him to the brink of despair. "We have to carry economy to the limit," he told Dorothea Lange just before the skull controversy erupted. "Don't make any trips unless you are sure they are authorized from this end, as we will have to keep an extremely close check on our travel budget for the next few months." Stryker privately wrote to a former academic colleague, expressing his fear that the file would not live out the year and exploring the possibility of shifting the entire documentary effort to Columbia.[9]

Stryker had reason to be nervous. Journalistic response to the skull controversy extended far beyond previous criticisms of photography as a bureaucratic boondoggle. "The whole resettlement program is a ghastly fake," wrote an outraged editor in Pennsylvania, "and what is more natural than that it should be promoted by fake methods similar to those used by ordinary confidence men." Or as the *Detroit Free Press* charged: "Another Fake Traced to Doctor Tugwell's Propagandists."[10]

Republicans were unable to turn propaganda into a solid campaign issue, but their assaults on Tugwell led to his resignation shortly after Roosevelt's reelection. Once the focal point of Republican criticism, the Resettlement Administration was quietly transferred to the Department of Agriculture, where its programs were housed under a unit with a less threatening title: the Farm Security Administration. With the transfer came an easing of financial pressure. While Stryker emerged from this crisis with a new sense of security, Arthur Rothstein would continue to bear the scars of this political battle.

Like his colleagues Dorothea Lange and Russell Lee, Rothstein would be remembered for a handful of images, but while their pictures would be praised as art, his were always tinged with contro-

versy. Each succeeding history of Stryker's project retold the steer skull story without exploring its ramifications. While defending Rothstein from the charges of photographic fakery, scholars inevitably judged him a second-rank artist. Most accounts of the FSA project advance depressingly uniform conclusions: Evans is the exemplar of documentary styling; Lange is the humanist; and Rothstein is the dedicated staff member and "seasoned veteran" who spearheaded the unit's technical expertise. One student of the period refused to grant Rothstein even this much credit, asserting that his movement of the steer skull "violated the spirit of documentary" and buttressing this claim with Walker Evans's denunciation of his colleague's transgressions.[11]

Indeed, Rothstein moved the skull, but he did so in the same spirit that his more illustrious coworkers arranged their subject matter. He, too, recognized that a photograph, for all its information, required a governing esthetic to be successful. By arranging the skull so that it cast an elongated shadow, Rothstein crafted an artful result and won immediate praise; *U.S. Camera* selected this image as one of the outstanding photographs of 1936. Rothstein did not know then, nor would he learn later, that many of Walker Evans's celebrated photographs also depended on manipulation to achieve their artistry. Nor was Rothstein aware that Dorothea Lange posed her subjects and used skillful studio techniques in her field work. Had Rothstein suppressed inferior versions of his photographs, as Evans often did, his techniques might never have been discovered and singled out for criticism. But Rothstein was obeying Stryker's instructions to submit as many pictures as possible. Unlike Evans, Rothstein dutifully followed directions.

When he took the skull photographs, Rothstein was responding to another stimulus that has hitherto been hidden from view: the narrative power of documentary film. Before he left for the Great Plains, Rothstein had seen pictures of the Dust Bowl, not in the work of Evans or Lange but in a recently completed film, *The Plow That Broke the Plains* (1936).[12] This pioneering documentary effort by Pare Lorentz presented riveting images of

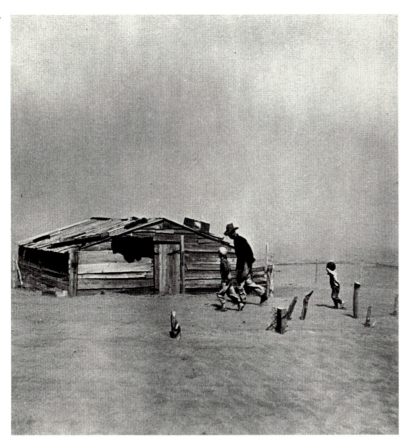

45. Arthur Rothstein, *Fleeing a Dust Storm*, Cimarron County, Oklahoma, April 1936 (FSA-LC).

parched earth, dust-blown flats, and bleaching cattle bones. Rothstein could not help but be influenced by this dramatic tale, since it had been commissioned by Rexford Tugwell and completed under the auspices of the Resettlement Administration. For his much-acclaimed depictions of the nation's tragedy, Lorentz used props ranging from rusting plows to abandoned farm machinery, and few complaints were heard. No one charged fakery when Lorentz used actors to stage a Dust Bowl exodus. Granted, there were cries that Lorentz's film constituted New Deal propaganda, but these allegations could not prevent the film from eventually being shown in more than three thousand movie theaters across the country.

The steer skull was not the only Rothstein image to bear the imprint of Lorentz's *Plow*. The director's styling is even more apparent in *Fleeing a Dust Storm*, Rothstein's classic photograph of a farmer and his two sons (see figure 45). If Lorentz's film has become the most powerful narrative of the Dust

Bowl, this photograph stands as its most memorable icon. Appropriately, the story behind this photograph is more complex than that of the skull and originates in a direct interconnection of Lorentz's work with Stryker's project.

Considering the pioneering contributions Lorentz and Stryker made to the documentary movement, it is strange that there has been little close examination of the relationship between their two efforts. The few works that mention the background of *The Plow That Broke the Plains* have left the impression that Lorentz drew his inspiration from Stryker's file. According to one account, Lorentz, pressed for time and short on funds, took "advantage of the many RA still photographs of the conditions in agricultural America," and then had Stryker's photographers "take pictures in various sections of the Dust Bowl."[13]

In fact, the only Dust Bowl stills in the file when Lorentz began his film were faded photographs that Stryker had inherited from the Department of Agriculture, pictures of soil erosion from the Soil Conservation Service, and a group of pictures on dust storm damage taken by a private South Dakota photographic studio. Lorentz may well have obtained these Dakota scenes during his own tour of the Great Plains late in 1934.[14] In the summer of 1935, Stryker was in no position to provide photographs for Lorentz. The file had yet to materialize, there were no adequate darkroom facilities, and Stryker was just beginning to assemble his staff of photographers.

Meanwhile, Lorentz had received official approval of his script and budget for his motion picture. He began shooting in the West in the fall of 1935, obtained stock footage from Hollywood early in 1936, and completed a working print by late winter. In early March, he took this print to the White House for a special presidential preview; after the showing, Roosevelt took Lorentz aside and told him how much he had enjoyed the film. Tugwell convinced Lorentz to begin another project on the way in which soil erosion and exploitation of the midland forests had led to the savage floods that had pushed the Dust Bowl from the headlines.

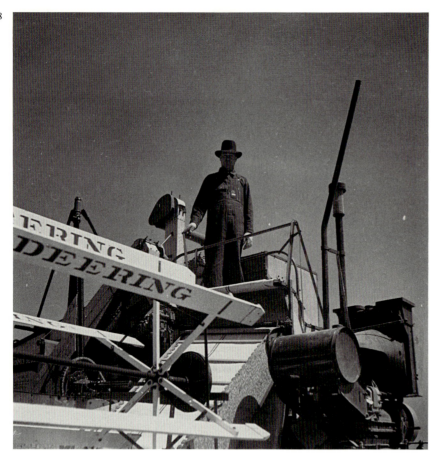

46. Arthur Rothstein, farmer and machinery, Amarillo vicinity, Texas, April 1936 (FSA-LC).

Roosevelt's approval, Tugwell's support—these were heady tributes for a man new to the craft of film making.

Lorentz's success was not wasted on Stryker, who had been in Washington long enough to know that the President's endorsement would generate widespread publicity that might be used to promote the efforts of his own agency. Because Lorentz had not taken any location stills, Stryker dispatched Rothstein to the Great Plains. The young photographer was the most likely to follow instructions and to produce the kind of photographs that would show best what the Resettlement Administration was doing about the drought. These images were necessary, since Lorentz ended his film in the migrant camps in California and made only fleeting references to New Deal reforms.[15]

Once in the West, Rothstein followed in Lorentz's footsteps. He began taking pictures near Amarillo, Texas, the same area Lorentz used for

his drought and Dust Bowl sequences. Moreover, Rothstein's photographs quickly gravitated to the many symbols that Lorentz had introduced to his audience. Note, for instance, figure 46. In this and other photographs of farm machinery in the Panhandle, Rothstein copied *The Plow*'s depiction of technology as an impersonal, ominous force. Rothstein shows the men who drive the combines and the tractors standing like dictators atop the awesome machines. This spirit permeates his photograph of a mechanical lister, an implement used for plowing the land so that it can withstand wind damage (see figure 47). Likewise, Lorentz's film had suggested that the machines that destroyed the grasslands were in turn ravaged by the ensuing dust storms and drought. Rothstein's several photographs of abandoned farm implements borrow directly from setups used in Lorentz's film. Rothstein even went so far as to entitle his photograph of an antique sod plow "The Plow that Broke the Plains: Look at It Now" (see figure 48).

Lorentz's most dramatic scenes exerted an equally strong influence on Rothstein's photography. In one particularly successful section of his film, Lorentz heralded the approach of a dust storm with sequential shots of the wind whistling across the barren flats, the sky filling with ominous clouds, a street light being buffeted by the howling gale, and a farm family running for shelter. When Rothstein witnessed a duster near Amarillo, Texas, he took photographs in a similar sequence—the black blizzard turning day into night, street signs nearly torn from their moorings, and residents racing for cover. But, while effective, these were urban scenes and *The Plow* was about man's eternal struggle with the land. Less than a hundred miles away, in Cimarron County, Oklahoma, Rothstein found what he had been looking for: a farmer and his sons fleeing a dust storm. This powerful image, along with *Migrant Mother*, quickly became a dominant symbol of rural suffering and exodus from the Dust Bowl.

Like Lange, Rothstein claimed that he came upon his subjects by accident. "It was in Cimarron County, in the middle of the Oklahoma Panhandle, that I found one of the farmers still on his land."

47. Arthur Rothstein,
mechanical lister,
Amarillo vicinity, Texas,
April 1936 (FSA-LC).

48. Arthur Rothstein,
*The Plow That Broke the
Plains: Look at It Now*,
Amarillo, Texas, April
1936 (FSA-LC).

49. Arthur Rothstein, approaching storm, Amarillo, Texas, April 1936 (FSA-LC).

Rothstein said he was busily taking pictures of the "barns and sheds" that were "almost buried by drifts" so deep that "in some places . . . only the tops of the fence posts could be seen." Rothstein remembered that the dust was everywhere. "While making my pictures I could hardly breathe . . . the land and the sky seemed to merge and there was no horizon." And then, "Just as I was about to stop shooting I saw the farmer and his two sons walk across the fields. As they pressed into the wind, the smallest boy walked a few steps behind, his hands covering his eyes to protect them from the dust." Rothstein says that without hesitation, without engaging his subjects in any way, he "caught the three of them as they neared the shed." Besides, he added later in response to questioning about his field-work procedure, "it would have been impossible in a blinding, roaring dust storm to exercise any control over this scene." Indeed, this image of flight is so well fashioned that its most recent interpreter claims that the picture "showed city dwellers how work stopped and farmers ran for the house when a dust storm came up." [16]

But however spontaneous it may now appear, *Fleeing a Dust Storm*, like Lange's *Migrant Mother*, was the product of deliberate experimentation and close cooperation between the photographer and his subjects, not unlike the relationship between a film director and his actors. Proof of this dramatic staging emerges from a close look at *Fleeing a Dust Storm*, at other pictures Rothstein took the same day, at his letters to Stryker, and at the photographer's various recountings of his stay in Cimarron County. The final evidence comes from a recently discovered and hitherto unprinted negative demonstrating that Rothstein experimented with at least one alternative composition of the flight scene.

Fleeing a Dust Storm gives little indication of the "blinding, roaring" tempest that Rothstein later claimed engulfed him that April day. There is a visible horizon in his image and the air is clear enough to reveal the details of the subjects' clothing as well as the wood grain on the shed in the rear. A true dust storm—and more than a hundred struck the Panhandle in 1935 and 1936—often turned

day into night and slammed into buildings at more than sixty miles an hour, temporarily blinding those caught outside. Photography under such conditions was impossible save to record the billowing black clouds that warned of the approach of a true duster. The relatively clear background in this picture stands in marked contrast to that of Rothstein's earlier photograph of a storm approaching Amarillo, forcing pedestrians to flee and drivers to turn on their headlights (see figure 49).

When he took *Fleeing a Dust Storm*, Rothstein described the weather in much less catastrophic terms. "Very dusty," he reported to Stryker, "winds 25 miles/hr. . . . Took 77 pictures." Rothstein said nothing in his letter about a dust storm. Indeed, the quantity of his production suggests that he was working during a lull between storms. Dust was a daily occurrence in the Panhandle, especially in the late winter and early spring where only one day in six was dust free. Rothstein had to contend with wind and dust, but he benefitted from the strong sunlight that is evident in the shadow detail of most of his Cimarron County pictures. Stryker had been pressing for greater depth of field and more graphic detail. He wanted pictures that showed the results of the dust storms, "dust blown up over the barns," and fields where "crops were covered with dust." [17] Stryker must have drawn these ideas from *The Plow*, for Lorentz had filmed similar scenes. Such pictures could best be recorded when there was strong sunlight.

Rothstein's claim that *Fleeing a Dust Storm* was a spontaneous image is further undercut by the existence of companion pictures of the farmer and his sons. These images have the same depth and angle of shadow as the master picture, suggesting that they were taken at approximately the same time of day. If, as Rothstein said, he came upon this family by accident as they ran for shelter, he would have been forced to wait until the end of the storm. The angle of the shadow would then have been different. It seems likely that he took the individual pictures before proceeding to the flight photograph. In his portraits of the two children, Rothstein tried to develop the impression that they were victims

82

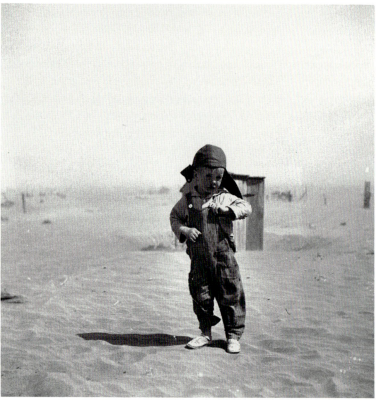

50. Arthur Rothstein,
farmer's son,
Cimarron County,
Oklahoma,
April 1936 (FSA-LC).

51. Arthur Rothstein,
farmer's son,
Cimarron County,
Oklahoma,
April 1936 (FSA-LC).

of a harsh environment, beaten by the wind and
forced to protect themselves from the stinging sand
(see figures 50 and 51). "Dust is too much for this
farmer's son," he wrote in the caption for the photo-
graph of the older boy.

The dust was not too severe to prevent the chil-
dren from playing while their father dug out around
a fencepost (see figure 52). Rothstein captioned this
image "Dust Bowl farmer raising a fence to keep it
from being buried under drifting sand." He later
claimed that the drifts on the farm were so deep
that "in some places only the tops of the fenceposts
could be seen."[18] But the farmer is not digging a
post out of a drift; there are no drifts in sight. The
barbed wire for the fence lies in a tangled stream on
land that is flat as far as the eye can see.

What purpose did these preliminary pictures
serve? They were designed, we can presume, to
build a bond of trust between the photographer
and his subjects. Both Evans and Lange employed
similar strategies in the field. Rothstein believed
that by taking a picture of the farmer at work, he
would gain the man's cooperation. Rothstein may
have prefaced his picture with the customary ex-
planation: people in the East needed to see that
Dust Bowl residents refused to give up. In fact, the
picture could be used to show that vast portions
of the Great Plains were no longer habitable. This
had been a major theme in *The Plow*; Lorentz had
included several closeups of farmers engaged in la-
borious but futile tasks. In one sequence, a woman
sweeps dust off the rickety porch in the back of her
cabin. Her expression, her body posture, and the
mechanical manner of her movement all combine to

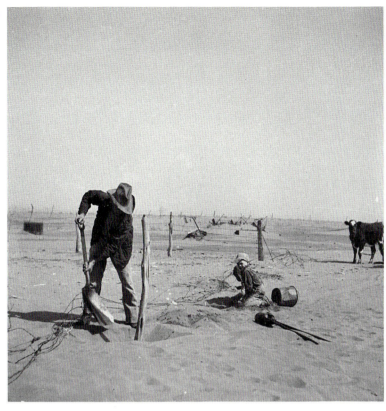

52. Arthur Rothstein, farmer and sons, Cimarron County, Oklahoma, April 1936 (FSA-LC).

53. Arthur Rothstein, farm woman, Cimarron County, Oklahoma, April 1936 (FSA-LC).

suggest despair over the endless struggle with the environment. Rothstein may well have thought of duplicating this scene when he took a picture of a woman in the doorway of her house, but her smile was not in keeping with his purpose (see figure 53). He took no more pictures of this Dust Bowl survivor and left the premises after taking one casual picture of the outside of her home.

The farmer and his two sons proved more useful subjects. The man agreed to pose and to allow Rothstein to photograph the two boys. In these closeups Rothstein appears to have been experimenting to see whether the young children would follow directions. He could not make an effective family portrait if either one peered at the camera, as the older boy does in the work picture (see figure 52). Once Rothstein had posed each boy individually, he was ready to proceed.

What happened next is best described by Rothstein himself in an article that he wrote in 1942. By then *Fleeing a Dust Storm* had become sufficiently famous that he was asked the inevitable question: how had he managed to capture such a dramatic scene? Proud of his achievement, Rothstein was eager to discuss the photograph as an example of "direction in a picture story." Picture stories, Rothstein wrote, did not simply happen; they were the result of careful planning. The photographer was more than a man behind the camera. He was a "scenarist, dramatist and director" as well. He often worked from a "shooting script" and directed the actions of his subjects. "Provided the results are a faithful reproduction of what the photographer believes he sees," Rothstein argued, "whatever takes

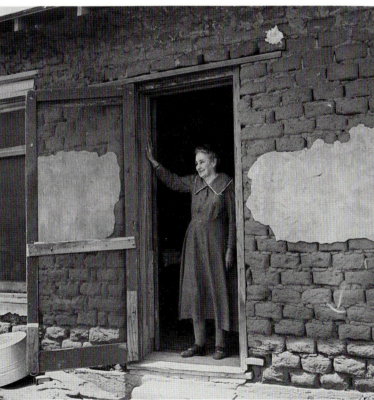

place in the making of a picture is justified. In my opinion, therefore, it is logical to make things happen before the camera and when possible, to control the actions of the subject."[19]

Rothstein's explanation appeared in Willard Morgan's influential *The Complete Photographer* and drew added support from Roy Stryker's companion essay on documentary photography. Stryker maintained that a staged photograph was honest so long as the photographer had his subjects perform tasks true to their everyday lives. For example, an individual documenting the important chores on the American farm wants to record the process of canning, but the harvest season has passed. No matter. The visitor can "'stage' the shot" by putting "a real fire in the stove and some real fruit in the pot. Before you know it, your model will forget that she is posing or that you are there in the kitchen holding that terrifying instrument the camera." The result, Stryker insisted, would be a "picture as true and lively as any candid shot."[20]

Rothstein probably staged *Fleeing a Dust Storm* for similar reasons. April was the height of the storm season. Should a duster occur, residents would naturally seek shelter. Indeed, some of the most dramatic stories of the Dust Bowl involved flight before the storms. Ed Phillips and his wife, long-time residents of Cimarron County, recalled "Black Sunday" in April 1935, when they had been returning home in their Model A Ford. "It was about five o'clock when the black wall appeared" and they still had fifteen miles to travel. They took one look at the storm, stopped their car, and raced for shelter in "an old adobe house." The dust was so thick that "they nearly missed the door. Inside they found ten other people, stranded, like themselves in a two-room hut, all fearing that they might be smothered, all unable to see their companions' faces."[21]

Even if Rothstein had been present during such a storm, he never would have been able to take pictures or to work with subjects who stood in fear of their lives. But, unable to work during a duster, Rothstein still wanted to communicate the way dust storms devastated the land. And so he staged

the flight sequence and by expert direction, careful composition, and repetition, turned a windy, dusty scene into an extraordinary symbol of man's struggle against the elements (see figure 54).

"The picture of the farmer and his sons in a dust storm was controlled in this way," Rothstein explained in his 1942 essay. "The little boy was asked to drop back and hold his hand over his eyes. The farmer was asked to lean forward as he walked."[22] What prompted Rothstein to issue these directions? By having the father and his oldest son lean forward as they walked, Rothstein created the impression that his subjects were proceeding into the teeth of a gale. He may well have instructed the older boy to turn his head away from the camera so that the broad bill of his oversized cap would be hidden from view (see figure 50).

Rothstein decided to have the smallest child follow in the rear for several reasons. Such placement avoided a congestion of figures at the center of the picture. Father and son proceed in a synchronous stride, their progress silhouetted against the shed. The youngest child falls behind; with his arm across his eyes, he appears both blinded and lost. Framed by the stumps in the foreground and the fenceposts in the rear, he is separated from the rest of the family. The resulting impression is that the storm is destroying family unity; the viewer is drawn into the picture out of concern for the safety of the young straggler. But in thus separating the child, Rothstein was hedging his bets. Of the three subjects, the youngster was the least likely to follow directions. What if he had failed to bring his arm across his face; what if he had looked at the camera instead? In this event, Rothstein could still have salvaged a usable picture by cropping the negative to eliminate the child. Fortunately, the young boy obeyed instructions and played his part in the creation of this classic Dust Bowl exodus.

Was Rothstein's triumph simply the result of expert direction and good fortune? In introducing *Fleeing a Dust Storm* as an example of photographic direction, he wrote, "The repetition of a scene before a different background with some changes of movement will sometimes result in a more effective

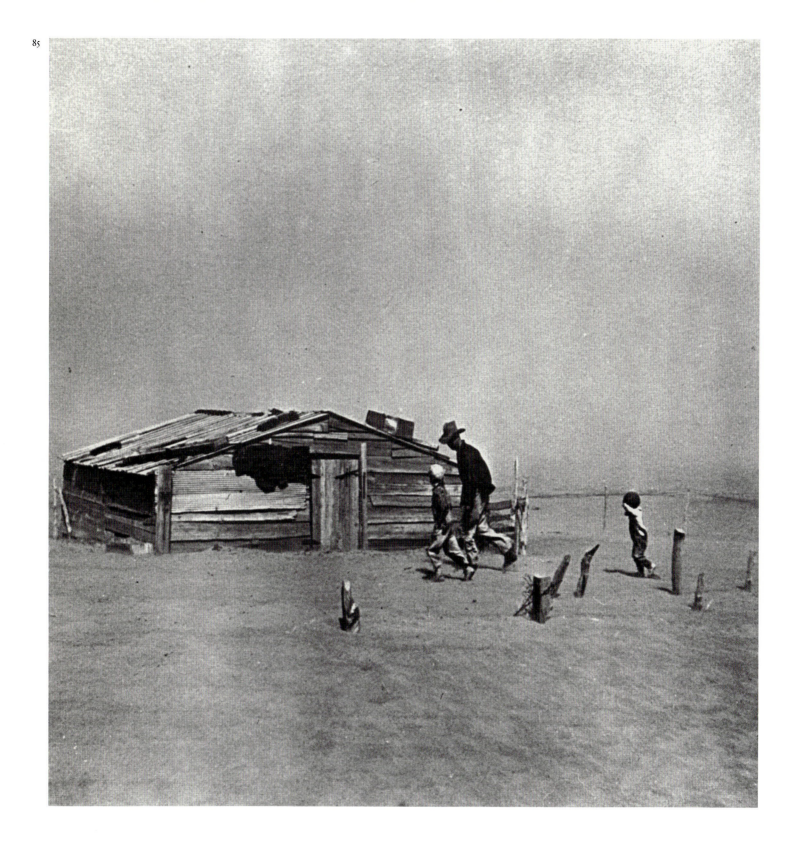

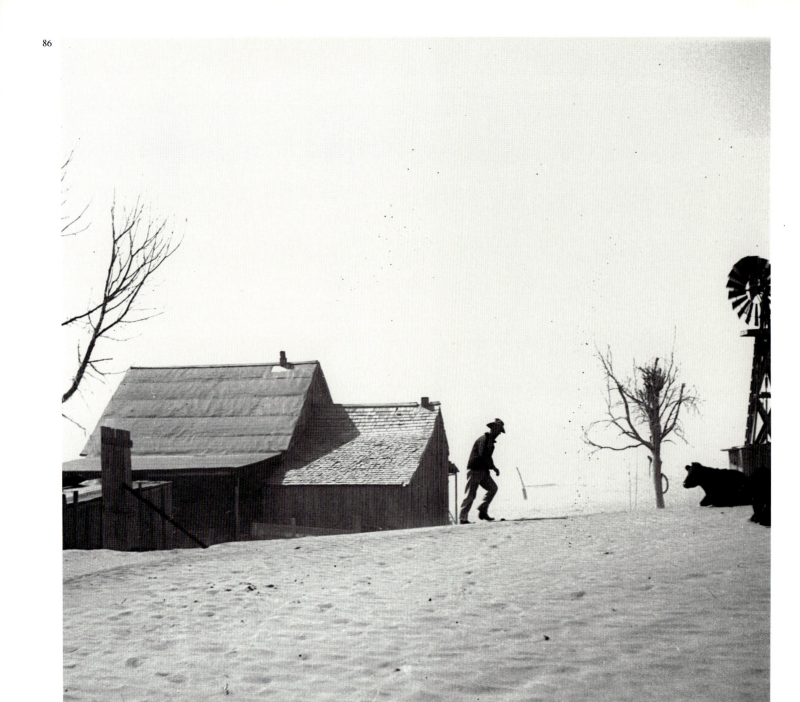

picture."[23] What is the meaning of this cryptic comment? Did Rothstein take variations of his famous flight scene like those Dorothea Lange took of *Migrant Mother*? If so, the pictures are not in the print file. But is it possible that some unprinted negatives exist?

Rothstein reported that he took seventy-seven pictures in the Panhandle region. Of this total, forty-five were printed and the prints placed in the file. What of the remaining negatives? They had to exist at some point, for Stryker's practice was to develop all field negatives, number them, make contact prints for identification, and select those suitable for final printing and placement in the file. What happened to the rejected negatives? Scholars have maintained that Stryker routinely destroyed negatives that displeased him; could this have happened here?[24] The file of unprinted negatives in the Library of Congress contains four envelopes in the same numerical sequence as *Fleeing a Dust Storm*. Could any of these be variations on the classic picture? Three of these negative holders are empty, but the fourth contains an image that is reproduced here for the first time (see figure 55).

Now, after nearly half a century, Rothstein's 1942 explanation of how he took his picture becomes clear. Contrary to his later denials that he did not stage *Fleeing a Dust Storm*, Rothstein not only directed his subjects but walked the farmer through at least this one practice frame and perhaps more.[25] In this image, he experiments with body posture, directing the man to hunch forward as he walks, a gesture that he would repeat in the master image. This pose was critical; Rothstein had no other way to suggest the presence of a storm. The practice photograph shows that the sun was shining, there were strong shadows on the house, the horizon was visible, and the wind, while fresh, was far below gale force. In taking this trial picture, Rothstein most certainly realized that the background was all wrong. How could he create the impression of flight before a storm when the farmer walks away from the house? Yet to have the man walk toward the house would undercut the drama of flight. Viewers

would never fear for the safety of a family that was within a few yards of home!

Including the farmhouse in the picture created other problems. The building was too substantial. Rothstein wrote that *Fleeing a Dust Storm* was "made to take place in front of the shed," because "this showed the effect of the dust storm and the poverty of the farmer more clearly than the other buildings." Actually the exterior of the shed gives little evidence of a storm in progress, although the large tarpaper patch on the siding may have been used to repair previous damage. The farmhouse appears unscathed. It is not "almost buried by drifts," as Rothstein would later maintain.[26] Other elements in this photograph document survival, not defeat. The windmill, the small herd of cattle, the crude swing on the tree limb: all suggest that this family, while by no means prosperous, did not face destitution. By contrast, the windswept flat in front of the shed was a perfect location for a picture designed to show the human suffering of the Dust Bowl.

Knowing the ways in which *Fleeing a Dust Storm* was staged does not answer the question of how a young, inexperienced photographer on his first trip to the Panhandle region managed to find subjects who were willing to reenact such a symbolic scene. If anything, the outpouring of national publicity made residents of the Great Plains more suspicious of outsiders. Furthermore, Rothstein was not an ordinary journalist; he worked for the RA at a time when resettlement had become a dirty word in the Dust Bowl. With more than 40 percent of Cimarron County's residents already forced off their land, those who remained had become fiercely proud of their ability to brave the forces of nature. No new agency was going to declare their land submarginal and force them to evacuate. "They'll have to take a shotgun to move us out of here," one Panhandle resident was quoted as saying. "We're going to stay here just as long as we damn please."[27]

But pride and determination were not enough to withstand the onslaughts of nature. Cimarron County's survivors were able to hold onto their land because of a massive influx of federal funds. By

55. Arthur Rothstein, farmer, Cimarron County, Oklahoma, April 1936 (FSA-LC).

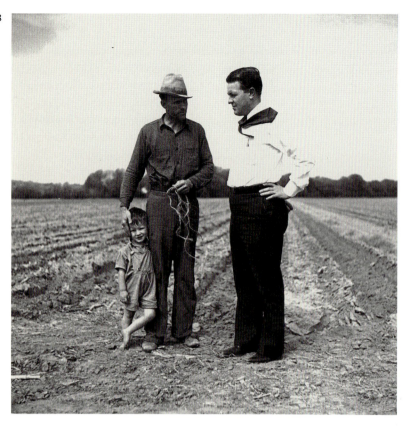

56. Arthur Rothstein, farmer and government agent, Jefferson County, Kansas, May 1936 (FSA-LC).

photographed a number of rehab clients and their badly blown fields."[29] Farrell quite probably was present when Rothstein took pictures of the farmer and his two sons. Farrell was more than a tour guide, more than a local resident steeped in the history of the region. He was a government bureaucrat to whom the area's residents were beholden. When he appeared on a farmstead he was probably dressed in the uniform of the New Deal agricultural expert, like the county supervisor in Kansas whom Rothstein photographed a month later (see figure 56). This official attire signified business, not socializing. However suspicious of outsiders the local farmers might be, they would not resist the visit of a photographer who came in the company of their government benefactor. And they would probably cooperate in whatever the two men wanted. After all, the rural rehabilitation program presumed to tell them how to manage their farms and their families. Having endured visits from well-intentioned relief officials, what was one more session with an enthusiastic young easterner?

Whether Farrell did more than introduce Rothstein to his "clients" remains a mystery. Having provided his visitor with the history of the region and the causes of the devastation, he might well have suggested ways in which the land might be photographed. Certainly Farrell could use pictorial proof that federal expenditures had brought improvements to the county. Thus Rothstein's photograph of a farmer standing next to a water pump maintains that "a possible solution to the dust problem is irrigation."[30] Likewise, Farrell may have come up with the idea of having the farmer enact the practice of "raising the fence post" (see figure 52).

But the flight before the storm was Rothstein's idea, inspired by *The Plow That Broke the Plains.* There is an obvious similarity between the intent of the photograph and the message of the film. The climax of Lorentz's story comes when a farm family loads its few precious belongings on the back of a truck and sets out for California. Lorentz filmed this sequence on an abandoned farmstead, where sand dunes came up to the level of the windows on the main house. The wonder was not that anyone could

1937, the county had received an average of $4,000 per farm, far more than the average per farm allotment for the western states as a whole. Relief came in many forms: crop loans, payments for not planting crops, wheat contracts, and cattle-purchase programs. Many of the loan plans amounted to outright gifts, as little or no repayment was required. These grants came with strings attached. Local and federal officials were instructed to ensure that government checks were applied solely to agricultural expenditures. By far the most aggressive of the relief efforts was the rural rehabilitation program that sought to make the family farm more efficient. Local rural rehabilitation supervisors were more than distribution agents; they entered into the lives of their "clients," instructing them in modern farming techniques, the best way to organize the home, even the proper way to care for children.[28] Such an official accompanied Rothstein on his tour of Cimarron County.

"Went out with Farrell, the rural rehabilitation supervisor," Rothstein reported to Stryker, "and

live under such conditions, but why they had not left sooner.

Conditioned by exposure to *The Plow*, Rothstein saw Cimarron County the same way. "This section is now a complete desert," he wrote to Stryker, despite having just taken pictures of irrigation and land reclamation projects.[31] Rothstein was not lucky enough to find a family packing up to move. The exodus from the Panhandle had occurred several years earlier. Lorentz had to hire actors for his departure scene, filmed in the fall of 1935. The people that Rothstein met were all survivors, committed, as was their county supervisor, to holding onto the land.

But Rothstein had not come to Cimarron County to pay tribute to its survivors. He had been sent to record devastation. And so he worked with a local farmer, one of the majority of county residents who did not emigrate, to create *Fleeing a Dust Storm*, an image that attests to the power of nature but not to man's ability to endure. He designed the picture to show that the farmer had no substantial property and that he was being forced to seek shelter in a dilapidated outbuilding. What can the man possibly do in such a harsh, barren environment? Exodus—resettlement—seems the only solution.

Rothstein's subjects remained on their land long after the photographer departed and his picture became famous. In 1977, author and photographer Bill Ganzel returned to Cimarron County to interview Darrel Coble, the young boy who trailed behind in *Fleeing a Dust Storm*. Coble lived no more than a dozen miles from the family homestead; his father and older brother had died but Darrel still recalled the days of the dust storms. As Ganzel set up his camera equipment in his subject's living room, Coble spoke of family history. "Back in the thirties, my Dad had some relatives in California . . . and they wanted him to get outa here. They said they'd pay his way to California, the whole family, but he said he wouldn't go. He was just a hard-headed Coble, I guess." Coble smiled as he recalled his childhood. "All the days was about alike then. For a three-year-old kid, you just go outside and play, dust blows and sand blows, and you don't know any different." But as an adult, Coble learned that one day's play had been different, that on a windy day in April 1936 he and his older brother had helped to create one of the Depression's most memorable images. A reproduction of that photograph, painted by a local artist, was hanging on the living room wall behind the chair in which Darrel was seated. Ganzel asked his subject to look away from the camera and then brought Coble and *Fleeing a Dust Storm* into sharp focus. Two years after Ganzel's departure, Darrel Coble died; he was forty-six.[32]

Chapter Five

"The Last Frontier"

Russell Lee and the
Small-Town Ideal

57. Russell Lee,
street scene, Pie Town,
New Mexico,
June 1940 (FSA-LC).

In May 1940, Russell Lee, the FSA's most prolific photographer, left Socorro, New Mexico, and headed west along U.S. 60. The new guidebook from the Works Progress Administration (WPA) told motorists that for more than a hundred miles the scenic highway twisted "uphill and down, through canyons and arroyos, near big game territory," winding "through a region of great natural beauty where the Apache roamed and hunted."[1] Stryker's photographer was not looking for Indians or big game but for something more elusive: the ideal small town. Lee and Stryker could not have chosen a locale more steeped in historical lore. According to the WPA guidebook, Highway 60 followed the same path across the continental divide taken by Coronado four centuries earlier. Names of the towns along this route—Magdalena, Augustine, Omega, and Quemado—bore witness to the Spanish conquest. Lee stopped at a village of fifty people founded not by the Conquistadors but by a twentieth-century miner who operated a filling station and supplemented his income by selling homemade pies. Out of this tiny, rough-hewn outpost with the homespun name of Pie Town, Russell Lee would fashion an idealistic portrait of a modern pioneer community (see figure 57).

Contrary to Lee's later recollections, he did not go to Pie Town on a chance assignment. His trip was the culmination of more than four years of FSA focus on American community life. Most accounts of Roy Stryker's project treat these small-town pictures as inferior products, far less significant than the file's well-known photographs of rural poverty, migrant labor, and Dust Bowl exodus. Because the FSA's village portraits exude positive values and stress plenty rather than want, they fail to interest critics who equate Stryker's photography with tough-minded realism. This perceived realism was in fact often the result of deliberate arrangement and conscious efforts to craft images that conformed to urban, middle-class values. Lee's Pie Town photographs reflect the same process. They also respond to scholarly interpretations of American culture, especially to the writings of Rexford Tugwell, Robert and Helen Lynd, J. Russell Smith, and Lewis Mumford.

In Pie Town, Lee and Stryker believed they had found the nation's "last frontier," an ideal environment that combined two powerful antidotes to the malaise of Depression America: the traditions of rugged individualism and community cooperation.[2] Pie Town was not the first community in which Stryker tried to locate the last frontier. Nearly four years earlier he commissioned a photographic study of another group of homesteaders who set out for the West in hopes of finding a brighter future (see figure 58).

The people who waved to the photographer from this truck were refugees not from the Dust Bowl but from New York City. They traveled less

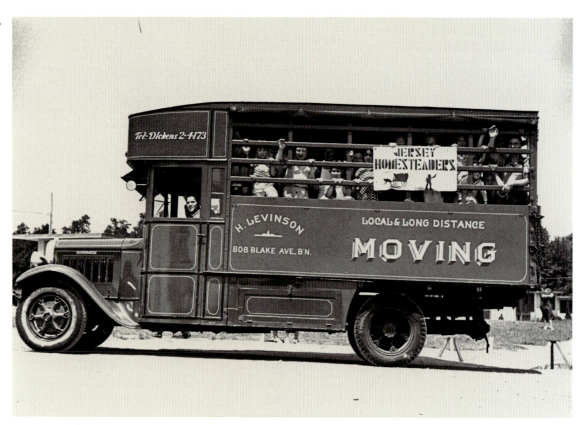

58. Carl Mydans,
Jersey Homesteaders,
Hightstown,
New Jersey, Summer
1936 (FSA-LC).

than a hundred miles, from the crowded neighborhoods of the Bronx to the empty fields of Hightstown, New Jersey. The occasion for their exodus was the official opening of Jersey Homesteads, a cooperative community designed to house and employ Jewish needleworkers from New York's garment district. As originally designed by private investors, the experimental town was to be located on 1,200 acres of farmland—a welcome alternative to crowded urban tenements. Residents would occupy modern houses, set on subsistence garden sites, work seasonally in a garment factory to be built on the land, and share in the profits of a truck farm and agricultural cooperative. Jersey Homesteads came under federal supervision in 1934 and a year later was one of many New Deal communities assigned to the newly created Resettlement Administration headed by Rexford Tugwell.

Although he was not involved in the original design of Jersey Homesteads, Tugwell had long advocated planned development of America's sub-

urban landscape. The modern American city, Tugwell argued in *American Economic Life*, was "an unplanned hodgepodge. In order to remake such a city . . . it would be necessary to destroy the whole structure and rebuild from the bottom up." Tugwell envisioned less costly alternatives to wholesale urban renewal. As Americans pressed out beyond the nation's city limits, they entered an area that Tugwell called the "new frontier," an undeveloped suburbia that offered a golden opportunity for "government planning of a favorable working and living environment."[3]

Tugwell's zeal for government planning became evident as soon as his Resettlement Administration took control of Jersey Homesteads. He wanted to make the colony a model of innovative prefabricated housing. A new plant located at Hightstown was to manufacture massive concrete slabs not only for the houses at Jersey Homesteads but for other New Deal communities. Stryker's pictures reveal his pride in this new technology. But all too quickly

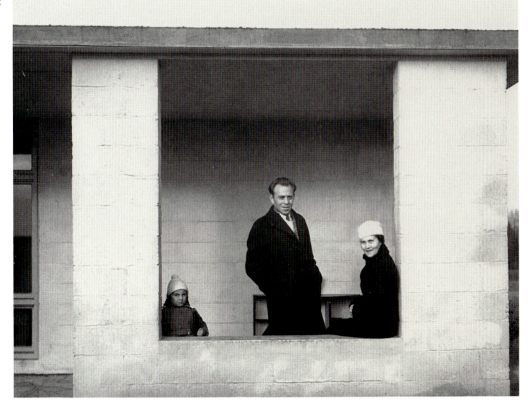

59. Arthur Rothstein,
new residents
of Jersey Homesteads,
Hightstown,
New Jersey, Fall 1936
(FSA-LC).

these huge blocks became monuments to ineffi-
ciency. The factory did not open in time to produce
slabs for Hightstown's houses. Cinderblocks were
used instead and then whitewashed to simulate the
new concrete style (see figure 59). When the slabs
were installed in later prototype houses, the walls
collapsed, along with Tugwell's experiments with
prefabrication.[4]

Unable to publicize a housing project that had
developed serious flaws, Stryker turned his atten-
tion to Hightstown's new garment factory. Of the
more than 150 file photographs Stryker would accu-
mulate of Jersey Homesteads, two-thirds deal with
construction and operation of this plant. Russell
Lee took the largest single block of pictures during
his visit to Hightstown in November 1936. For Lee
this was a trial assignment; Stryker obviously liked
what he saw, for Lee was soon a full-time member
of the photographic staff.

Born in 1903 near Ottawa, Illinois, Lee came to
photography after an unsatisfying career in indus-
try. Trained as a chemical engineer, he grew restless
in the bureaucracy of a small industrial plant in Illi-
nois. Lee's marriage to Doris Emrick, a talented
midwestern painter, sparked his interest in the visual
arts. Drawing on a family inheritance, he resigned
his job and spent five years of study at the Wood-
stock art colony in southern New York state. His
efforts at painting failed, but when he turned to
photography in 1935, he discovered a medium that
absorbed both his creativity and his fascination with
technology.[5]

Lee endeared himself to Stryker because he
lacked Walker Evans's egotism and recalcitrance.
Evans balked at taking a large quantity of file pic-
tures; Lee took as many as Stryker wanted. During
his three-week stay in Hale County, Alabama, in
August 1936, Evans produced fewer than a hundred
photographs; three months later, Lee made nearly
seventy in just two days at Jersey Homesteads.
While on the road, Lee kept in constant touch with
Washington, sending detailed letters describing

60. Russell Lee,
tailor at Jersey Home-
steads, Hightstown,
New Jersey, December
1936 (FSA-LC).

social conditions, suggesting new subjects for documentation, and keeping up a running dialogue with Stryker about technical matters. Unlike both Evans and Lange, Lee in 1936 had no artistic reputation independent of the project. Indeed he was so compliant that when the Zeiss Corporation asked to exhibit some of his Jersey Homestead photographs, Lee cheerfully allowed Stryker to make all the selections.[6]

Lee's photographs of Jersey Homesteads clearly reflect his acceptance of Stryker's direction and his commitment to Resettlement's policies. By calling attention to the Jersey Homestead's garment factory, Stryker tried to counter criticism that the community was a radical social experiment in cooperative living. "The American taxpayer is putting up $1,800,000 to create a model of a Russian Commune halfway between New York and Philadelphia," an editorial in the Philadelphia *Inquirer* had claimed the previous spring.[7] No wonder Lee shied away from taking pictures of the cooperative management structure that was the factory's most distinctive quality! Instead he focused on the workers.

Lee's photographs resemble Lewis Hine's positive work portraits of the 1920s. Like Hine, Lee shows the individual in control of the garment trade, from the operation of sophisticated machines to the close hand work of skilled tailors (see figure 60). While he documents the entire process of garment making, Lee has only three pictures of female workers. The settlers at Jersey Homesteads were members of David Dubinsky's International Ladies Garment Workers Union. They had chosen as their community symbol a statue of a woman at a sewing machine. Yet when Lee wanted to photograph women at work, they were nowhere to be seen. Moreover, in the three pictures in which women do appear, Lee identifies them as daughters of the homesteaders and not working wives. Perhaps the new residents were fearful that an emphasis on women in the workplace might only increase the negative publicity that the community had already aroused.

This sensitivity to public scrutiny is even more evident in other scenes that Lee was unable to

photograph at Jersey Homesteads. Absent from his coverage are pictures of the multitude of social committees that made the colony "almost overorganized."[8] Two photographs show the outside of the cooperative grocery store, but there are no pictures of the other cooperatives being built at Hightstown: a clothing store, a medical clinic, and a tearoom. Nor are there more than a handful of file pictures of the interiors of the new houses.

Lee fared little better when he went to New York City to shoot "before" pictures for the Hightstown story. Stryker instructed him to document the crowded living conditions and unsafe work practices that would be remedied by the homesteaders' migration to the New Jersey countryside. Despite a letter of introduction, Lee was unable to penetrate the surface of the Jewish neighborhood in New York City. Lee gained access to the dwelling of one prospective homesteader only to find a well furnished apartment that could hardly be used to support the claim that the Jewish neighborhood was a deprived ghetto.[9]

That the homesteaders were not living on the edge of poverty should have come as no surprise to Stryker. Each family had to pay $500 to join the colony. Even with this hefty fee, there had been more than eight hundred applications for the two hundred available places. Furthermore, the successful applicants had to demonstrate "some understanding of cooperative endeavor," and had to "have a family which showed evidence of good home management."[10] Stryker's before and after strategy was therefore poorly conceived. What family would allow itself to be typecast as a symbol of poverty when proof of efficient management had been a prerequisite for selection?

The new residents of Jersey Homesteads were suspicious of any investigations, even those of government officials like Lee. They had already been badly served by newsmen who posed as sympathetic friends. "I remember him sitting in the back [of the bus]," one of the original settlers said of a Hearst *Journal American* reporter who accompanied the homesteaders on an early inspection trip. "I felt very protective . . . because I sensed how he was viewing

98

61. Arthur Rothstein,
mural at Jersey
Homesteads, Hights-
town, New Jersey,
1936 (FSA-LC).

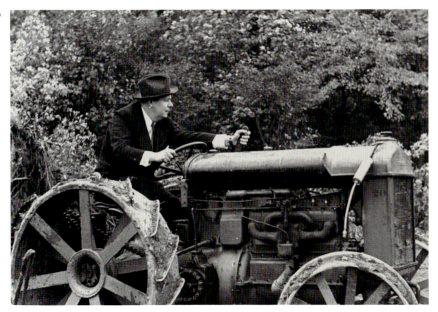

62. Arthur Rothstein, government official, Greenbelt, Maryland, Fall 1935 (FSA-LC).

my people from the outside without knowing their true qualities."[11]

Although Stryker and Lee tried to portray Hightstown's settlers as modern pioneers, the new-comers had another heritage in mind. Any public criticism reminded them of earlier persecution. Prejudice, not pioneering, became a central theme in the mural Ben Shahn completed for the community center at Hightstown. Noted artist, frequent contributor to the photographic file, later a resident of Jersey Homesteads, Shahn created panels on the plight of Jewish immigrants as they were tagged and processed at Ellis Island, struggled to find work, and endured the evils of the tenements. The final section of his huge mural credits the government with offering Jews relief from past oppressions. This panel shows a team of urban planners gazing intently at the blueprints for Jersey Homesteads. On the wall above the drafting board hangs a poster of FDR, captioned "A Gallant Leader" (see figure 61).

While defensible as decoration for the walls of a New Deal community center, the image of aggressive government planning was hardly compatible with the campaign to characterize the Jersey homesteaders as natural heirs to the pioneer legacy. Stryker did the best he could to document experimental communities like the colony at Hightstown, but shied away from explicit reference to govern-

ment sponsorship, cloaking federal activism in more traditional garb.

Nowhere was this more evident than in the pictorial coverage of Tugwell's most idealistic experiment in community design: the construction of the first Greenbelt town on the outskirts of the nation's capital. Rexford Tugwell believed that Greenbelt towns would provide a permanent solution to dislocations in rural and urban America. He envisioned twenty-five new communities, each planned and constructed with government funds, located on the perimeters of major metropolitan areas, and protected by belts of undeveloped farm land. The Greenbelt town would provide inexpensive housing for as many as ten thousand residents, to be selected from low-income city dwellers and farmers displaced by resettlement. Most important, these communities would be models of cooperative civic life.[12]

In the fall of 1935, Tugwell and his planners rode high on a wave of optimism. Although only four Greenbelt towns were approved, construction was beginning on the first and most symbolic, a 3,600-acre site at Berwyn, Maryland, just seven miles from the Capitol Rotunda. Resettlement officials turned out en masse for the ground-breaking ceremonies in October, where they obligingly posed for government cameras. The awkward picture of a Resettlement bureaucrat, in coat and tie, driving a bulldozer, set the tone for the hundreds of photographs that would eventually constitute Stryker's Greenbelt file (see figure 62).

Machines were everywhere at Greenbelt, many of them bearing the RA logo: a completed house. Stryker even experimented with aerial photography, not to show the famous greenbelt, but to record the massive clearing and landfill operations. The natural environment, supposedly a key ingredient in this ideal community, disappeared from view.[13] Politics forced conservation to take a back seat to construction. Tugwell was under pressure to demonstrate that RA projects put the jobless back to work. Moreover, he needed pictorial proof that transients and other nonunion laborers could be effective workers. Stryker willingly created such pic-

63. Arthur Rothstein,
community center,
Greenbelt, Maryland,
1937 (FSA-LC).

tures, even showing that work went on in the dead of winter.

The proud display of modernization stopped short of Greenbelt's radical social design. According to one scholar, "cooperative society was almost a religion" at the Resettlement Administration, but Stryker found the new faith fraught with public relations problems. Tugwell distinguished between "involuntary totalitarian collectivism" sweeping Europe and the "voluntary, democratic cooperatives" that he planned for Greenbelt; Stryker found it difficult to make such distinctions pictorially.[14] He therefore avoided architectural scenes that might have called attention to Greenbelt's cooperative ideal. For instance, there are almost no images of the multifamily apartment buildings that would house nearly half of Greenbelt's residents. Not until the fall of 1937 did Stryker commission pictures of the community building, considered by many observers the most striking structure in the new town (see figure 63). Even though the building was used for a variety of activities, especially the meetings of the many cooperatives, Stryker insisted on referring to the center as a school. The only interior shots in the file show students in elementary classes.

Similarly, Stryker avoided all but the most cursory treatment of Greenbelt's main street, location of the community's many business cooperatives. In 1938, Russell Lee took one of the few pictures that makes explicit reference to these cooperatives. Even here, he was careful to include a mother and child in the image, demonstrating that social experimentation had not displaced the family unit (see figure 64). Actually, Tugwell's teachings were so effective that even the children at Greenbelt organized a cooperative.[15]

But in 1938, there was no way to make the word "cooperative" palatable to most Americans. Stryker had as much chance of making Greenbelt a national showplace as he had for making Co-op cornflakes America's favorite breakfast food. Greenbelt was Tugwell's pet project; as he became controversial so did the new town. Keeping Tugwell out of information photographs accomplished nothing, so long as his Resettlement Administration was in evi-

64. Russell Lee,
food cooperative,
Greenbelt, Maryland,
1938 (FSA-LC).

dence. Even Tugwell's resignation did not still the criticism.

Stryker decided on a new strategy. He would locate the values of individualism, democracy, and cooperation in the private, not the public, sector. If the planned government communities were too controversial, America's small towns were above suspicion. Stryker's decision to reassess rural communities grew out of his association with two preeminent intellectuals of the Depression decade: Robert Lynd and Sherwood Anderson.

Stryker's development of the small-town file was no mere afterthought or the byproduct of the documentation of rural poverty. Indeed his survey of village life constitutes one of his most original and creative contributions to the documentary movement. Stryker took this campaign seriously. When the file was first taking shape in 1936, he met with Columbia sociologist Robert Lynd, whose influential *Middletown* (1929) had appeared while Stryker was still teaching at Columbia. Lynd and his wife argued that the residents of Middletown (Muncie, Indiana) were caught up in a spiraling consumer culture that stripped away traditional values. At the time of his meeting with Stryker, Lynd had just completed a second volume to determine the impact of the Depression on Middletown's citizens. Lynd was now even more concerned about the debasement of democratic values than he had been a decade earlier. Hard times had intensified the average citizen's fixation on the almighty dollar.[16]

As Lynd gazed intently at Stryker's photographs of rural America, he began to wonder whether small towns preserved the very values Middletown had lost. From the notes that Stryker took at this meeting, it is clear that Lynd hoped to find village outposts where home, family, church, and community were still primary cultural agents. Stryker returned to Washington and hammered out a small-town "shooting script" that would govern his photographers for the next four years.[17]

Heading Stryker's list of priorities was photographic documentation of small-town Americans "at Home in the evening." Stryker wanted to demonstrate that in the countryside, the family was not,

65. Russell Lee,
farm couple,
Hidalgo County,
Texas, February
1939 (FSA-LC).

in Lynd's words, "declining as a unit of leisure-time pursuits." More than half the teenagers that Lynd surveyed in *Middletown* spent fewer than four evenings at home each week. Drawn outside the home by an expanding range of activities, young people in Middletown were less obedient to parental instructions. Modern technology played an important role in this domestic disruption. "Why on earth do you need to study what's changing this country?" Lynd was asked by one resident, who promptly volunteered: "I can tell ya what's happening in just four letters: A-U-T-O!" Lynd agreed. He concluded that automobiles upset family finances, provoked fights, facilitated adolescent rebellion, curtailed socializing, and generally "revolutionized" leisure. Motion pictures exerted a similar influence. There were so many movies shown in Middletown that family members often went in separate directions to obtain their weekly (sometimes daily) dose of Hollywood entertainment. Although located in the home, the radio did not always promote togetherness as the variety of programming invited individual family members to claim whole blocks of time for their own private listening.[18]

Stryker wanted to counter Lynd's portrait of declining family solidarity with fresh visual evidence of how Americans spent their evenings *in the home*. He wanted pictures of people playing bridge, entertaining guests, and listening to the radio. Russell Lee had these directions in mind several years later when he photographed a farm couple in Hidalgo County, Texas, inside the home that they had recently secured with the help of an FSA loan (see figure 65). At first glance, this image contradicts the normal emphasis on the thrift of government clients. The farmer is so poor that he has holes in his socks; his wife wears ancient work shoes; yet the farmer spent a considerable sum on the enormous floor-length receiver. Lee placed the object at the center of his composition not to suggest that it was an extravagant purchase, but to show the important role radio played in promoting family unity. The shiny console is the only hint of affluence in an otherwise spare interior. The stark simplicity of the spotlessly clean furnishings is an ironic contrast to the elegance of the eighteenth-century scene depicted in the cheap wall hanging.

Modern viewers see this image as high camp, not stopping to think about the significance of the radio and its centrality to the life of this farm couple. Like the traditional hearth, the radio in this photograph symbolizes unity, an impression reinforced by the objects displayed on its polished surface. Here stand portraits of the couple's two children, who appear to be old enough to have moved away from home. Yet their pictures remain, a visual tribute to the strength of family ties.

Why the insistence on family unity *in the home*? In the process of taking countless pictures of the homeless, adrift on the nation's highways, Stryker needed a counterweight to assure his contemporaries that home life still mattered, that it was a basic determinant of American values. And so he urged his photographers to take pictures looking "out the kitchen window" and "down my street."[19] Viewed from this perspective, the world took on a much more settled and stable appearance.

Second to home was church. Stryker presumed that *all* small-town Americans went to church. He wanted pictures of villagers at home, preparing to go to church and gathering after services. He instructed his photographers to follow their subjects back home to show family visiting. Such images would contradict Lynd's findings that "sabbath breaking" had increased in Middletown.

When his photographers looked beyond the home, Stryker wanted them to document the various small-town meeting places. He was intent on showing that disparities in wealth did not deprive communities of meaningful social interchange. Stryker believed that the "well-to-do" had lodges and country clubs and the "poor" had "beer halls, pool halls, street corners, garages and cigar stores." Here, too, he was responding to Lynd's conclusions that Middletown's pursuit of economic security had impaired community cohesion.[20]

In the years following his meeting with Lynd, Stryker refined and broadened his small-town shooting script. Main Street joined Home and Church as prescribed locales. Stryker wanted pictures of

town buildings: the courthouse, local stores, the movie theater, the filling station, even the bank. He intended these pictures to show that while population growth and dispersion had undermined Middletown's civic unity, rural villages still had vital commercial centers that were alive and prosperous. He urged the staff to photograph "people on the street," and "Saturday afternoon shopping and sidewalk scenes."[21]

Arthur Rothstein's 1939 portrait, *Saturday Night, Main Street, Iowa Falls, Iowa,* filled this prescription nicely (see figure 66). Rothstein abandoned a frontal perspective that might have included the entire movie marquee. By framing the picture so that it halted the electrified announcement in mid-sentence, he departed radically from the esthetics of his former colleague, Walker Evans, who routinely composed pictures to include as much graphic detail as possible. Rothstein was more intent on conveying a sociological than an artistic message. His Iowa Falls photograph directly contradicts Lynd's conclusion that movie houses threatened family and community solidarity. Rothstein's frame is filled with people engrossed in conversation. The group in the foreground includes a couple and their two children, proof that in America's heartland, families still went to the movies together. Not only is the sidewalk a well-traveled thoroughfare, it is a prime location for social gathering.[22]

In Stryker's view, such socializing, even when it took the form of "loafing," was evidence of small-town neighborliness, in contrast to the anonymity of the city. Moreover, the free and easy exchange along Main Street bespoke an egalitarianism that Stryker considered typical of village life. He presumed that the class divisions so evident in Middletown had few rural counterparts.

From 1936 to 1939, Stryker's photographers crisscrossed the country, taking pictures of village life whenever possible. The small-town file soon contained thousands of images. Frightened by the excesses of mass movements in Europe in the late 1930s, Americans searched for proof that individualism and democracy had not fallen prey to the Depression but remained firmly rooted in native soil.

In 1939, the same year that war broke out in Europe, Stryker went to a publisher's office with his pictorial antidote to national anxieties. Why not produce a picture book on the small town?

The time was right. For the past two years there had been a growing market for extended pictorial essays, addressing contemporary problems and integrating text with photographs. Spurred in part by the success of *Life* magazine, this trend also had its origins in the popularity of documentary film. In these visual narratives, the photograph became more than mere illustration; images told the story, often more powerfully than accompanying text.

An innovative book in this new genre was Archibald MacLeish's *Land of the Free* (1938), an extended poem based on Stryker's FSA photographs. According to its author, the work was "the opposite of a book of poems illustrated by photographs. It is a book of photographs illustrated by a poem. The photographs existed . . . before the poem was written." Writing elsewhere, MacLeish indicated his debt to documentary film by referring to his poetry in *Land of the Free* as a "sound track" for Stryker's photographs.[23] Stryker proposed to follow MacLeish's book with his portrait of village life. To write the text for this volume, he entered into an agreement with Sherwood Anderson, whose reputation rivaled that of MacLeish.

Like many of his fellow regionalists, Anderson began his career as a critic of the rural scene, but had a change of heart during the Depression. His literary fame rested on two early novels, *Winesburg, Ohio* (1918) and *Poor White* (1921), in which he subjected his small-town roots to harsh criticism. By the mid-1920s, Anderson had grown weary of urban life and of wanderings that had taken him from Chicago to Reno to New Orleans to New York. He bought a farm in Virginia's hill country, purchased two local newspapers, and set himself up as a country editor. In 1933, at the urging of FDR's adviser, Raymond Moley, Anderson began a series of essays on the reactions of common people to the Depression. Collected two years later and published under the title *Puzzled America,* Anderson's observations gained him the reputation of being a staunch

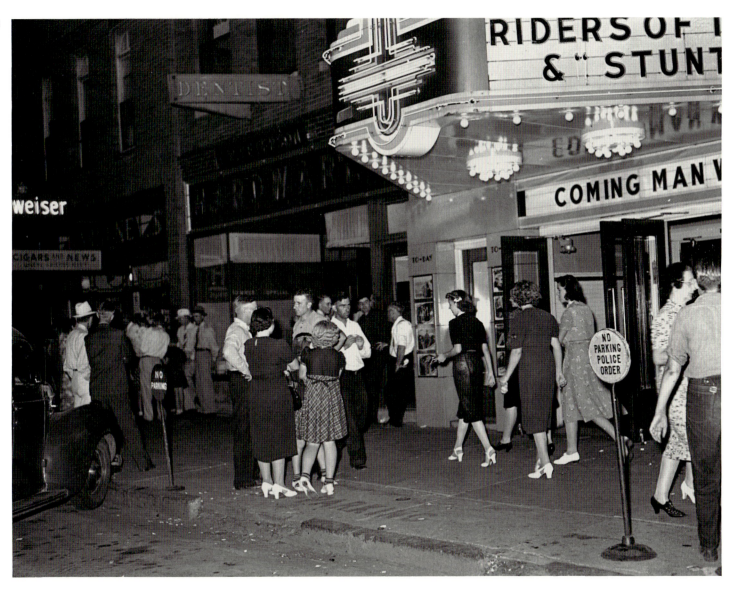

66. Arthur Rothstein,
Saturday Night, Main Street,
Iowa Falls, Iowa,
September 1939 (FSA-LC).

supporter of the New Deal and a proponent of small-town revitalization.[24]

Just as *Land of the Free* has rarely been listed among Archibald MacLeish's literary masterpieces, so Sherwood Anderson's collaborative work with the FSA, a book he entitled *Home Town*, has been frequently dismissed as a minor work tinged with the nostalgia of Anderson's declining years. Yet this pictorial essay was a major statement of deeply felt beliefs and widely shared values. He proposed the small town as the perfect corrective to what he termed the "false bigness running rampant in the

world." Anderson was well aware that a majority of Americans lived in the cities, but he maintained that they were recent arrivals on the urban scene and therefore vividly remembered "the intimacy of life in the towns. Many of them," he continued, would "remain, during all their life as city men, at heart small-towners." And this small-town mentality would be the nation's first line of defense against those who would be "big thinkers" and whose aim was to remake society by becoming movers of "masses of men." As Anderson put it, "The real test of democracy may come in the towns."[25]

Anderson closed *Home Town* with an optimistic summary of recent national history. He maintained that the Depression had halted "the continual flow of young life . . . to our cities" and had even prompted a move in the opposite direction, "back to the towns." In contradiction to Lynd's assessments of technological growth, Anderson contended that "modern machine-driven life has brought the land and the people of the land closer to the towns."[26] It was this enduring association with the land that would, in Anderson's view, keep the small town at the center of American life.

Stryker was equally optimistic in his selection of images for *Home Town*. He drew many of these pictures from the small-town file that he had been compiling since his meeting with Lynd. But he commissioned one important series expressly for inclusion in Anderson's book. In April 1939, Stryker directed Russell Lee to select a typical village "within the general area of where you will be within the next three or four weeks," and "settle down there for four or five days" to document the town "quite thoroughly." Lee was in Texas when he received Stryker's letter and, after consulting with a professor at Texas A&M, he selected San Augustine, a small community in the red hills north of Beaumont.[27]

Although San Augustine was one of the oldest communities in east Texas, Russell Lee was interested in its present, not its past. In his file of more than 250 pictures he presented this town of 1,249 people as an ideal blend of commercial enterprise and communal cohesion. Adhering to Stryker's

67. Russell Lee,
merchant,
San Augustine,
Texas, April 1939
(FSA-LC).

68. Russell Lee,
general store,
San Augustine,
Texas, April 1939
(FSA-LC).

shooting scripts, Lee posed San Augustine's businessmen against backgrounds of advertising posters and commercial products that attested to the town's modernity (see figure 67). The newspaper editor, the auto mechanic, the tailor, the pharmacist, the jeweler, the store clerk—all appear in similar up-to-date settings. This range of occupations conforms neatly to Stryker's belief in the egalitarian spirit of small-town enterprise. No captains of industry here!

Lee's summary image was another symbol of democratic enterprise: the general store (see figure 68). Lee intended this as more than a comment on the face-to-face commerce typical of small towns. His lens incorporated the diverse array of products. The brooms and the smoked hams suspended from one part of the ceiling and the light bulb and electric fan suspended from the other suggest the interplay of past and present. Dominating the counter and indeed almost obscuring the clerk is the cash register, but it too has the look of tradition and not the streamlined appearance that had come into fashion during the Depression. This is the type of machine that allows the customer clear view of the amount of the sale.[28]

69. Russell Lee, courthouse square, San Augustine, Texas, April 1939 (FSA-LC).

The themes of prosperity and communality were even more evident in a series of photographs that Lee took along San Augustine's main street on a Saturday afternoon. By far the most distinguished is Lee's photograph of the courthouse square, a locale that Stryker had previously singled out for special consideration (see figure 69). According to the WPA Texas guidebook entry, San Augustine's square was a "wide" and "tranquil" place around which small groups of farmers occasionally gathered "to discuss their crops."[29] Nearly a hundred people crowd into Lee's photograph, many of them dressed in work clothes but a large number in more formal

attire, all showing evidence of prosperity and many dressed in current fashions. The photograph implies active interchange between all levels of San Augustine's society. Actually, this gathering was atypical. Lee knew that there was to be a community meeting in the courthouse, obtained permission to photograph, and then shot this picture either before or after the crowd met inside.

Like many of Lee's San Augustine photographs, the picture of the courthouse square is composed more with an eye for modernity than tradition. In contrast to Walker Evans, who had been fascinated with Vicksburg's Civil War statuary, Lee took no

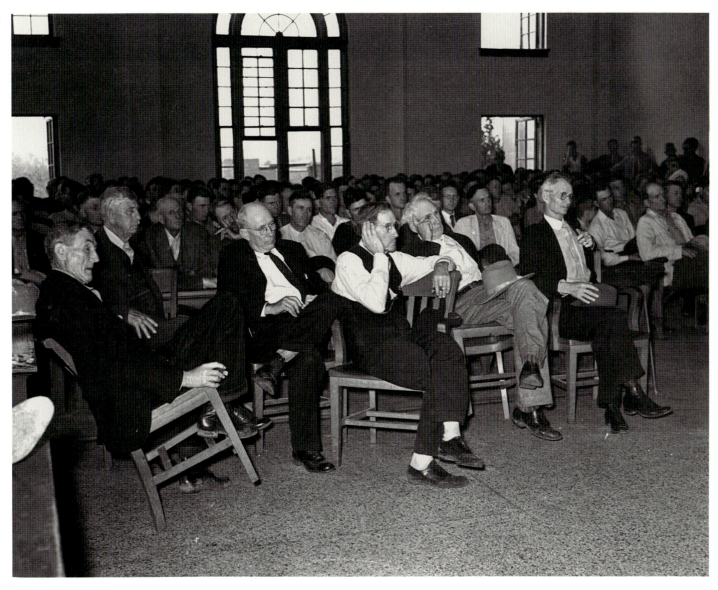

70. Russell Lee,
courthouse meeting,
San Augustine,
Texas, April 1939
(FSA-LC).

frontal views of San Augustine's courthouse monument. Instead he chose an aerial perspective and widened his focus to include a number of automobiles, trucks, and other conveyances. In this way, Lee restates a dominant theme from the small-town shooting scripts: modern transport integrated outlying rural families into the life of the town.

While abreast of the times, San Augustine still preserved the traditions of democracy that Lynd found fading from the urban scene. Lee's praise of civic responsibility and small-town democracy found fullest expression in his well-known photograph of the courthouse meeting (see figure 70).

Lee chose a frontal, wide-angle perspective to demonstrate the size of the crowd and to imply a high degree of citizen participation in local government. There is a blend here of formality, signified by the dress, set against the individualism of men who rock back on their chairs. Here we see a tough-minded citizen, not to be swept away by demagogues. Had Lee taken this picture from the balcony, where the powerful members of the county commission had their seats, the effect would have been totally different.

One wonders how Lee gained his preferred vantage point inside the closed society of Texas politics.

71. Russell Lee,
tie cutter,
Pie Town, New
Mexico, June
1940 (FSA-LC).

The answer lies in his governmental status. The captions for Lee's photographs indicate that this was not in fact a typical town meeting or an exercise in grass-roots democracy, but a strategy session to obtain more WPA funds for the county's roads. The federal government convened this gathering and later entertained the audience with a USDA film program.

The New Deal's imprimatur did not open all of San Augustine's doors. Some local residents remained suspicious of Lee as a government investigator—and with good reason. Lee had come to San Augustine with the shooting script in his pocket but with a hidden agenda as well. In taking pictures of schoolchildren he was instructed to be on the lookout for hookworm disease, considered widespread in the county. Lee did his best to carry out this assignment without arousing local suspicions. He created flattering portraits of the San Augustine school and accorded the principal as much respect as any other community leader. When he came upon children known to be suffering from

hookworm, Lee took routine pictures without comment. Yet he could not overcome local fears generated by recent FSA campaigns against a historic disease once estimated to affect as much as 40 percent of the South's rural population. Lee wrote to Stryker that he was being forced to curtail his San Augustine assignment because sensitivity to the hookworm issue was so high.[30]

Lee's search for an ideal small town, a quest begun with enthusiasm and civic cooperation, ended in an atmosphere of fear and suspicion. The FSA had placed its own photographer in an untenable position. Instructed by Stryker to create portraits of a modern, democratic community, Lee was at the same time forced to collect evidence of a disease that carried the stigma of backwardness. Small wonder, then, that Lee never gained access to San Augustine's homes. In his file of some 250 San Augustine photographs, there are only 7 pictures of domestic life—all of a poor family diagnosed as having hookworm. Fears that San Augustine would become a target for ridicule proved groundless. Stryker

ignored the hookworm issue, pronounced the community in perfect health, and selected twenty of Lee's photographs as a major part of *Home Town*.

With the publication of Anderson's book, Stryker's idealized portrait of American small-town life was nearly complete. He had come to the defense of American village life by a circuitous route. An eager student of Tugwell's lessons on planned economic development, Stryker had hoped to present communities like Jersey Homesteads and Greenbelt as models of rural revitalization. Construction delays, political infighting, and increased public anxiety about government propaganda forced him to search for less controversial examples. *Home Town* proved an ideal vehicle. No less than Anderson, Stryker built the community of his dreams. In the process, he provided 1930s America with usable symbols to allay their fears that modernization and mechanization led only to metropolitan sprawl and the destruction of individualism. Although *Home Town* insisted that "in the homeland of Hollywood tricks and advertising campaigns," the FSA photographic file was "doing much to keep photography an honest woman," Stryker's staff was in fact constructing an idealized version of American life quite similar to the cinematic creations they disliked.[31]

With the broad pictorial outlines of the small-town ideal now in place, Stryker turned from sociology to history to invest his creation with tradition. In the spring of 1940, he sent Russell Lee to New Mexico, to document Pie Town as the symbol of "the last frontier." Since his days at Columbia, Stryker had been attracted to frontier typology, thanks in part to J. Russell Smith's *North America*, which restated the theories of Frederick Jackson Turner about the persistence of frontier traditions in American life. Lee read Smith's text with great enthusiasm and went to Pie Town prepared to find a new pioneer spirit that reestablished the bond between the individual and the land.[32]

In pursuit of the frontier myth, Lee altered Pie Town's appearance. According to the WPA guidebook, the community served as "a marketing point for pinon nuts gathered in this area by Indians who sell to traders or to wholesalers." Just as nineteenth-

century pioneers had pushed back Indians who blocked their westward progress, so Lee eliminated all vestiges of native American culture from his photographs. He took not a single picture of the Indians who used Pie Town as a major marketing center. Nor did he show how some of the new homesteaders depended on the pinon trade for their livelihood. This exclusion was not a matter of ignorance. In *North America*, Smith wrote that pinon nuts held the key to the prosperity of the region, because the poor soil and inadequate rainfall made both farming and ranching difficult. Ignoring these specifics, Lee instead turned to Smith's mythic description of "the American frontiersman" as the "follower of an unappreciated profession, the profession of conquering the wilds with small resources." According to Smith, the prototypical pioneers "went into the woods with an axe and built cabins and raised families of sturdy children." Their lives were a "continuous application of self-reliance and inventiveness."[33]

Lee followed Pie Town's residents "into the woods" and showed how they used the broadaxe, the splitting maul, and the cross-cut saw to convert the huge pine trees into railroad ties (see figure 71). While admitting that tie cutting was a specialized trade, Lee implied that the homesteaders were using this experience to learn the rudiments of wood technology.[34] What Lee did not say was that only a few of the residents chose such seasonal labor in the lumber camps and even then worked mainly as burro drivers, hauling the finished ties down from the hills.

Why was Lee so intent on taking the homesteaders back into the forest and portraying them as woodsmen? Persuaded by Smith's evocation of frontier mythology, Lee was also fascinated by Lewis Mumford's *Technics and Civilization* (1934), a book that Lee ranked alongside *North America* as a brilliant interpretation of American culture. "The place of the woodman in technical development has rarely been appreciated," Mumford maintained, "but his work is in fact almost synonymous with power production and industrialization." Moreover, Mumford claimed that "wood-culture and

wood-technics, which survived through the age of metals, are likely also to endure through the age of synthetic compounds: for wood itself is nature's cheaper model for these materials."[35]

Lee presented Pie Town's homesteaders not as victims of a technological society who sought refuge in a simpler past, but as eager students in nature's laboratory. In one caption, he maintained that many of the farmers came from areas where wood was in short supply and therefore the pines in their new locale were "a never-ending source of delight."[36] His praise of frontier ingenuity and adaptability

found its fullest expression in his exhaustive examination of Pie Town's log houses and dugouts.

Lee's exploration of the log-cabin mystique oversimplified both the pioneer past and the Pie Town present. Powerful symbol that it had become, the nineteenth-century log home was never intended as anything but a temporary dwelling. Once constructed, it was often replaced by a second-generation structure that involved finished work by skilled artisans or itinerant carpenters. Many of Pie Town's homesteaders had in fact already moved out of their crude log houses, in some cases retaining

73. Russell Lee,
Mrs. George Hutton,
Pie Town, New
Mexico, June
1940 (FSA-LC).

one room log house." To underscore his point, Lee lavished great care in composing a photograph of their first log dwelling, against which are arrayed a collection of hand tools obviously intended to demonstrate their mastery of the critical first stage of modern culture (see figure 72). Ironically, the newer adobe dwellings that Lee ignored were examples of an architectural style rich with historic and regional meaning. "Adobe," claimed New Mexico's WPA guidebook, had been "used from time immemorial." Even the regional headquarters of the National Park Service, the agency that administered much of the land near Pie Town, was housed in a recently constructed adobe building.[38]

Lee believed that the challenge of a rugged environment created hardy individuals, but he was also confident that it fostered cohesive families. Lee presented Pie Town's pioneers as resourceful people bound together by a reverence for tradition and religion. George Hutton's family served as Lee's model. Inside their home he took pictures of their family album, including images of the ancestral farm in Oklahoma. Lee did not portray the Huttons as destitute Okies driven from their land by drought and mechanization but as well-to-do farmers who came to Pie Town by choice to take advantage of the large homestead allotments. Once in New Mexico, they quickly learned the lessons of the land. Lee portrayed George Hutton and his son as skilled hunters, avid students of Indian lore, inventive farmers, and masters of log construction. At home in the wilderness, they also spent time in the workshop, perfecting tools for taming the arid environment. Where the Hutton males exemplified qualities of inventiveness and adaptability, Mrs. Hutton represented conservation of family and religious tradition (see figure 73). Lee's pictures show this pioneer wife and mother attending to precious ancestral memorabilia, gazing intently at the family Bible, and displaying the homemade preserves in her well-stocked pantry.

The themes of solidarity and nurturance appear repeatedly in Lee's photographs of Pie Town's families gathered at the dinner table. The emphasis here is on plenty, a sharp contrast to the deprivation dramatized by Lange's *Migrant Mother*. Yet Lee

them as outbuildings. Ironically, the one man Lee did show building a log dugout was in fact relocating a structure that he had rented from a previous owner.[37]

Lee paid scant attention to the new homes that Pie Town's initial settlers had built to replace their log buildings. In his caption for a photograph of a "homesteader and his wife in the living room of their new adobe house," Lee stated emphatically that the couple had been in Pie Town for seven years before they had been able to upgrade their residence and during that time they had lived "in a

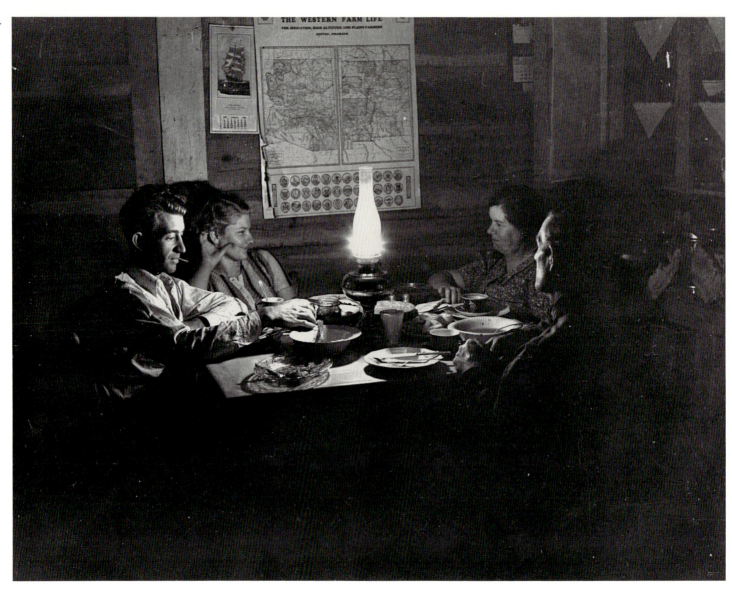

74. Russell Lee,
farm family,
Pie Town, New
Mexico, June
1940 (FSA-LC).

75. Russell Lee,
general store,
Pie Town, New
Mexico, June
1940 (FSA-LC).

did not intend his pictures of well-stocked larders and groaning tables to suggest excess. His captions abound with phrases such as "home-cured," "home-grown," "put-up by hand," and "hand-made." Lee's pioneers have progressed through the survival stage and achieved self-sufficiency. Bound together by this mission, they were not likely to be fragmented by the forces of modernization that disrupted family life in Middletown. Indeed one of the most artistic images in the Pie Town file shows a family gathered around the table, their after-dinner conversation illuminated by the light of the traditional oil lamp (see figure 74).

From the land and the family, Lee proceeded to the village itself. Although officially credited with a population of only fifty, Pie Town appears in Lee's photographs as a vital, cohesive community with a wide range of communal and cultural institutions. To create this impression, Lee deliberately employed frontal-perspective closeups. Lee placed the general store at the center of Pie Town's commercial life. He began by showing the owner, Mr. Keele, posed in the front door, flanked by modern advertising posters and the matching mileage boards that listed distances to better-known places such as Santa Fe and Denver (see figure 75).

76. Russell Lee,
horseman,
Pie Town, New
Mexico, June
1940 (FSA-LC).

77. Russell Lee, log building, Pie Town, New Mexico, June 1940 (FSA-LC).

This photograph reflects the prevailing FSA determination to show how deeply such symbols of national commerce and mobility had penetrated the interior of the country. While featuring Pie Town's links with the nation at large, Lee was not trying to suggest that the pioneers were restless and eager to move on. Quite the contrary. Modern transport was bringing the world to their doorstep without disrupting their noble experiment. Huge delivery trucks brought essential produce to the general store. The daily "stage" (in fact a modern automobile) brought mail to Pie Town's U.S. Post Office, from whence the homesteaders obtained correspondence and national magazines, such as the one tied behind a farmer's saddle for the trip home (see figure 76).

In this photograph of the farmer on horseback and in other images of Pie Town's transport, Lee eschewed subtlety. He was intent on demonstrating that these farmers were so secure in their commitment to a pioneer experiment that they could not be lured by the adventure of the road or the prospect of owning the type of modern machines advertised on the back cover of the magazine. Not that Pie Town's pioneers were opposed to automobiles; without their machines they would never have been able to move across the divide. But once settled on the land, the family might well convert the car into a makeshift tractor or use its doors as part of their log buildings (see figure 77).

Lee saw no apparent contradiction between Pie Town's consumption of national products and its

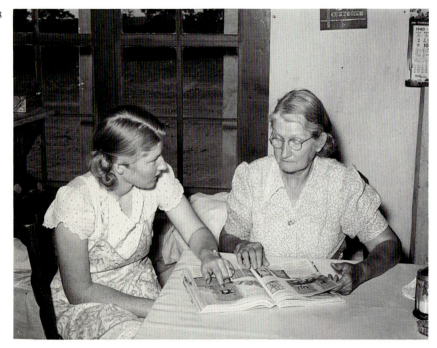

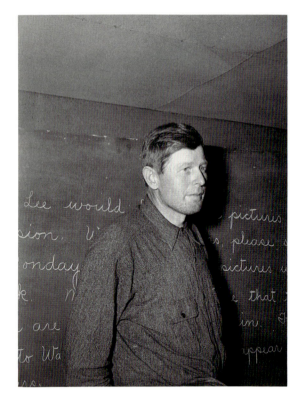

78. Russell Lee,
farm family,
Pie Town, New
Mexico, June
1940 (FSA-LC).

79. Russell Lee,
farmers' meeting,
Pie Town, New
Mexico, June
1940 (FSA-LC).

commitment to self-sufficiency. Indeed he suggested that the constant use of homemade goods made the farmers intelligent consumers. Having learned the lessons of frontier economics—how to get by on bare necessities—they were in no danger of being seduced by luxurious nonessentials. Lee recorded a posed image of a mother and daughter perusing a mail-order catalogue but stated in the caption that their purchases were limited to such necessary items as "household equipment and bought clothing" (see figure 78).

Lee was less successful in his attempts to depict Pie Town as a model of frontier democracy. Despite his claim that the monthly meeting of the Farm Bureau provided a forum where "all local problems from farm questions to state and county politics are studied," his photograph of the event reveals little active discussion and virtually no attendance. "This is only part of the gathering," Lee wrote defensively.[39] In reality, the farmers appear to have been summoned solely to facilitate Lee's photography. A blackboard behind this small group contains the evening's agenda: instructions to assemble the town's children for a picture session and assurances that Lee's photographs would be "sent to Washington" where they would "appear in magazines and newspapers" (see figure 79).

If unsuccessful in documenting an actual town meeting, Lee was able to present other social activities as examples of a vibrant community spirit. His portrait *Jigger at the Square Dance* has become one of his best-known images (see figure 80). At this lively event, Lee recorded more than the frenzy of the dancers; he carefully noted the quilting frame tied above their heads. Throughout his stay in Pie Town, Lee featured quilts as evidence of continuity with rural traditions and examples of cooperative enterprise among the women of the community. Lee extended this theme in his portraits of the women "putting out the refreshments of cakes, cookies and lemonade." At the same time, he could not resist a visit to the back room where he showed the males "having a bottle of beer."[40]

To Lee, this festive evening seemed a perfect example of democratic communality, an idea he may

80. Russell Lee,
*Jigger at
the Square Dance*,
Pie Town, New
Mexico, June
1940 (FSA-LC).

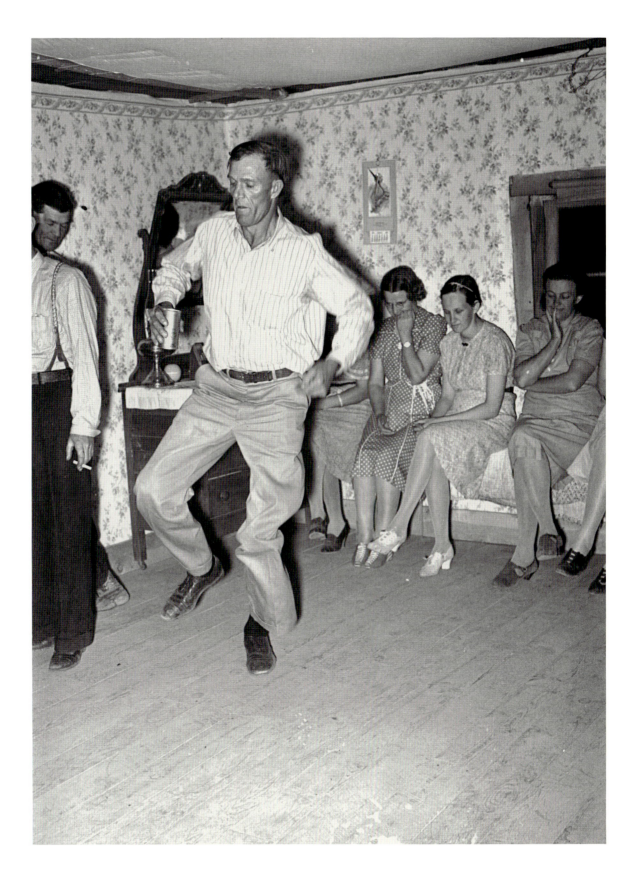

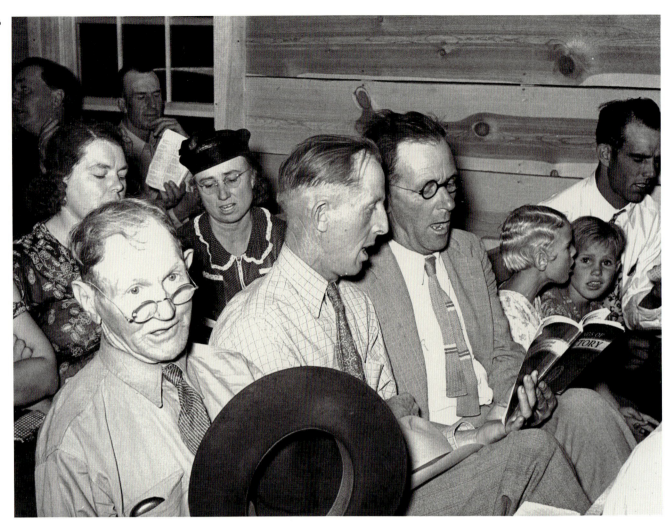

81. Russell Lee,
community sing,
Pie Town, New
Mexico, June
1940 (FSA-LC).

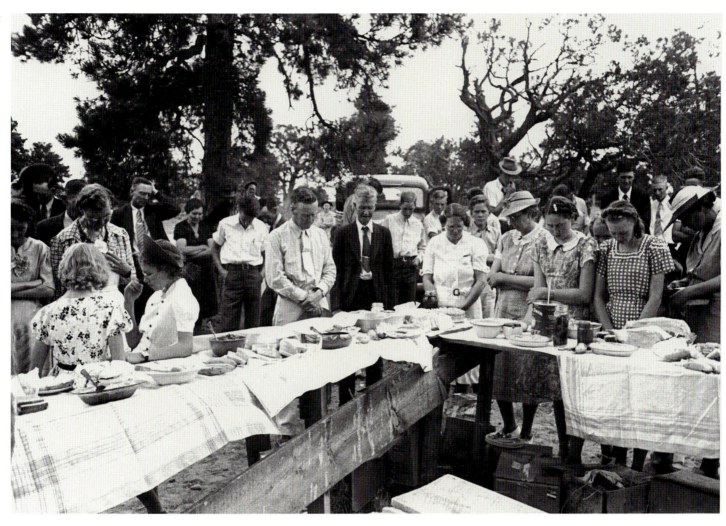

82. Russell Lee,
community supper,
Pie Town, New
Mexico, June
1940 (FSA-LC).

82. Russell Lee, community supper, Pie Town, New Mexico, June 1940 (FSA-LC).

well have borrowed from the famous square dance sequence in the film version of *The Grapes of Wrath* (1940). Pie Town residents remember the dances differently. High spirits to be sure, but of a less law-abiding sort. "There was plenty of bootleggers in this country," one old-timer recalled. "There was very little law and it was good money, ready money. Them old boys would go to these dances and they'd make quite a few dollars selling whiskey."[41] No doubt the bootleggers chose to stay away the night of Lee's visit.

If the square dances sometimes revealed collective frenzy, the community sing was a model of social cohesion and civic cooperation (see figure 81). In the dozens of pictures that he took at this event, Lee showed the homesteaders in close harmony with one another and in keen competition with singers from a nearby town. The Farm Bureau meeting had been sexually segregated but the sing involved men, women, and children of all ages. Held in Pie Town's church, this all-day event was followed by an outdoor community supper (see figure 82). As in his previous pictures of home life, Lee stressed the abundance of food in a community that he again praised for its self-sufficiency. Spread out before the residents were baked goods, casseroles, and homemade preserves. Lee tried to show that each family contributed to the occasion. His portrait of the homesteaders saying grace was a master stroke because it endowed Pie Town with

a religious aura lacking in his pictures of formal church services, where vacant seats were more notable than the piety of the worshippers.[42]

Russell Lee left New Mexico in the summer of 1940 and spent the next year trying to find a publisher for his Pie Town story. He considered the assignment so significant that he and his wife wrote a six-thousand-word text to accompany the pictures. Stryker tried to place the story in both *Collier's* and *Readers' Digest*, but to no avail. Well over a year elapsed before a reduced version of the Pie Town story appeared in *U.S. Camera*. Lee's article contained forty-five pictures, the largest collection accorded a single FSA staffer by a major photography magazine. The text revealed Lee's indebtedness to both Lewis Mumford and J. Russell Smith. "In Pie Town we could apply a twentieth century camera to a situation more nearly typical of the eighteenth century," Lee wrote, revealing yet again his belief that the picture-taking process was akin to the collection of scientific data.[43]

Lee's article affords one last glimpse of the peace-time rationale that Stryker had perfected since 1935, replete with familiar defenses that World War II would quickly render obsolete. "I was hired by a democratic government to take pictures of its land and its people," Lee wrote in explaining his presence in Pie Town. Perhaps fearful that the word "democratic" might not allay suspicions of government sponsorship, Lee quickly added that FSA photographers were public servants helping the nation find and preserve a usable past. "The Historical Section is accumulating a file of pictures which may endure to help the people of tommorow understand the people of today, so they can carry on more intelligently." But Lee thought of the present as well, and especially of the people in the tiny New Mexico village where he had discovered "the last frontier." He had earned their trust, he believed, by telling them that they had nothing to fear from a government photographer whose only intent was an honest presentation of the facts. "To the people of Pie Town I said with exact truth, 'I want to show the rest of the country how you live.'"[44]

Notes

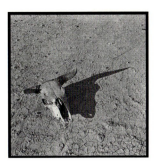

PREFACE

1. To avoid confusion the single term "FSA" is used throughout, even though several federal bureaucracies were involved. Stryker's photographic project was created in 1935 under the historical section of the Information Division of the Resettlement Administration (RA), an agency established in the spring of 1935 by President Franklin Roosevelt and headed by his controversial adviser, Rexford Tugwell. Following Tugwell's resignation late in 1936, Stryker's photographic unit was transferred to the Department of Agriculture and lodged under the Farm Security Administration (FSA). Stryker continued to report to the FSA until 1942, when his unit was reassigned once again, this time to the Office of War Information. By the fall of 1943, Stryker had lost most of his original staff. Fearing for the safety of his photographs, he arranged for their transfer to the Library of Congress, where they have remained to this day. Stryker resigned from government service following this relocation of the file.

2. Edward Steichen, "The F.S.A. Photographers," in *U.S. Camera Annual 1939*, ed. T. J. Maloney (New York, 1938), 44. There was no *U.S. Camera Annual* for the year 1938, which explains why the 1939 volume bears a 1938 publication date. Edward Steichen, curator, "The Family of Man," Museum of Modern Art, 1955, and "The Bitter Years: 1935–1941, Rural America as Seen by the Photographers of the Farm Security Administration," Museum of Modern Art, 1962.

3. Archibald MacLeish, *Land of the Free* (New York, 1938), 89. Foremost among modern scholars who argue for the objective nature of the FSA's photographic inquiry is F. Jack Hurley, *Portrait of a Decade: Roy Stryker and the Development of Documentary Photography in the Thirties* (Baton Rouge, La., 1972).

4. A. D. Coleman, "The Directorial Mode: Notes Toward a Definition," in *Photography in Print: Writings from 1816 to the Present*, ed. Vicki Goldberg (New York, 1981), 483–84. Walker Evans, "The Reappearance of Photography," in *Classic Essays on Photography*, ed. Alan Trachtenberg (New Haven, Conn., 1980), 185.

5. For a discussion of the rearrangement of the FSA file following World War II, see "A Note on Sources."

6. For a sophisticated study of the role of photographs in urbanization, see Peter B. Hales, *Silver Cities: The Photography of American Urbanization, 1839–1915* (Philadelphia, 1984). Hales's work has greatly informed my reconsideration of Stryker's apprenticeship at Columbia and the urban background that he shared with the photographers on his staff.

7. Roy Emerson Stryker and Nancy Wood, *In This Proud Land: America, 1935 to 1943 as Seen in FSA Photographs* (Greenwich, Conn., 1973), 9.

8. Allan Sekula, "On the Invention of Photographic Meaning," in Goldberg, *Photography in Print*, 455. Sekula's article should be read in conjunction with the work of Roland Barthes, particularly his *Image, Music, Text* (New York, 1974).

CHAPTER ONE

1. *New York Times*, April 18, 1938; publicity pamphlets for the First International Photographic Exposition at the Grand Central Palace, New York City, April 18–29, 1938, in Roy Stryker Collection, Photographic Archive, University of Louisville (hereafter cited as RSC).

2. List of photographs for the Grand Central exhibit, prepared by Arthur Rothstein and Russell Lee, RSC.

3. Farm Security Administration, response cards of people attending the Grand Central exhibit, April 1938; typed compilation in RSC. Elizabeth McCausland, "Rural Life in America as the Camera Shows It," Springfield (Mass.) *Sunday Union and Republican*, September 11, 1938, RSC.

4. The literature on the FSA photographic project is extensive and ably summarized in Penelope Dixon's *Photographers of the Farm Security Administra-*

tion: *An Annotated Bibliography, 1930–1980* (New York, 1983). For a discussion of the documentary style and the attendant issue of realism, see William Stott, *Documentary Expression and Thirties America* (New York, 1973). For a more recent discussion of these issues that incorporates excellent material on art and photography, see David Peeler, *Hope Among Us Yet: Social Criticism and Social Solace in Depression America* (Athens, Ga., 1987). The standard history of the FSA project is F. Jack Hurley, *Portrait of a Decade: Roy Stryker and the Development of Documentary Photography in the Thirties* (Baton Rouge, La., 1972). Hurley presumes that FSA images were shot solely for the record and therefore require no analysis. A similar bias mars the most useful collection of FSA images: Hank O'Neal, *A Vision Shared: A Classic Portrait of America and Its People, 1935–1943* (New York, 1976).

5. Roger D. Abrahams, "Moving in America," *Prospects* 3 (1977): 63.

6. Public response cards, April 1938, RSC.

7. Hurley, *Portrait of a Decade*, 3–16.

8. Rexford Guy Tugwell, Thomas Munro, and Roy E. Stryker, *American Economic Life and the Means of Its Improvement* (New York, 1925, 1930), 131, 218, 238, 59. The only comprehensive account of Tugwell's career is Bernard Sternsher, *Rexford Tugwell and the New Deal* (New Brunswick, N.J., 1964).

9. J. Russell Smith, *North America: Its People and the Resources, Development, and Prospects of the Continent as an Agricultural, Industrial, and Commercial Area* (New York, 1925).

10. Smith, *North America*, 4, 587. The only work to treat Smith's career and writings is Virginia M. Rowley, *J. Russell Smith: Geographer, Educator and Conservationist* (Philadelphia, 1964). The relationship between Smith and Stryker is discussed in Charles A. Watkins, "The Blurred Image: Documentary Photography and the Depression South" (Dissertation, University of Delaware, 1982), 57–63.

11. The most recent and provocative assessment of Hine is Peter Seixas, "Lewis Hine: From 'Social' to 'In-terpretive' Photographer," *American Quarterly* 39 (Fall 1987): 381–409. See also Judith Mara Gutman, *Lewis Hine and the American Social Conscience* (New York, 1967), and Walter Rosenblum et al., *America and Lewis Hine: Photographs 1904–1940* (New York, 1977).

12. Lewis Hine, "Social Photography: How the Camera May Help in the Social Uplift," *Proceedings, National Conference of Charities and Corrections* (June, 1909), reprinted in *Classic Essays on Photography*, ed. Alan Trachtenberg (New Haven, Conn., 1980), 111–12.

13. Lewis Hine, *Men at Work: Photographic Studies of Men and Machines* (New York, 1932), xi.

14. Tugwell, Munro, and Stryker, *American Economic Life*, 98, 189, 649. For a sensitive examination of the last image see Seixas, "Lewis Hine," 397–98. For a different interpretation of the relationship between Tugwell and Stryker that also concentrates on the Hine photographs, see two recent articles by Maren Stange: "'Symbols of Ideal Life': Technology, Mass Media, and the FSA Photography Project," *Prospects* 11 (1987): 81–104, and "The Management of Vision: Rexford Tugwell and Roy Stryker in the 1920s," *Afterimage* (March 1988): 6–10.

15. Roy Stryker to Lewis Hine, November 11, 1935, and July 24, 1936, RSC.

16. Of the many books that discuss Tugwell and the Resettlement Administration, the two most useful are Paul Conkin, *Tomorrow a New World: The New Deal Community Program* (Ithaca, N.Y., 1959), and Sternsher, *Rexford Tugwell and the New Deal*. On the formation of the project and Stryker's relationship with Tugwell, see Hurley, *Portrait of a Decade*.

17. Chapter 4 discusses Lorentz and the influence of his pioneering documentary film, *The Plow That Broke the Plains*.

18. Hurley, *Portrait of a Decade*, 38–40.

19. Roy Stryker to Walker Evans, December 10, 1935; Stryker to Evans, (1936?); Stryker to Dorothea Lange, May 17, 1938; RSC.

20. Transcribed interview of Arthur Rothstein by Richard K. Doud, Archives of American Art, Detroit (May 25, 1964), 11.

21. Roy Emerson Stryker and Nancy Wood, *In This Proud Land: America, 1935 to 1943 as Seen in FSA Photographs* (Greenwich, Conn., 1973), 8.

22. Beaumont Newhall, transcriber, "Walker Evans, Visiting Artist: A Transcript of His Discussion with the Students of the University of Michigan, 1971," in his *Photography: Essays and Images* (New York, 1980), 315–17.

23. Stryker and Wood, *In This Proud Land*, 8–9.

24. O'Neal, *A Vision Shared*, 267–69.

25. Rothstein-Doud interview, 5.

26. Evans quoted in Newhall, *Photography*, 317.

27. James Agee and Walker Evans, *Let Us Now Praise Famous Men* (Boston, 1941, 1960).

28. Walker Evans, *American Photographs, with an Essay by Lincoln Kirstein* (New York, 1938). Public response cards and list of photographs, Grand Central exhibit, April 1938, RSC.

29. Agee and Evans, *Let Us Now Praise Famous Men* (1941 edition). The two Evans prints appear on facing pages as the fourteenth and fifteenth images in an unnumbered portfolio at the beginning of their book. Chapter 2 discusses Evans's efforts to disguise the fact that he posed his subjects.

30. Roy Stryker to Dorothea Lange, September 18, October 30, 1935; January 3, 1936; RSC. Lange's working relationship with Stryker is discussed in Chapter 3. See also Karin Becker Ohrn, *Dorothea Lange and the Documentary Tradition* (Baton Rouge, La., 1980), 53–98.

31. Interview of Dorothea Lange by Suzanne Riess, 1960–1962, "Dorothea Lange: The Making of a Documentary Photographer" (typescript from the Regional Oral History Office, Bancroft Library, University of California, Berkeley, 1968), 170–72 (hereafter cited as Lange-Riess interview).

32. Of the many works that consider Dorothea Lange's photography, Robert

Coles's essay in his *Dorothea Lange: Photographs of a Lifetime* (New York, 1982) provides the most sensitive reading of Taylor's influence on Lange's field work. On Taylor's own use of the camera, see Richard Steven Street, "Paul S. Taylor and the Origins of Documentary Photography in California, 1927–1934," *History of Photography* 7 (October–December 1983): 293–304. The most severely cropped versions of this photograph appear in Hurley, *Portrait of a Decade*, 19, and Stryker and Wood, *In This Proud Land*, 62. In reproducing the image on page 60 of her book *Dorothea Lange*, Karin Ohrn has left the original framing intact so that Taylor is seen in half profile.

33. Lange-Riess interview, 159. Chapter 3 provides a complete description of the Migrant Mother series.

34. Lange was released in October 1936, ostensibly because of budget restrictions during the final months of FDR's reelection campaign. Yet Stryker's correspondence clearly indicates that he opened negotiations with Russell Lee at precisely the same time. Lange's severance and Lee's appointment occurred within the same week. Stryker knew that Carl Mydans was departing for the new *Life* magazine team and he could easily have kept Lange on the payroll instead of hiring the inexperienced Lee. For Hurley's confusing account of these comings and goings, see *Portrait of a Decade*, 78–80, 92–94. Lange-Riess interview, 174.

35. Dorothea Lange to Roy Stryker, December 7, 1938; Stryker to Lange, December 22, 1938; Lange to Stryker, May 16, 1939; Stryker to Russell Lee, June 13, 1939; Lee to Stryker, June 14, 1939; RSC. Dorothea Lange and Paul Schuster Taylor, *An American Exodus: A Record of Human Erosion* (New York, 1939).

36. Lange's bitterness and frustration with Stryker's emerging reputation as a founding father of the documentary movement is evident in a passage in her interview with Riess (169–70), to which Lange later appended a note saying that the section was unfair and needed to be revised. Following Lange's death, Paul Taylor added notes to some sections of the transcript but left this portion unchanged.

37. Interview of Vernon Evans by Bill Ganzel, July 18, 1977, in his *Dust Bowl Descent* (Lincoln, Neb. 1984), 24. Rothstein-Doud interview, 4.

38. Rothstein's letters to Stryker provide some information on his itinerary, but the main evidence comes from the photographic file. The captions for Rothstein's photographs provide approximate dates for each image and therefore make possible the reconstruction of his itinerary. Rothstein-Doud interview, 30.

39. Stryker and Wood, *In This Proud Land*, 11.

40. Stryker and Wood, *In This Proud Land*, 9–11. On the departures of Paul Carter and Theo Jung, see Hurley, *Portrait of a Decade*, 76–78, and O'Neal, *A Vision Shared*, 26–27.

41. Roy Stryker, "Documentary Photography," *The Complete Photographer: An Encyclopedia of Photography*, ed. Willard Morgan (20 vols, New York, 1941–43), 4:1364–74. Chapter 4 discusses the steer skull controversy in some detail.

42. Stryker and Wood, *In This Proud Land*, 14.

43. Robert S. Lynd and Helen Merrell Lynd, *Middletown: A Study in Modern American Culture* (New York, 1929). For a discussion of the influence of *Middletown* on the emergence of Stryker's small-town ideal, see Chapter 5.

44. Transcribed interview of Russell Lee by Richard K. Doud, Archives of American Art, Detroit (June 2, 1964), 4.

45. O'Neal, *A Vision Shared*, 136.

46. Exhibition list, Grand Central exhibit, RSC. The apportionment of individual photographs is: Lee twenty-four, Rothstein twenty, Lange fifteen, Shahn eight. The rest are scattered among Mydans, Carter, Jung, and Vachon. The sole Evans picture is discussed earlier in this chapter.

47. Lee's photographs of the logging camp near Effie, Minnesota, are in lot 1143 of the FSA collection (microfilm).

48. Lee, photograph 11352-M1, September 1937, FSA collection.

49. Roy Stryker to Arthur Rothstein, July 8, 1940, RSC.

CHAPTER TWO

1. James Agee and Walker Evans, *Let Us Now Praise Famous Men* (Boston, 1941, 1960), 15.

2. Walker Evans, *American Photographs, with an Essay by Lincoln Kirstein* (New York, 1938); William Carlos Williams, "Sermon with a Camera," *New Republic* 96, no. 10 (October 12, 1938): 282; M. D., "Evans' Brilliant Camera Records Modern America," *Art News* 37, no. 2 (October 8, 1938): 12–13; E. A. Whiting, Jr., "Walker Evans," *Magazine of Art* 31, no. 12 (December 1938): 721–22; Selden Rodman, "The Poetry of Poverty," *Saturday Review of Literature* 24, no. 34 (August 23, 1941): 6. For a contemporary assessment of *American Photographs* that echoes most of these sentiments see Andy Grundberg, "An Evans Show, 50 Years Later," *New York Times*, January 19, 1989. Grundberg was reviewing the Museum of Modern Art's fiftieth anniversary retrospective of Evans's 1938 show. For a complete bibliography of works by and about Evans, see John Szarkowski, *Walker Evans* (New York, 1971), 183–89. See also two posthumous collections of Evans's photographs published by the estate of Walker Evans: *Walker Evans: First and Last* (New York, 1978) and *Walker Evans at Work* (New York, 1982).

3. "Puritan Explorer," *Time* December 15, 1947, 73.

4. Evans quoted in William Stott, *Documentary Expression and Thirties America* (New York, 1973), 269.

5. William Ferris, "Images of the South: Visits with Eudora Welty and Walker Evans," *Southern Folklore Reports* 1 (1977): 32. This publication contains an excellent bibliography, including some material that appeared after Szarkowski's *Walker Evans* (1971).

6. Agee and Evans, *Let Us Now Praise Famous Men*, 234, 13. Agee changed the surnames of the tenant families as follows: Tengle became Ricketts, Fields

became Woods, and Burroughs became Gudger. Since extant photographic captions refer to the tenants by their real names, those names are used hereafter.

7. On Evans's career in photography, see essays by Lincoln Kirstein in Evans, *American Photographs*, 187–95, and Szarkowski in *Walker Evans*, 9–20.

8. William I. Homer, ed., *Avant-Garde Painting and Sculpture in America, 1910–1925* (Wilmington, Del., 1975), 15; Walker Evans, "Photography," in *Quality*, ed. Louis Kronenberger (New York, 1969), 169–211.

9. Walker Evans, "When 'Downtown' Was a Beautiful Mess," *Fortune* 65, no. 1 (January 1962): 101–6. See two additional comments by Evans in "Come on Down," *Architectural Forum* 117, no. 1 (July 1962): 96–100, and in Leslie Katz, "Interview with Walker Evans," *Art in America* 59, no. 2 (March–April 1971): 85.

10. The most insightful analysis of the American Scene movement is Dickran Tashjian, *William Carlos Williams and the American Scene, 1920–1940* (New York, 1978); the most recent and provocative discussion of symbols and iconography of the 1930s is Karal Ann Marling, *Wall-to-Wall America: A Cultural History of Post Office Murals in the Great Depression* (Minneapolis, 1982). See also Matthew Baigel, *The American Scene: American Painting in the 1930s* (New York, 1974); Nancy Heller and Julia Williams, *The Regionalists* (New York, 1976); Wanda Corn, *Grant Wood: The Regionalist Vision* (New Haven, 1983); Joseph S. Czestochowski, *John Steuart Curry and Grant Wood: A Portrait of Rural America* (Columbia, Mo., 1981); David Shapiro, *Social Realism: Art as Weapon* (New York, 1973); and David Peeler, *Hope Among Us Yet: Social Criticism and Social Solace in Depression America* (Athens, Ga., 1987).

11. For instance, see Evans, *American Photographs*, 19, 21, 25, 27, 35, 39, 55, 59, 79, 89, 103, 117, 139, 143, 147, 163, 171.

12. Lloyd Goodrich, *Edward Hopper* (New York, 1971), 99–101.

13. Martin Greif, *Depression Modern: The Thirties Style in America* (New York, 1975), 31–32. See also Donald J. Bush, *The Streamlined Decade* (New York, 1975); Jeffrey Meikle, *Twentieth Century Limited: Industrial Design in America, 1925–1939* (Philadelphia, 1979), and Richard Guy Wilson, *The Machine Age* (Brooklyn, 1986).

14. Berenice Abbott, *A Guide to Better Photography* (New York, 1941), 66–68.

15. *Time*, December 15, 1947, 73.

16. Agee and Evans, *Let Us Now Praise Famous Men*, 364.

17. Ibid.

18. *Walker Evans: Photographs for the Farm Security Administration, 1935–1938*, introduction by Jerald C. Maddox (New York, 1973; hereafter cited as *Evans: Farm Security Photographs* with reference to photographs by catalogue number. The Library of Congress has not issued similar catalogues for the other FSA photographers. Yet their original assignments can be reconstructed by using the OWI microfilm of the entire FSA print collection (Washington, 1943–44). On the nature of this microfilm see A Note on Sources.

19. *Evans: Farm Security Photographs*, nos. 5–8, 23–28. On the photography of Ben Shahn, see Margaret Weiss, ed., *Ben Shahn, Photographer* (New York, 1973).

20. *Evans: Farm Security Photographs*, nos. 200, 201, 203, 204, 207, 208. Compare these with Edward Hopper's street scenes, especially his famous *Early Sunday Morning* (1930).

21. *Evans: Farm Security Photographs*, no. 241; Katz, "Interview with Walker Evans," 82.

22. *Evans: Farm Security Photographs*, nos. 205, 206.

23. Ibid., nos. 132, 133, 134, 171, 209, 210, 215, 216.

24. Ibid., nos. 129, 130. The catalogue identifies photograph no. 131, a cropped version of the scene in no. 130, as an original 4 x 5 negative. If so, it is the only 4 x 5 picture Evans took in Vicksburg. More likely it is a cropped 8 x 10 negative taken at the same time as no. 130. The reason for the cropping is not apparent.

25. Evans, *American Photographs*, 57. F. Jack Hurley, *Portrait of a Decade: Roy Stryker and the Development of Documentary Photography in the Thirties* (Baton Rouge, La., 1972), 61. There is a strong physical resemblance between the white man in the automobile and the one sitting on the bench; they may be the same individual.

26. *Evans: Farm Security Photographs*, nos. 305–12.

27. Ibid., no. 313.

28. Ibid., nos. 246–48, 250–54, 280–90, 295–303. The Fields family portrait is reproduced as Figure 2 in Chapter 1.

29. *Evans: Farm Security Photographs*, no. 269. In making this comparison, William Stott prefers the Evans photograph as "merely factual," arguing that Van Gogh "sentimentalized" his subject in a manner befitting Norman Rockwell. See Stott, *Documentary Expression*, 273.

30. For the second edition published in 1960, Evans decided to expand the number of photographs in *Let Us Now Praise Famous Men*. He might have used some of these 35mm. pictures but instead chose a number of 8 x 10 photographs from other assignments outside Hale County. The expanded collection has scenes from Selma, Greensboro, Moundville, Birmingham, and even a few pictures from Vicksburg, Mississippi. Evans quoted in Ferris, "Images of the South," 33.

31. Katz, "Interview with Walker Evans," 85.

32. *Evans: Farm Security Photographs*, no. 9. This may be the interior of the house shown in no. 12 in the catalogue, and therefore the room is most likely a hallway. The odd placement of the bureau beneath a picture further suggests that this scene may have been a temporary and abnormal arrangement.

33. Agee and Evans, *Let Us Now Praise Famous Men*, 156.

34. Ibid., 170–71; *Evans: Farm Security Photographs*, no. 267.

35. Agee and Evans, *Let Us Now Praise Famous Men*, 174.

36. Szarkowski, *Walker Evans*, 95.

37. These alterations can be seen by comparing Figure 17 with Evans's trial shot of the same scene, published in the posthumous collection, *Walker Evans: First and Last*, 78.

38. Agee and Evans, *Let Us Now*

Praise Famous Men, 172–73; *Evans: Farm Security Photographs*, no. 263. Evans also seems to have moved the calendar slightly and may have relocated the pincushion.

39. Agee and Evans, *Let Us Now Praise Famous Men*, 162–63; *Evans: Farm Security Photographs*, no. 262.

40. *Evans: Farm Security Photographs*, nos. 265, 260.

41. Agee and Evans, *Let Us Now Praise Famous Men*, 138, 150.

42. Ibid., 177, 180–82; *Evans: Farm Security Photographs*, no. 260.

43. Agee and Evans, *Let Us Now Praise Famous Men*, p. 178.

44. Ibid.; *Evans: Farm Security Photographs*, no. 264.

45. Katz, "Interview with Walker Evans," 87–88.

46. Agee and Evans, *Let Us Now Praise Famous Men*, 210.

CHAPTER THREE

1. Roy Emerson Stryker and Nancy Wood, *In This Proud Land: America, 1935–1943, as Seen in the* FSA *Photographs* (Greenwich, Conn., 1973), 19.

2. George P. Elliott, *Dorothea Lange* (New York, 1966), 7. The best studies of Lange's life are Milton Meltzer, *Dorothea Lange: A Photographer's Life* (New York, 1978), and Karin Becker Ohrn, *Dorothea Lange and the Documentary Tradition* (Baton Rouge, La., 1980). In addition to Elliott, *Lange*, the best collections of Lange's photographs are Therese Thau Heyman, *Celebrating a Collection: The Work of Dorothea Lange* (Oakland, Calif., 1978); Robert Coles, *Dorothea Lange: Photographs of a Lifetime* (New York, 1982); and Dorothea Lange and Paul Schuster Taylor, *An American Exodus: A Record of Human Erosion* (New York, 1939).

3. The source for this translation is a memorial tribute to Lange by Wayne Miller, reproduced on page 245 of "Dorothea Lange, The Making of a Documentary Photographer," interview by Suzanne Riess, 1960–1962 (Regional Oral History Office, Bancroft Library, University of California, Berkeley, 1968) (hereafter Lange-Riess interview). If

this was the exact quotation that Lange pinned to her darkroom door it was a loose translation of section 129 in Bacon's *Novum Organum*. Most translators agree that the wording of the second line should be "Without *superstition* or imposture" (emphasis added). The use of "substitution" implies that Lange might have adhered to an even stricter definition of observation than Bacon advocated, but one that is more relevant to the debate on the nature of the documentary method.

4. Lange to Stryker, February 28, 1939, Roy Stryker Collection, Photographic Archives, University of Louisville (hereafter RSC).

5. Dorothea Lange, "The Assignment I'll Never Forget: Migrant Mother," *Popular Photography* 46, no. 2 (February 1960): 42–43, 128.

6. Bryan B. Sterling, comp., *The Best of Will Rogers* (New York, 1979), 45.

7. See, particularly, Robert S. Lynd and Helen Merrell Lynd, *Middletown: A Study in Modern American Culture* (New York, 1929).

8. Lange, "Assignment," 42–43. While we cannot be sure of the exact order in which she took these photographs, Lange says that she worked closer with each picture. This would make the long shots the first two in the series and *Migrant Mother* the last. In analyzing the intervening three images, I will follow the order suggested in Ohrn, *Dorothea Lange*, 85–87.

9. In "Assignment" (pp. 42–43), Lange says that she "made five exposures," not six. Hank O'Neal, in *A Vision Shared: A Classic Portrait of America and Its People, 1935–1943* (New York, 1976), 76, locates the sixth photograph in the Oakland Museum but does not publish it. Heyman, *Celebrating a Collection* (n.p.), refers to a series of six photographs but reproduces only four. Coles, *Dorothea Lange* (p. 20), refers to the series as having only five photographs. That book (put out in part by the Oakland Museum) publishes only the five now in the Library of Congress, as does Ohrn, *Dorothea Lange*, 79–88. The sixth picture appears without comment, along

with the other five from the series, in an article by Lange's husband, Paul Taylor, "Migrant Mother: 1936," *American West* 7, no. 3 (May 1970): 41–47.

10. This quote is from the caption of FSA print (neg. 9098C) in the Library of Congress.

11. Most authors, including F. Jack Hurley in *Russell Lee: Photographer* (Dobbs Ferry, N.Y., 1978), 48, identify the Iowa town as Smithfield, in contradiction of the caption on FSA neg. 10125D; Smithland is the proper name. It is located near the Little Sioux River about twenty-five miles southwest of Sioux City, Iowa. A companion photograph (FSA neg. 1133-M1) shows the mother of the family with two of the children.

12. Paula Fass, *The Damned and the Beautiful: American Youth in the 1920's* (New York, 1977), 53–118. The average family size appears even smaller in U.S. Department of Commerce, *Historical Statistics of the United States* (Washington, D.C., 1976), 1: 41. The difference is a result of the government's use of a definition of "household" that included families without children and families in which children were grown and no longer living with their parents.

13. Lange-Riess interview, 80.

14. On the importance of religion in popular literature and culture during the Depression, see Warren Susman, *Culture and Commitment, 1929–1945* (New York, 1973). Irma Jaffe provides an excellent model for the analysis of religious symbolism in art of the Depression era in "Religious Content in the Painting of John Steuart Curry," *Winterthur Portfolio* 22 (Spring 1987): 23–45. For literature on art of the American Scene movement, see Chapter 2, note 10.

15. Maria Warner, *Alone of All Her Sex: The Myth and the Cult of the Virgin Mary* (New York, 1976), 223, 203. This is the most sensitive of the many works concerning the image of the Madonna in art and literature.

16. Lange-Riess interview, 16.

17. Lange and Taylor, *American Exodus*, 82–83.

18. Coles: *Dorothea Lange*, 62–64; Lange photographs, especially lot 344,

FSA collection, Library of Congress. These conclusions are the result of extended analysis of this image, revealing the following: the shadow details clearly show that the object is forward of the wagon; the child could not have thrown the object off the wagon and still returned her hands to her lap; the object could hardly have fallen forward unless there was a strong wind, and such a wind would have disturbed the clothing of subjects; the shadow detail indicates that the object is in motion and about to hit the ground; the object is about the size of a film holder. While Lange is taking the picture head on, she still might have used a cable release, allowing her to step aside and toss the object into the picture; or an assistant (Lange frequently had help from Taylor or friends) could have introduced the object while Lange stood ready to time her shutter release. The alternate view of this scene is not in the Library of Congress but is in Lange and Taylor, *American Exodus*, 64.

19. Warner, *Alone of Her Sex*, 23, 33.

20. Fass, *Damned and the Beautiful*, 88–89.

21. John Steinbeck, *The Grapes of Wrath* (New York, 1939), 463–64.

22. Ohrn, *Dorothea Lange*, 24.

23. Lange-Riess interview, 17–18.

24. Meltzer, *Dorothea Lange*, 133–34. For an early reproduction of *Migrant Mother* showing the thumb, see James L. McCamy, *Government Publicity: Its Practice in Federal Administration* (Chicago, 1939), facing p. 238. McCamy's book presented the government's use of photographs in a most favorable light. McCamy takes particular care to thank Stryker for helping him understand the nature of documentary photography (pp. ix, x). Lange to Stryker, May 16, 1939, RSC. For a discussion of the retouching incident, see F. Jack Hurley, *Portrait of a Decade: Roy Stryker and the Development of Documentary Photography in the Thirties* (Baton Rouge, La., 1972), 142–43; and Ohrn, *Dorothea Lange*, 102, 251 n. 18.

25. *New York Times*, August 24, September 17, 1983; *Los Angeles Times*, September 17, 1983.

CHAPTER FOUR

1. Hank O'Neal, *A Vision Shared: A Classic Portrait of America and Its People* (New York, 1976), 21. On Rothstein's background and work with Stryker, see (in addition to O'Neal) Richard K. Doud, interview with Arthur Rothstein (May 25, 1964), Archives of American Art, Detroit, and F. Jack Hurley, *Portrait of a Decade: Roy Stryker and the Development of Documentary Photography in the Thirties* (Baton Rouge, La., 1972). The most convenient published collections of Rothstein's Depression photographs are his *The Depression Years as Photographed by Arthur Rothstein* (New York, 1978) and *The American West in the Thirties* (New York, 1981).

2. Stryker to Rothstein, April 6, 1936, Roy Stryker Collection, Photographic Archives, University of Louisville (hereafter RSC).

3. Resettlement Administration, "Guide for Photography of the Land," RSC. Although undated, this manuscript must have been in effect during 1936, since the RA went out of existence shortly after the election in November 1936. Rothstein's Pennington County photographs can be found in lots 403 and 404, of the FSA collection (microfilm), at the Library of Congress.

4. J. Russell Smith, *North America: Its People and the Resources, Development, and Prospects of the Continent as an Agricultural, Industrial, and Commercial Area* (New York, 1925), 415. Rothstein may also have been familiar with the well-known painting *Cowskull, Red, White, and Blue* (1931) in which Georgia O'Keefe suspended a steer's skull against a background of broad stripes in the colors of the American flag. On O'Keefe's image see Lloyd Goodrich, *Georgia O'Keefe* (New York, 1970), 24.

5. Stryker to Rothstein, June 6, 1936, RSC.

6. Fargo *Evening Forum*, August 27, 1936, as quoted in *Time*, September 7, 1936, 36.

7. Edwin Locke to Rothstein, August 29, 1936, RSC.

8. C. B. Baldwin to Stryker and Stryker to Baldwin, October 23, 1936; undated photograph of a mock steer skull; postcard with the following superimposed over the picture of the steer skull: "200 miles from Water, 200 miles from Town, Merry Christmas"; RSC.

9. Stryker to Lange, August 25, 1936, RSC. Stryker to Harry Carman, July 24, 1936, October 20, 1936, RSC.

10. Quoted in Hurley, *Portrait of a Decade*, 90; *Detroit Free Press*, quoted in Penelope Dixon, *Photographers of the Farm Security Administration: An Annotated Bibliography, 1930–1980*, (New York, 1983), 137. Dixon mentions "a few" examples of the numerous newspaper stories devoted to the skull controversy; her list runs more than two pages.

11. O'Neal, *A Vision Shared*, 20–22; Hurley, *Portrait of a Decade*, 40, 84–92. William Stott, *Documentary Expression and Thirties America* (New York, 1973), 61, 269.

12. Among the works that consider *The Plow That Broke the Plains* and America's documentary film movement, the most helpful are William Alexander, *Films on the Left: American Documentary Film from 1931 to 1942* (Princeton, N.J., 1981); Richard D. MacCann, *The People's Films: A Political History of U.S. Government Motion Pictures* (New York, 1973); Robert L. Snyder, *Pare Lorentz and the Documentary Film* (Norman, Okla., 1968); and Peter C. Rollins, "Ideology and Film Rhetoric: Three Documentaries of the New Deal Era (1936–1941)," in his *Hollywood as Historian: American Film in a Cultural Context* (Lexington, Ky., 1983), 32–48. See also the excellent pamphlet by John O'Connor, "Teaching History with Film and Television" (American Historical Association, 1987), which includes extensive commentary on Lorentz's film.

13. In *Portrait of a Decade*, Hurley discusses Resettlement's formation and Stryker's early work but does not mention Pare Lorentz or RA's films. William Stott's decision to exclude discussion of documentary film constitutes a glaring weakness in his otherwise useful *Documentary Expression and Thirties America*. Snyder, *Pare Lorentz*, 28.

14. These early photographs of the Dust Bowl from the Soil Conservation Service and other sources are found in lot 264 of the FSA collection (microfilm). Alexander, *Films on the Left*, 96. That Lorentz may have been the motive force behind the first field photography is suggested in a letter from Walker Evans to an unknown individual, August 1935, RSC.

15. Lorentz shot footage in Nebraska of several Resettlement projects and intended these scenes as an epilogue to his film. Evidently, this section was cut because it was too blatant a presentation of government programs. The epilogue has been restored and can be seen in the videotape of *The Plow* released by the National Audio Visual Center. This epilogue is similar in tone and content to the conclusion of Lorentz's next film, *The River* (1937), which ends with a pictorial paean to the Tennessee Valley Authority.

16. Rothstein's several accounts of the background of this photograph can be found in Arthur Rothstein, "Direction in a Picture Story," in *The Complete Photographer: An Encyclopedia of Photography*, ed. Willard Morgan (20 vols., New York, 1941–43), 4: 1356–64, and "The Picture That Became a Campaign Issue," *Popular Photography*, September 1961, 42. Rothstein's unsuccessful attempt to reconcile the contradictions in these two accounts appears in his article "Setting the Record Straight," *Camera 35* (April 1978): 50–51. Bill Ganzel, *Dust Bowl Descent* (Lincoln, Neb., 1984), 6.

17. Rothstein to Roy Stryker, April 23, 1936, RSC. Stryker to Rothstein, April 13, 1936, RSC. By far the best account of the Dust Bowl, especially the Texas/Oklahoma Panhandle where both Lorentz and Rothstein worked, is the excellent treatment by Donald Worster, *The Dust Bowl: The Southern Plains in the 1930s* (New York, 1979).

18. Rothstein, "The Picture That Became a Campaign Issue," 42.

19. Rothstein, "Direction in a Picture Story," 1356.

20. Roy Stryker, "Documentary Photography," in Morgan, *Complete Photographer*, 4:1364–74, 1367. Stryker's description of the camera as a "terrifying instrument" may have been inspired by a similar phrase in *Let Us Now Praise Famous Men*, published the year before Stryker's article. See Chapter 2 for a discussion of this quote.

21. Worster, *Dust Bowl*, 18.

22. Rothstein, "Direction in a Picture Story," 1360.

23. Ibid.

24. On the process of destroying negatives or rendering them unprintable by punching holes in them, see O'Neal, *A Vision Shared*, 7.

25. Rothstein's denial appeared in "Setting the Record Straight," *Camera 35*, 22 (April 1978): 50–51. He claimed that he intended to use *Fleeing a Dust Storm* as a hypothetical example and that his original wording read: "The picture of the farmer and his sons could have been controlled in this way. The little boy could have been asked to drop back and hold his hand over his eyes. The farmer could have been asked to lean forward as he walked." Rothstein maintained that the editors changed his conditional tense to the more direct past tense. Significantly, Rothstein does not retract his statements about repetition of a scene, nor does he disavow the other examples of direction that he used as the basis for his 1942 essay. This hitherto unpublished photograph is the final proof that Rothstein did not suddenly look up from taking pictures of the farm and see the father and sons walking across the field. He knew precisely the kind of picture that he wanted and proceeded to work with the farmer until he achieved the desired results. He may have taken other practice pictures as well but they have either been destroyed or scattered in the negative file and are thus impossible to locate.

Rothstein may also have played an active role in creating a new copy negative of *Fleeing a Dust Storm* (US Z62 11491) that is now used to fill orders for prints of his famous picture. According to sources at the Library of Congress, Rothstein felt that prints from this new copy negative gave visual evidence of the dust storm that he alleged was in progress. Prints from this new negative are much darker and more somber in tone than those from the original file negative (LC-USF34-4052E), which now has a note attached saying "Do not copy."

26. Rothstein, "Direction in a Picture Story," 1360. Rothstein, "The Picture That Became a Campaign Issue," 42.

27. Worster, *Dust Bowl*, 42.

28. Ibid., 127, 161.

29. Rothstein to Stryker, April 23, 1936, RSC.

30. Arthur Rothstein, caption, photograph of a farmer in Cimarron County, Oklahoma, April 1936, neg. 4106C, FSA collection, Library of Congress. Rothstein reported that Farrell briefed him on the background of the area's residents and the improper techniques they used to cultivate the soil; Rothstein to Stryker, April 23, 1936, RSC.

31. Rothstein to Stryker, April 23, 1936, RSC. See Rothstein's photographs of project work in Cimarron County, lot 521, FSA photographs (microfilm), Library of Congress.

32. Ganzel, *Dust Bowl Descent*, 20–21.

CHAPTER FIVE

1. Works Progress Administration (WPA), *New Mexico: A Guide to the Colorful State* (New York, 1940), 358. The best treatment of Russell Lee's career is F. Jack Hurley, *Russell Lee: Photographer* (Dobbs Ferry, N.Y., 1978). See also Ann Mundy's videotape documentary, *Photographer: Russell Lee* (Austin, Tex., 1987), available from Ann Mundy & Assoc., P.O. Box 5354, Austin, Texas.

2. Lee to Stryker, May 30, 1940, Roy Stryker Collection, Photographic Archives, University of Louisville (hereafter RSC).

3. Rexford Guy Tugwell, Thomas Munro, and Roy E. Stryker, *American Economic Life and the Means of Its Im-*

provement, 3d ed. (New York, 1930), 465. Paul Conkin, *Tomorrow a New World: The New Deal Community Program* (Ithaca, N.Y., 1959), 264. Conkin's masterful work provides the most complete account of Tugwell's views on urban planning and the New Deal's experiments in community design.

4. Conkin, *Tomorrow a New World*, 265.

5. Hurley, *Russell Lee*, 9–14.

6. Evans may have taken more pictures during his visit with the Alabama sharecroppers, but he turned in less than a hundred to the file. Stryker to Lee, January 7, 13, 1937; Lee to Stryker, January 8, 1937, RSC.

7. Conkin, *Tomorrow a New World*, 268, 274.

8. Ibid., 273.

9. On Stryker's desire for before and after shots, see M. E. Gilford to Ralph Armstrong, October 28, 1936; Stryker to Lee, October 23, 1936; Lee to Stryker, December 12, 1936; RSC. Further evidence of Lee's difficulty in obtaining suitable "before" shots can be found in the photographs and captions for the Bronx series, lot 1292, FSA collection.

10. Conkin, *Tomorrow a New World*, 264.

11. Edwin Rosskam, *Roosevelt, New Jersey: Big Dreams in a Small Town and What Time Did to Them* (New York, 1972), 2–3.

12. The most thoughtful treatment of the Greenbelt program is in Conkin, *Tomorrow a New World*, 305–25. See also Joseph Arnold, *The New Deal in the Suburbs: The History of the Greenbelt Town Program, 1935–1954* (Columbus, Ohio, 1971); Phoebe Cutler, *The Public Landscape of the New Deal* (New Haven, 1985); and David Myrha, "Rexford Tugwell: Initiator of America's New Greenbelt Towns, 1935–1936," *Journal of the Institute of Planning* 40 (May 1974): 176–88.

13. The file photograph of November 1935 (neg. 1339D, FSA collection), shows Tugwell talking with two workers who appear to be planting a tree. This is one of the few photographs of Tugwell in the Greenbelt file and one of the only images that suggest reforestation activity.

14. Conkin, *Tomorrow a New World*, 202.

15. Ibid., 202–3, 312, 316–18.

16. Robert S. Lynd and Helen Merrell Lynd, *Middletown: A Study in Modern American Culture* (New York, 1929).

17. Stryker's "shooting scripts" can be found in the collection of his official papers at the University of Louisville. His notes on the meeting with Lynd are in the form of a script and are reprinted in his collaborative work with Nancy Wood: *In This Proud Land: America, 1935 to 1943 as Seen in FSA Photographs* (Greenwich, Conn., 1973), 187.

18. Stryker and Wood, *In This Proud Land*, 187; Lynd and Lynd, *Middletown*, 134–35, 251–64, 270.

19. Stryker and Wood, *In This Proud Land*, 187.

20. Ibid., 187; Lynd and Lynd, *Middletown*, 340–41, 478–81.

21. The refined and enlarged versions of the shooting script for the small town can be found in RSC.

22. For comparison, see Evans's picture of an Alabama movie theater, 1936, neg. 8235A. On Evans's penchant for graphics and lettering, see Chapter 2. In *Wall-to-Wall America: A Cultural History of Post Office Murals in the Great Depression* (Minneapolis, 1982), 98, 102, Karal Ann Marling provides a careful reading of Rothstein's photograph, but still leaves the impression that he sought only the "factual and true," and was not therefore responding to any preconceived notions. While the picture is, as she maintains, largely unposed, it is a direct response to the items on Stryker's shooting script for the small town.

23. Archibald MacLeish, *Land of the Free* (New York, 1938), 89. MacLeish's comment on the "sound track" is quoted in William Stott, *Documentary Expression and Thirties America* (New York, 1973), 212. Of the other picture books that preceded MacLeish's work, by far the most influential was Erskine Caldwell and Margaret Bourke-White, *You Have Seen Their Faces* (New York, 1937). For an evaluation of the documentary picture books of the 1930s that extends Stott's analysis see Jefferson Hunter, *Image and Word, the Interaction of Twentieth-Century Photographs and Texts* (Cambridge, Mass., 1987). Unfortunately Hunter pays little attention to Sherwood Anderson's *Home Town*.

24. The most recent and in many respects the best biography of Anderson is Kim Townsend, *Sherwood Anderson* (Boston, 1987). While recognizing the significance of Anderson's journalistic writings of the 1930s, Townsend, like many previous critics, dismisses his collaboration with Stryker. Townsend views *Home Town* as an exercise in myth making.

25. Sherwood Anderson, *Home Town*, in *The Face of America*, ed. Edwin Rosskam (New York, 1940), 5, 9, 22. Rosskam joined Stryker's staff in the late 1930s and was responsible for a number of publications, including *Home Town* and *Twelve Million Black Voices* (New York, 1941), in which he used FSA photographs to illustrate a text by Richard Wright. Russell Lee took many of these pictures during a special trip to Chicago.

26. Anderson, *Home Town*, 140, 142.

27. Stryker to Lee, April 7, 1939; Lee to Stryker, April 11, 1939; RSC.

28. On the fascination with streamlining see Donald J. Bush, *The Streamlined Decade* (New York, 1975), and Martin Greif, *Depression Modern: The Thirties Style in America* (New York, 1975). At the entrance to the New York World's Fair in 1939, gate receipts from each paying customer were registered on a giant cash register.

29. Works Progress Administration, *Texas: A Guide to the Lone Star State* (New York, 1940), 382.

30. See Lee's picture of the superintendent, neg. 33064D, FSA collection. This image is also reproduced in Anderson's *Home Town*, 144. Lee to Stryker, April 19, 1939, RSC. On hookworm and the stigma associated with this disease, see John Ettling, *The Germ of Laziness: Rockefeller Philanthropy and Public Health in the New South* (Cambridge, Mass., 1981).

31. Anderson, *Home Town*, 144.

32. J. Russell Smith, *North America: Its People and the Resources, Development, and Prospects of the Continent as an Agricultural, Industrial, And Commercial Area* (New York, 1925); Lee to Stryker, May 5, 30, 1940; Stryker to Lee, September 20, 1940; RSC.

33. WPA, *New Mexico*, 362; Smith, *North America*, 564–65, 579–81.

34. Russell Lee captions for Pie Town photographs (microfilm reel 45), FSA collection. See especially negs. 12779-M3 and 36595D.

35. Lewis Mumford, *Technics and Civilization* (London, 1934), 79, 81. On Lee's views on Mumford see Lee to Stryker, November 15, 1938, RSC. F. Jack Hurley first drew my attention to Mumford's influence in an unpublished paper delivered at the Citadel Conference on the South in April 1985.

36. Lee caption for Pie Town photograph, neg. 12778-M3, FSA collection.

37. Terry Jordan, *American Log Buildings* (Chapel Hill, N.C., 1985), 14–15. Lee captions for Pie Town photographs, negs. 36905D and 12733-M1, FSA collection.

38. Lee caption for Pie Town Photograph, neg. 36859D, FSA collection. WPA, *New Mexico*, 149, 154–55.

39. Lee caption for Pie Town Photograph, neg. 36553D, FSA collection.

40. Lee caption for Pie Town Photograph, neg. 36898D, FSA collection. For quilt images, see for instance Lee's Pie Town photographs, negs. 36692D, 36659D, 36693D, and 36694D, FSA collection.

41. Bill Ganzel, *Dust Bowl Descent* (Lincoln, Neb., 1984), 87.

42. See for instance Lee's Pie Town photographs, negs. 12775 and 12800, FSA collection.

43. Lee to Stryker, May 4, 1940; September 27, 1940; Stryker to Lee, September 20, 1940; April 23, 1941; June 6, 1941; RSC. Russell Lee, "Pie Town, New Mexico. Life on the American Frontier, 1941 Version," *U.S. Camera* (October 1941): 39–54, plus photographic portfolio.

44. Lee, "Pie Town, New Mexico," 39, 54.

A Note on Sources

This brief essay comments on some of the most important primary and secondary sources for this volume; it does not include reference to all works cited in the notes. Readers wishing a comprehensive guide to the literature on Roy Stryker and the major FSA photographers should consult Penelope Dixon, *Photographers of the Farm Security Administration: An Annotated Bibliography, 1930–1980* (New York, 1983).

The Farm Security Administration photographs constitute the most basic evidence for this study. Since 1943, the FSA print and negative files have been stored at the Library of Congress and have attracted considerable attention from both historians and picture researchers. Neatly mounted on gray cards, the prints are magnificent to behold but difficult to use because a postwar reorganization divided the file into 1,300 subject categories, thereby destroying much of the original arrangement by region and assignment. Fortunately, the Office of War Information (OWI) microfilmed all 80,000 prints shortly after absorbing Stryker's project during World War II. These 108 reels of microfilm reproduce the file as originally arranged: by state, within each state by lot number, and within each lot by assignment, date, and photographer.

In his recent essay "From Image to Story: Reading the File," Alan Trachtenberg provides an incisive analysis of the philosophy underlying the rearrangement of the print file in the Library of Congress. Trachtenberg's essay appears in *Documenting America: 1935–1943*, ed. Carl Fleischhauer and Beverly W. Brannan (Berkeley, Cal., 1988), 43–73.

Using this microfilm, one can reconstruct the FSA field assignments, placing such famous photographs as Dorothea Lange's *Migrant Mother* and Russell Lee's *Christmas Dinner in Iowa* alongside companion images. Since all of Stryker's photographers took series of pictures as a matter of course, comparing frames within a series is essential to understanding intent. Such comparison also provides insights into the preconceptions that Stryker and his staff brought to field work and the meanings they assigned to the finished photographic prints. Walker Evans's field work can also be reconstituted by consulting *Walker Evans: Photographs for the Farm Security Administration, 1935–1938* (New York, 1973), a work prepared by the staff of the Library of Congress. This volume presents all of Evans's FSA prints, arranged by date and location. More than 1,300 of Dorothea Lange's photographs and original captions are reproduced in the microfiche portion of *Dorothea Lange: Farm Security Administration Photographs: 1935–1939* (2 vols., Glencoe, Ill., 1981). Although valuable as a research tool, this microfiche is no substitute for the OWI microfilm, which contains all of Lange's file photographs.

FSA photographs provide a much more reliable guide to individual field assignments than

either correspondence or personal interviews, the main sources for previous scholarly treatments of Stryker's project. The Roy Stryker Collection (located in the photographic archive at the University of Louisville) includes personal and official correspondence as well as the original shooting scripts for the small-town studies and other key assignments. Although Stryker was an avid correspondent, he and his photographers rarely discussed individual images.

The Stryker Collection also contains copies of publications that first printed file photographs. Many of these volumes, such as *The Annual Report of the Resettlement Administration* (Washington, 1936), are now difficult to obtain. Stryker also saved materials relating to such major FSA exhibits as "How American People Live" (1938). Stryker's papers contain transcriptions of the more than five hundred response cards submitted by viewers of this important show at New York's Grand Central Palace. Stryker did not maintain extensive administrative files although he did record the number of photographs distributed each month. Part of his cost-effective approach to photography, this accounting was designed to defend the file and is therefore a misleading index to the actual circulation of FSA prints. These administrative records are available on microfilm from the Archives of American Art.

Although conducted long after the fact, personal interviews have hitherto been a major source of evidence for analysis of FSA photography. Indeed, the two standard histories of Stryker's project—F. Jack Hurley's *Portrait of a Decade: Roy Stryker and the Development of Documentary Photography in the Thirties* (Baton Rouge, La., 1972) and Hank O'Neal's *A Vision Shared: A Classic Portrait of America and Its People, 1935–1943* (New York, 1976)—rely heavily on the recollections of Stryker and his staff. The first systematic set of FSA interviews was undertaken in 1964 by Richard K. Doud; transcripts are available from the Archives of American Art, Detroit. Hurley conducted more extensive interviews three years later for his work on Stryker; transcriptions of these sessions remain in Hurley's possession. Be-

cause Stryker and his photographers were looking back over more than a quarter of a century, their recollections reveal more about the function of selective memory than the actual process of field photography.

Although transcribed, few of the FSA interviews have been published. Suzanne Reiss's extended dialogue with Dorothea Lange is an exception. "Dorothea Lange: The Making of a Documentary Photographer" (Berkeley, 1968) appeared three years after the photographer's death and is annotated by Lange's husband, Paul Taylor. Although this bound typescript has been given only limited circulation by the Bancroft Library's Regional Oral History Office, it has had considerable impact on the two major assessments of Lange's work: Milton Meltzer, *Dorothea Lange: A Photographer's Life* (New York, 1978), and Karin Becker Ohrn, *Dorothea Lange and the Documentary Tradition* (Baton Rouge, La., 1980). Of the two, Ohrn contributes the more sensitive interpretation of Lange's documentary career, although she is rarely given to analysis of individual images. A similar reticence mars Robert Coles's insightful essay in *Dorothea Lange: Photographs of a Lifetime* (New York, 1982). In this literate and highly personal presentation, Coles seems more intent on tribute to Lange as a kindred spirit than on appraisal of her photographs.

Also based on extensive personal interviews, F. Jack Hurley's *Russell Lee: Photographer* (Dobbs Ferry, N.Y., 1978) is a collaborative work in which the author provided the introductory essay and the photographer selected and supervised the production of accompanying pictures. This handsome volume provides ample evidence of Lee's artistry but little interpretation of visual material.

Lee's colleague Arthur Rothstein also received belated recognition for his government service. More than a decade elapsed between Rothstein's interviews with Doud and Hurley and the appearance of two collections of the photographer's images: *The Depression Years as Photographed by Arthur Rothstein* (New York, 1978) and *The American West in the Thirties* (New York, 1981). Neither work has an adequate introductory essay, leaving

Rothstein as much at the mercy of modern critics as he was during the infamous steer skull episode in 1936.

One of those detractors was Walker Evans, who told an interviewer that moving the skull was a gross violation of documentary ethics. This comment was typical of the diffidence that Evans employed to distance himself from his colleagues and hold all but admirers at bay. Although Evans repeatedly denied that his photography was fine art, scholars and critics have spent the last fifty years explaining the artistic acclaim first accorded him by the Museum of Modern Art in 1938. Indeed, it is from Lincoln Kirstein's essay in *American Photographs* (New York, 1938) that modern interpreters have taken their cues, praising Evans as a latter-day Matthew Brady, armed with the vision of Walt Whitman. Such effusive admiration, born as it was of personal friendship, mars both the introduction to the Museum of Modern Art's 1971 retrospective of Evans's work, *Walker Evans* (Greenwich, Conn., 1971) by MOMA's curator of photography, John Szarkowski, and William Stott's analysis of Evans's photography in *Documentary Expression and Thirties America* (New York, 1973).

Those who pay tribute to the artistic achievements of FSA photographers have been quick to discount Roy Stryker's influence on the project and on documentary photography in general. To understand Stryker's conception of images as illustrative, not esthetic, documents, one must begin with his work as picture editor for Rexford Tugwell's *American Economic Life and the Means of Its Improvement* (New York, 1925, 1930), paying particular attention to Stryker's development of detailed captions and his use (and misuse) of the photographs of Lewis Hine. It was in the context of this Columbia apprenticeship that Stryker encountered two other books that would have a profound impact on his attitude toward both photography and American culture: J. Russell Smith, *North America: Its People and the Resources, Development, and Prospects of the Continent as an Agricultural, Industrial, and Commercial Area* (New York, 1925), and Robert S. Lynd and Helen Merrell Lynd, *Middletown: A Study*

in Modern American Culture (New York, 1929). Stryker's lifelong dependence on these materials makes it clear that he regarded photographic field work not as a form of sociological inquiry but as the search for images to confirm and illustrate a predetermined set of attitudes toward American rural life.

Stryker's attachment to photographs as narrative documents shaped his approach to field photography and made the file a collection of picture stories, a fact camouflaged by postwar FSA picture books, including his own selection of the best of the FSA, prepared with co-author Nancy Wood and entitled *In This Proud Land: America 1935–1943 as Seen in the FSA Photographs* (Greenwich, Conn., 1973). To understand Stryker's growing commitment to the pictorial essay, one should begin by studying Pare Lorentz's relationship with the FSA project and especially the impact of his pioneering film, *The Plow That Broke the Plains* (1936). Unfortunately the best treatment of Pare Lorentz and America's fledgling documentary film movement, William Alexander's *Films on the Left: American Documentary Film from 1931 to 1942* (Princeton, N.J., 1981), makes little mention of Lorentz's relationship to the Resettlement Administration or to Stryker's project.

Lorentz's influence is evident not only in the still pictures that Stryker commissioned to help publicize *The Plow* and Lorentz's next government film, *The River* (1937), but in a number of FSA picture books that experimented with new ways to integrate words and text. The most important of these are Archibald MacLeish, *Land of the Free* (New York, 1938), and Sherwood Anderson, *Home Town* (New York, 1940). Although not sponsored by the FSA, Dorothea Lange's and Paul Schuster Taylor's *An American Exodus: A Record of Human Erosion* (New York, 1939) also adopts the narrative format in which the text approximates a movie soundtrack (MacLeish's analogy). The most succinct statement of FSA photography's debt to documentary film is Arthur Rothstein's article, "Direction in a Picture Story," in Willard Morgan, *The Complete Photographer* (20 volumes, New York, 1941–43), 4:1356–64, which immediately precedes Roy Stryker's essay entitled "Documentary Photography." By contrast

there is a deliberate disengagement of words and images in James Agee and Walker Evans, *Let Us Now Praise Famous Men* (New York, 1941), a work neglected in its own day but revered in our time.

Despite its apotheosis of Agee and Evans, Stott's *Documentary Expression and Thirties America* remains the essential starting point for a definition of the documentary style popular in both literature and photography during the Depression. Unfortunately Stott does not consider parallel documentary impulses in American art and film.

David Peeler's *Hope Among Us Yet: Social Criticism and Social Solace in Depression America* (Athens, Ga., 1987) attempts a much more ambitious fusion of literature, photography and painting. Although he, too, ignores documentary film, Peeler fashions an effective synthesis. His discussion of FSA photography is occasionally marred by dependence on the standard project interviews, especially Arthur Rothstein's tortured explanations of the genesis of *Fleeing a Dust Storm*. When he manages to elude the grasp of such questionable evidence, Peeler provides some excellent visual analysis. Although impressive in both scope and sophistication, Peeler's interpretation of painting will not displace two landmark studies of Depression iconography: Wanda Corn, *Grant Wood: The Regionalist Vision* (New Haven, 1983) and Karal Ann Marling, *Wall-to-Wall America: A Cultural History of Post Office Murals in the Great Depression* (Minneapolis, 1982). In their use of pictorial materials as primary evidence, these works demonstrate the promise of an interdisciplinary approach to material culture of the Depression decade.

Several recent exhibition catalogues indicate the upswing in scholarly interest in documentary photography. Although *The Highway as Habitat: A Roy Stryker Documentation, 1943–1955* (Santa Barbara, Calif., 1986) concentrates on Stryker's post-FSA career, Ulrich Keller's pictorial analysis is much more complex and persuasive than Steven Plattner's earlier treatment of the same subject: *Roy Stryker U.S.A., 1943–1950: The Standard Oil (New Jersey) Photography Project* (New York and Austin, Texas, 1983). Designed to call attention to the photographs of other New Deal agencies, *Official Images: New Deal Photography* (Washington, D.C., 1987), by Pete Daniel and others, inadvertently confirms the pre-eminence of Stryker's project. Maren Stange's essay on the FSA in this volume is not up to the level of her other published work on documentary photography, especially her recent "The Management of Vision: Rexford Tugwell and Roy Stryker in the 1920s," *Afterimage* (March, 1988), which reconsiders Stryker's use of Hine's photographs in *American Economic Life*. Stange's interpretation of the relationship between Stryker and Hine differs markedly from my own, as does her reading of visual evidence.

The most persuasive essay in *Official Images* is Sally Stein's consideration of the photographs of the National Youth Administration. Stein demonstrates a keen ability to discuss both the esthetic and cultural content of documentary photographs, a prowess she displayed in her contribution to *Marion Post Wolcott: FSA Photographs* (Carmel, Calif., 1983). Stein's essay on one of the FSA's neglected photographers deserves much wider circulation than it has thus far received.

Wolcott and other female government photographers are the subject of Andrea Fisher's *Let Us Now Praise Famous Women: Women Photographers for the US Government, 1935 to 1944* (London, 1987). While several passages of this book recall Susan Sontag's brilliant discourse, *On Photography* (New York, 1977), Fisher confounds more than she enlightens her readers. For a more thorough discussion of Fisher's book and *Official Images*, see this author's review essay "Documentary Photographs as Texts," *American Quarterly* 40 (June 1988): 246–52.

Although documentary photography is tangential to his main interests, Peter B. Hales has written two magnificent books that establish the legitimacy of photographs as historical evidence. In *Silver Cities: The Photography of American Urbanization, 1839–1915* (Philadelphia, 1984) and *William Henry Jackson and the Transformation of the American Landscape* (Philadelphia, 1988), Hales shows that the camera was more than a passive machine. Photography was an active social process rendering order in the city and taming the wilderness.

Index

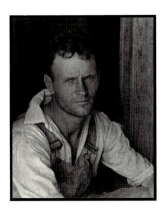